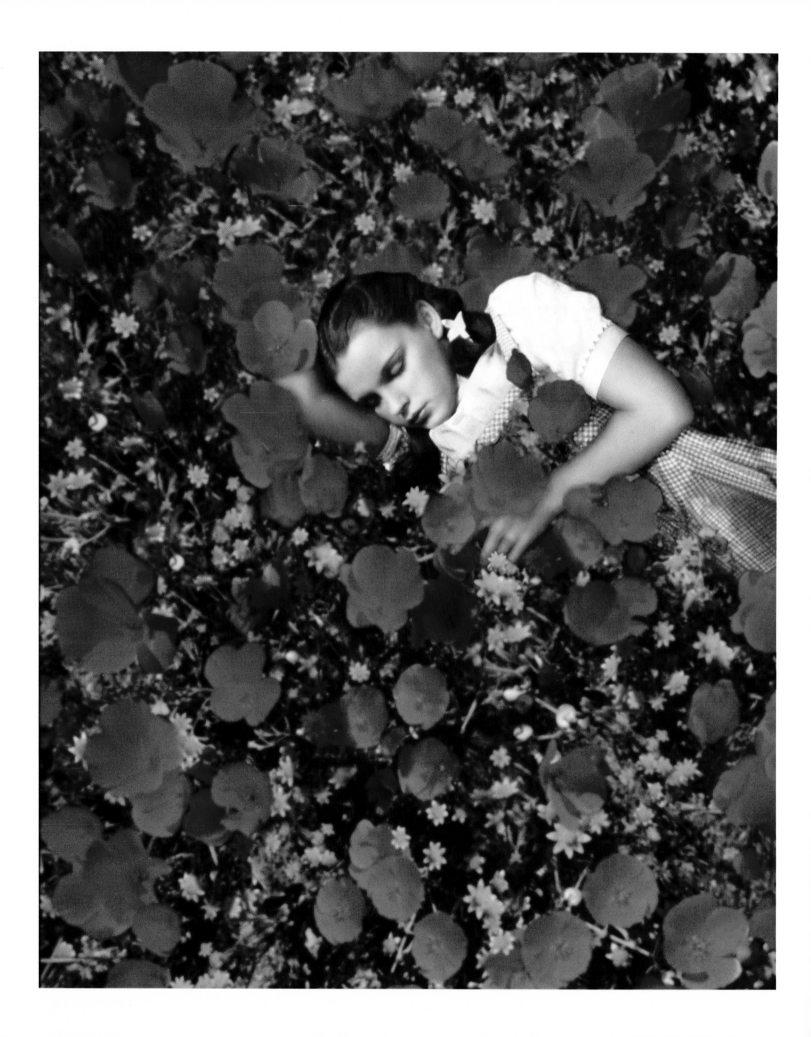

The WIZARD of Oz

The
OFFICIAL
75th
ANNIVERSARY
COMPANION

JAY SCARFONE AND WILLIAM STILLMAN

FOREWORD BY CAREN MARSH–DOLL

HARPER DESIGN
An Imprint of HarperCollinsPublishers

The WIZARD of Oz

THE WIZARD OF OZ

In association with Warner Bros. Global Publishing
Harper Design

Copyright © 2013 Turner Entertainment Co.
THE WIZARD OF OZ and all related characters and elements are trademarks of and
© Turner Entertainment Co.
"Judy Garland as Dorothy from THE WIZARD OF OZ"
WB SHIELD: ™ & © Warner Bros. Entertainment Inc.
(s13)
Oscar®, Oscars®, Academy Award®, and Academy Awards® are trademarks
and service marks of the Academy of Motion Picture Arts and Sciences.

HarperCollins books may be purchased for educational, business, or sales promotional use.
For information please e-mail the Special Markets Department at SPsales@harpercollins.com.

First published in 2013 by
Harper Design
An Imprint of HarperCollins*Publishers*
10 East 53rd Street · New York, NY 10022
Tel: (212) 207–7000 · Fax: (212) 207–7654
www.harpercollins.com · harperdesign@harpercollins.com

Distributed throughout North America by HarperCollins*Publishers*
10 East 53rd Street · New York, NY 10022
Fax: (212) 207–7654

Library of Congress Control Number: 2013940368
ISBN 978-0-06-227801-2

Printed in the U.S.A.
First Printing, 2013
Designed by Paul Kepple and Ralph Geroni at Headcase Design
www.headcasedesign.com

FOR SCOTT,

OUR GUARDIAN ANGEL

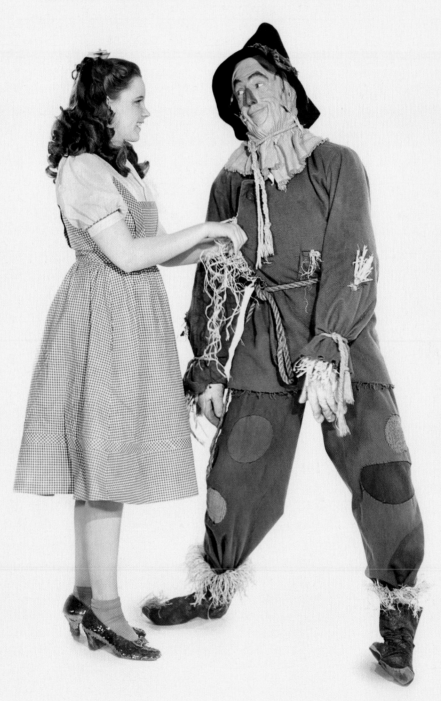

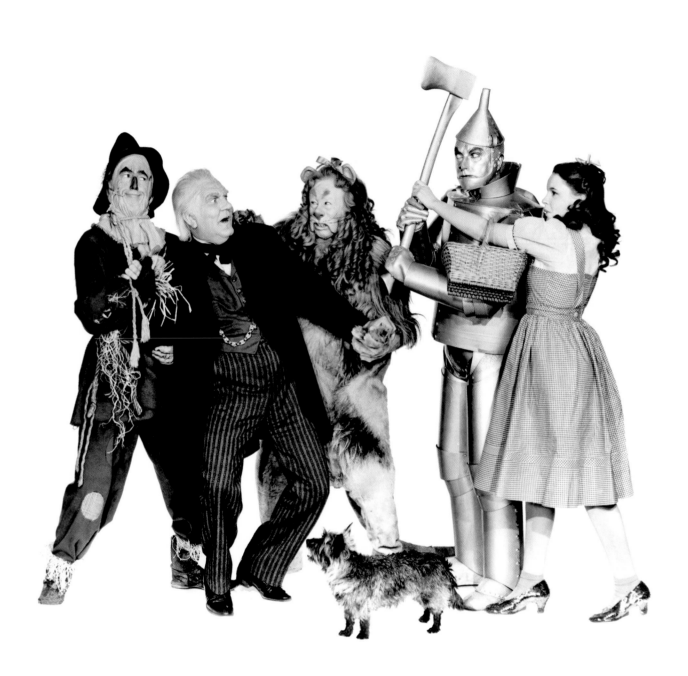

Contents

HEN I FIRST met Judy Garland, she was sixteen years old and I was nineteen. I was working as a dancer on the M-G-M lot when I was chosen to be Judy's stand-in for *The Wizard of Oz.* As I quickly learned, a stand-in never appears on film but takes the place of the actor while technicians are setting up the lights and camera. This job is important to all the technical work that is performed before shooting, so a stand-in must be of the same height, weight, and coloring as their famous counterpart. I understood why the young man who approached me about being a stand-in thought my appearance and dancing ability would be a perfect fit with Judy:

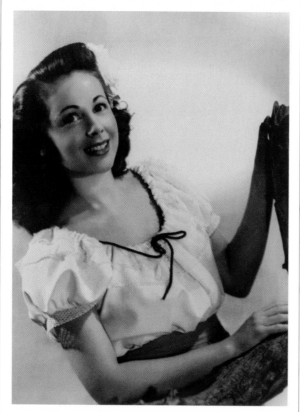

with both of us at four feet, eleven inches tall, with dark hair and eyes, we could have been taken for twins.

Being on the set of *The Wizard of Oz* was an education. When I arrived at M-G-M for my morning call, my first stop was the makeup department. There, the makeup man sponged Max Factor's "4N" peaches-and-cream foundation on me, perfect for Technicolor lighting because it looked light and natural. Next, a hairdresser made me look the part by following a picture of Judy as Dorothy as she wrapped my own hair around a long hairpiece before pinning it in place. A nice wardrobe lady led me to a dressing room, where I slipped out of my slacks and shirt and put on my costume of a blue-and-white checked pinafore and a pale pink, puff-sleeved blouse. I was told that the blouse would photograph as white on Technicolor film.

My first scene was on a soundstage arranged to look like a forest with the Yellow Brick Road running through it. I was surprised because I expected the first scenes to be the cyclone, followed by Munchkinland. But it was explained to me that movies were rarely shot in sequence. After several days, that set folded up, and I waited to be called for the next scene that would be shot about a month later, which would be set in Munchkinland.

In Munchkinland, I felt as though I was in a little storybook village with cartoon houses and oversize flowers. For a magical moment one day, I stood where the Yellow Brick Road began and closed my eyes, imagining I was the real Dorothy. After I had rehearsed the way the scene was to be staged, and all was properly lit and ready to go, they'd call Judy away from her tutor to take my position.

Throughout the course of filming, Judy and I lunched together several times in the M-G-M commissary. I felt guilty with my chicken sandwich and chocolate milk,

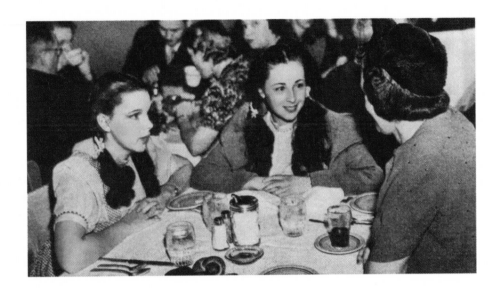

Judy Garland and Caren Marsh (center) are joined in the M-G-M commissary by a Hollywood reporter during production of *The Wizard of Oz* in January 1939.

while Judy only had a bowl of soup. (We both understood that the camera adds about ten pounds to your appearance on the screen, and Judy always seemed to be struggling with her weight then.) But she was sweet and friendly, the real-life embodiment of Dorothy. I had the feeling that Judy didn't think she was attractive and wished that she could have been beautiful. I thought she was perfect.

These many years later, it remains a delight to me to be associated with *The Wizard of Oz*. I have loved the book since I was a girl. Little did L. Frank Baum know that his book would be made into a motion picture that would be a favorite of young and old alike to this very day. As I look back on my many past performances, *The Wizard of Oz* will always hold a special place in my heart.

The Wizard of Oz: The Official Seventy-Fifth Anniversary Companion honors the diamond anniversary of *The Wizard of Oz* and draws upon an incredible wealth of *Wizard of Oz*-related memorabilia that authors Jay Scarfone and William Stillman have been amassing for

more than forty years. When I first saw the Scarfone/Stillman collection, I felt as though I were back on the movie set, surrounded by all of my friends. Through all the rare photographs and new research they have uncovered, most of which is presented here for the first time, I learned things about *The Wizard of Oz* I never knew—and I was there! It will keep the memories alive for fans of the film, and for future generations who will delight in discovering the magic of *The Wizard of Oz* for the first time.

Caren Marsh-Doll

—CAREN MARSH-DOLL
PALM SPRINGS, CALIFORNIA

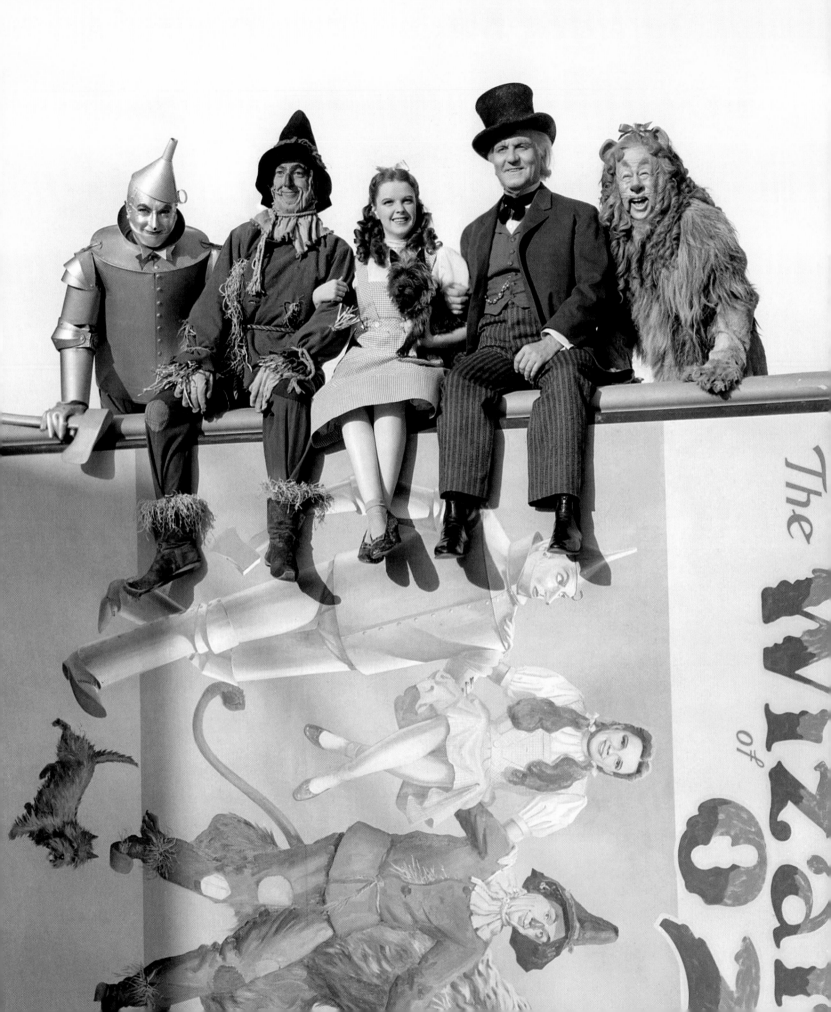

INTRODUCTION

THE WIZARD OF OZ remains as fresh and vibrant as it was when it first debuted in 1939. Like so many other children, we were each captivated by the film, and watched its annual television broadcasts throughout the 1960s and 1970s. Once an air date was announced, the anticipation grew to encompass schoolyard chatter and lunchroom buzz—all leading to the momentous evening when the family gathered to savor those magical hours. It always seemed to pass by so quickly, leaving the aftereffect of a bittersweet sadness in knowing we'd have to wait until the next year to return to the Land of Oz. In the interim, we'd search for tangible reminders of that happy experience, be it a *Wizard of Oz*–related picture book, a sound-track recording, or porcelain figurines. Before we consciously realized it, we were on our way to becoming avid collectors and, as a byproduct of our passion, historians and archivists of the film.

Over the years, there have been numerous books devoted to or associated with the film. As much as we enjoy and admire *The Wizard of Oz*, we desired to honor this celebratory occasion only if we had something unique to present. We aspired to compile a commemorative album that adhered to strict criteria: its visuals would be largely composed of material rarely seen or previously unknown since 1939; and its text would contain newly uncovered quotes and fresh facts. As one might imagine, this was no easy feat for a motion picture so extensively written about, so intensively analyzed, and so fervently collected by dedicated Ozophiles. But in the course of our research odyssey, extraordinary materials "magically" surfaced to support our mission. To that end, we are pleased to present this comprehensive volume—a lavish tribute to the Turner Entertainment Co. film for its diamond anniversary.

We hope you'll enjoy.

—JAY SCARFONE and WILLIAM STILLMAN

THE WIND BEGAN TO SWITCH—
THE HOUSE, TO PITCH
AND SUDDENLY THE HINGES
STARTED TO UNHITCH...

AS CORONER, I MUST AVE
I THOROUGHLY
EXAMINED HER...

...AND SHE'S
not only merely dea
SHE'S REALLY
most sincerely dea

PART

①DREAMS

...IT LANDED ON THE WICKED WITCH
IN THE MIDDLE OF A DITCH...

...WHICH WAS NOT A HEALTHY SIT-
UATION FOR THE WICKED WITCH.

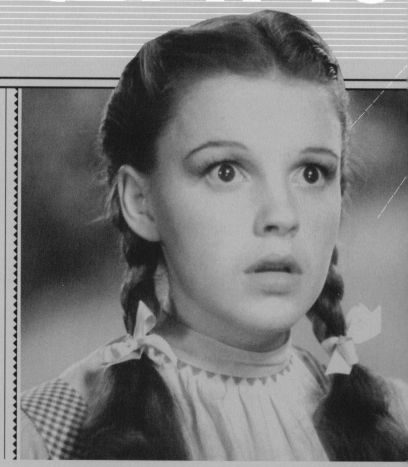

GLINDA, TO DOROTHY:

KEEP TIGHT INSIDE OF THEM...

The *RUBY* SLIPPERS

...THEIR MAGIC MUST BE VERY POWERFUL,
OR SHE WOULDN'T WANT THEM SO BADLY!

The

WICKED WITCH

of the **WEST**

(she's worse than the other one was)

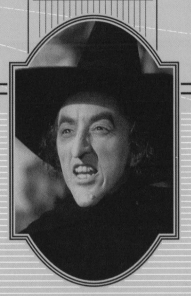

THAT YOU DARE TO DREAM

Casting a Spell

DOROTHY, UPON HER ARRIVAL
IN MUNCHKINLAND:

TOTO—I'VE A FEELING
— **WE'RE NOT IN** —
KANSAS ANYMORE.
WE MUST BE
OVER THE **RAINBOW!**

TO DOROTHY:

I'LL GET YOU,

my pretty,

AND YOUR

LITTLE DOG

TOO!

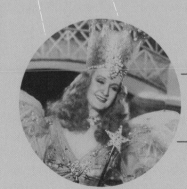

GLINDA, TO THE WICKED WITCH OF THE WEST:

*Be gone, before somebody drops
a house on you, too.*

THE STORY OF how *The Wizard of Oz* was made has a long history. Its attendant anecdotes have become nearly as legendary as the film itself. It is a rare occasion when two or more people gather to watch the film and no one present recites random, purported behind-the-scenes truths. In recent times, this has included such myths as a Munchkin suicide caught on-camera (a complete fabrication) and the alleged synchronicity of Pink Floyd's *Dark Side of the Moon* with on-screen events. Each generation has embraced *The Wizard of Oz* as its own, interpreting it uniquely. This is remarkable in that the film itself has never changed, despite our evolving tastes in popular culture.

Movie audiences of 1939 watched *The Wizard of Oz* unfold before their eyes. The film's introductory statement read:

FOR NEARLY FORTY YEARS THIS STORY HAS GIVEN FAITHFUL SERVICE TO THE YOUNG IN HEART; AND TIME HAS BEEN POWERLESS TO PUT ITS KINDLY PHILOSOPHY OUT OF FASHION.

TO THOSE OF YOU WHO HAVE BEEN FAITHFUL TO IT IN RETURN

. . . AND TO THE YOUNG IN HEART

. . . WE DEDICATE THIS PICTURE.

As this dedication implies, the fable that would ultimately become one of the most-seen and best-loved motion pictures of all time had its origins nearly four decades prior. And in order to appreciate how *The Wizard of Oz* attained its mythic mantle, one must first understand the era in which it was created.

PRELUDE TO A MOVIE CLASSIC

I N 1 9 0 0 , L. Frank Baum's best-selling book *The Wonderful Wizard of Oz* set the contemporary standard for children's literature and became America's first fairy tale. Baum's fantasy was a departure from traditional nursery rhymes and European fairy tales, and readers of all ages were charmed by Dorothy, her friends, and her little dog, too. An adaptation of Baum's story, set to music, became Broadway's biggest hit of 1903 and made celebrities of Fred Stone and Dave Montgomery, the show's Scarecrow and Tin Man. Successful cinematic ventures, however, were another matter. All screen treatments prior to 1938 had been busts: there had been a little-known 1910 interpretation; an obscure 1933 cartoon short; and a much-hyped but ultimately disastrous 1925 slapstick silent film starring Larry Semon, then a Comedy King. A fledgling radio serial of the early 1930s had experienced modest success, but that was an anomaly. Even Baum's own early experiments with motion picture adaptations of his stories ended in financial ruin.

The unprecedented success of Walt Disney's *Snow White and the Seven Dwarfs* (1937)—which grossed $3.5 million in Depression-era dollars—caused major motion picture studios to seriously reconsider the viability of film fantasy. According to a 1939 *Cosmopolitan* article, the story that moviegoing fans most wanted to see on-screen was that of the adventures of Dorothy and her dog Toto in the Land of Oz. A beloved classic for generations of readers, Baum's tale had all the makings of a proper fantasy, and Hollywood was quick to pick up on its cinematic potential.

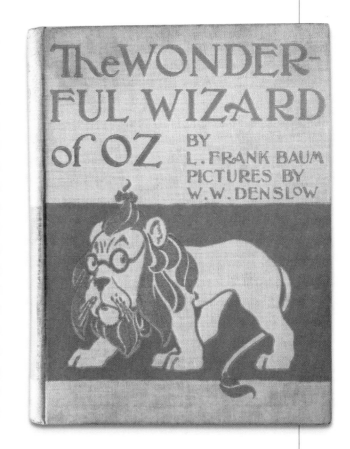

The Wonderful Wizard of Oz (1900) was L. Frank Baum's sixth book for children, published when the author was turning forty-four. Its whimsical, ingenious illustrations were rendered by William Wallace Denslow (1856–1915). Throughout Baum's writing career, he composed thirteen sequels, fifty-five novels in total, more than eighty short stories, more than two hundred poems, and various scripts for the stage.

L FRANK BAUM (BORN May 15, 1856) had careers as an actor, shopkeeper, newspaper editor, and traveling salesman before writing *The Wonderful Wizard of Oz*, which was printed in May 1900. In 1939, Baum's widow, Maud, remembered that he wrote the story on scraps of hotel stationery and other bits of paper, scribbling down the fairy-tale anecdotes he had previously told his four sons and the neighborhood children. The story begins with little Dorothy and her black terrier, Toto, who live with Aunt Em and Uncle Henry on a meager farm in the midst of the great, gray Kansas prairie. The setting is typical of many hardscrabble American pioneers of the era, but when a cyclone unexpectedly sweeps across the plains, it whisks Dorothy and Toto to the extraordinary Land of Oz. The Land of Oz is a parallel world not completely unlike Kansas: it is peopled with farmers, cornfields, tinsmiths, and carny magicians; but it is also a magical land. On her journey to return home, Dorothy befriends an animated scarecrow, a woodcutter made of jointed tin, and a talking but fearful lion.

L. FRANK BAUM:

THE MAN WHO DISCOVERED THE LAND OF OZ

"TO PLEASE A CHILD IS A SWEET AND LOVELY THING THAT WARMS ONE'S HEART AND BRINGS ITS OWN REWARD."

—L. FRANK BAUM

The October 1900 issue of *The Literary News* declared *The Wonderful Wizard of Oz* "ingeniously woven out of commonplace material," and suggested that it "will surely be found to appeal strongly to child readers . . . and one of the most familiar and pleading requests of children is to be told another story." Telling more stories about the Land of Oz was not Baum's intention, but after the success of this book, the author was deluged with letters requesting further chronicles about Dorothy, the Scarecrow, the Tin Woodman, the Cowardly Lion, and all the other creatures of his fanciful tale. In total, Baum penned fourteen Land of Oz–related books—usually one a year—in addition to many other children's stories, adult novels, songs, and poems.

On April 19, 1903, Atlanta, Georgia's *The Constitution* published L. Frank Baum's inspiration for the word "Oz" of the book's title. "Well," he said, "I have a little cabinet file on my desk that is just in front of me. I was thinking and wondering about a title for the story, and had settled on 'Wizard' as part of it. My gaze was caught by the gilt letters on the three drawers of the cabinet. The first was A-G; the next drawer was labeled H-N; and on the last were the letters O-Z. And 'Oz' it at once became."

When L. Frank Baum passed away on May 6, 1919, *Los Angeles Times* book critic Guy Bogart poignantly and prophetically eulogized the author in a letter to his widow: "It is scant relief in the first bitterness of loss to know that Mr. Baum is one of the world's greatest literary figures of all ages—that he is the creator and discoverer of a new world of fiction for children; to realize that the millions to whom he has brought joy are but the first fruits of the many, many millions who will enjoy the Baum stories through centuries to come—because they are permanent."

After Baum's death, the characters and geography of the Land of Oz continued to be explored by other authors in additional related titles, until the books totaled forty in all. The series was discontinued after 1963, but the anticipation of an annual book for the holidays continued with the tradition of yearly television broadcasts of the film for the Christmas season and, later, at Eastertime.

OPPOSITE: A 1908 portrait of author L. Frank Baum was among the family photographs loaned by Baum's widow, Maud, to M-G-M in 1939 in order to publicize *The Wizard of Oz*. • INSET: C. F. Payne's mixed media portrait satirizes L. Frank Baum (1856–1919) as the Wizard of Oz in his runaway balloon accompanied by the creatures of his fertile imagination.

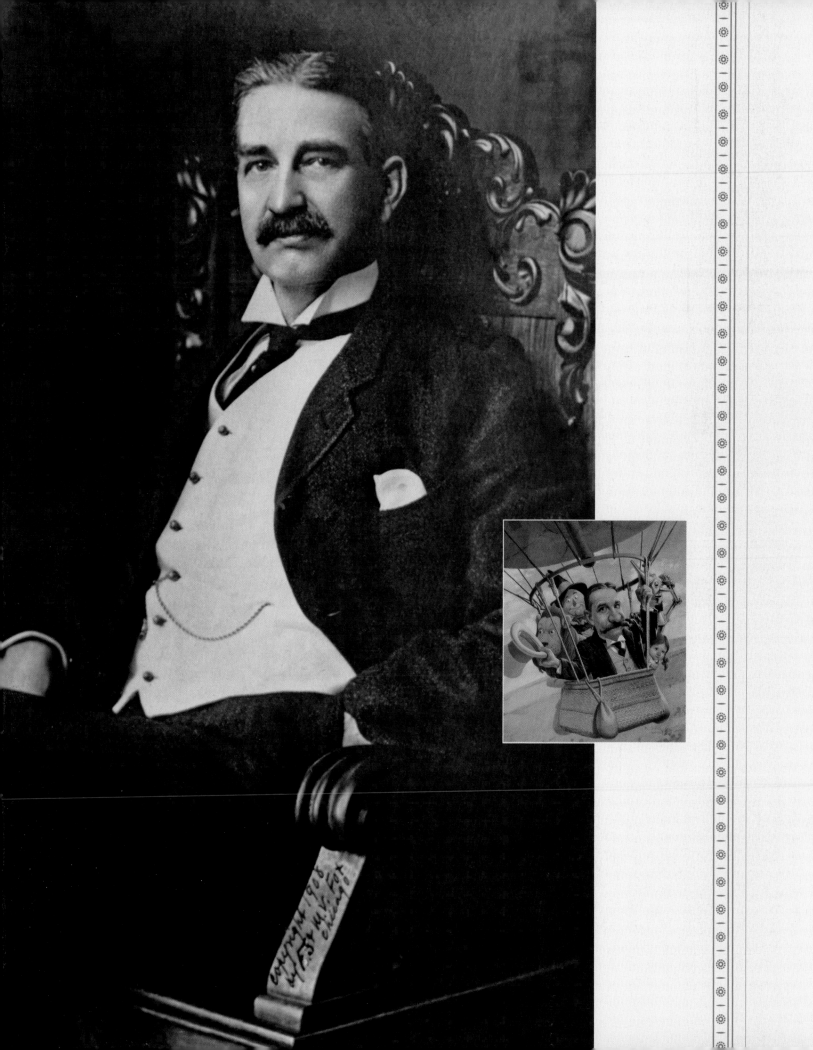

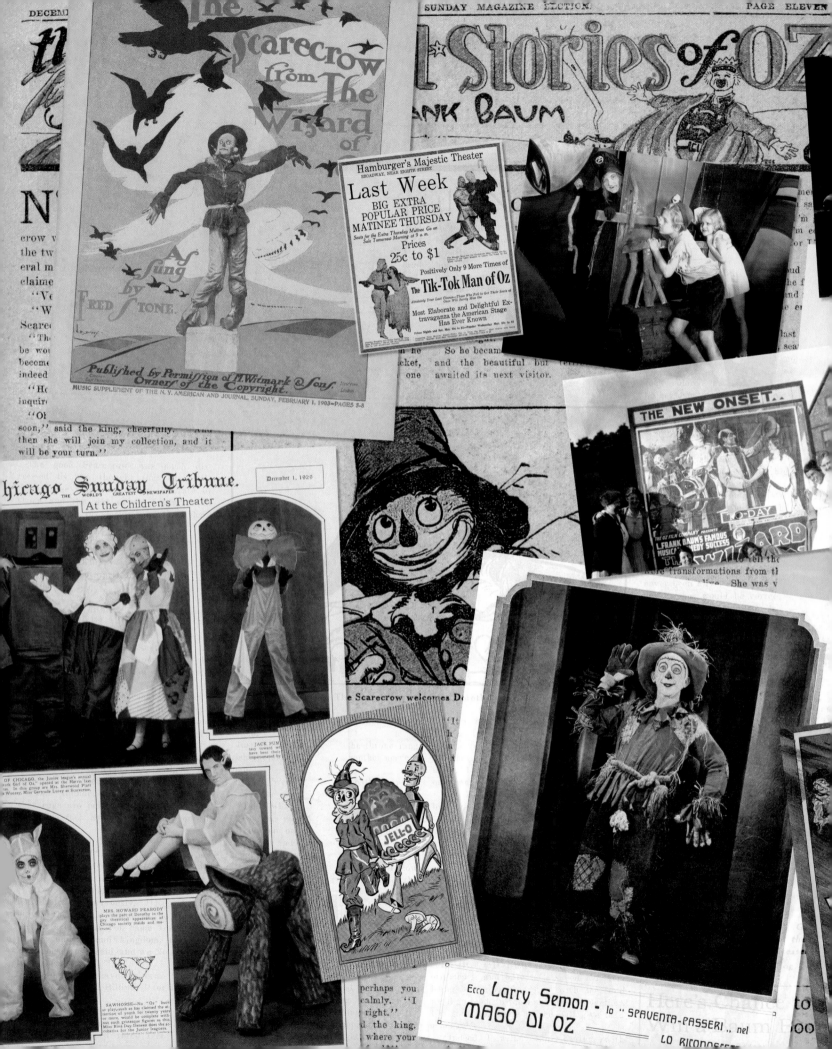

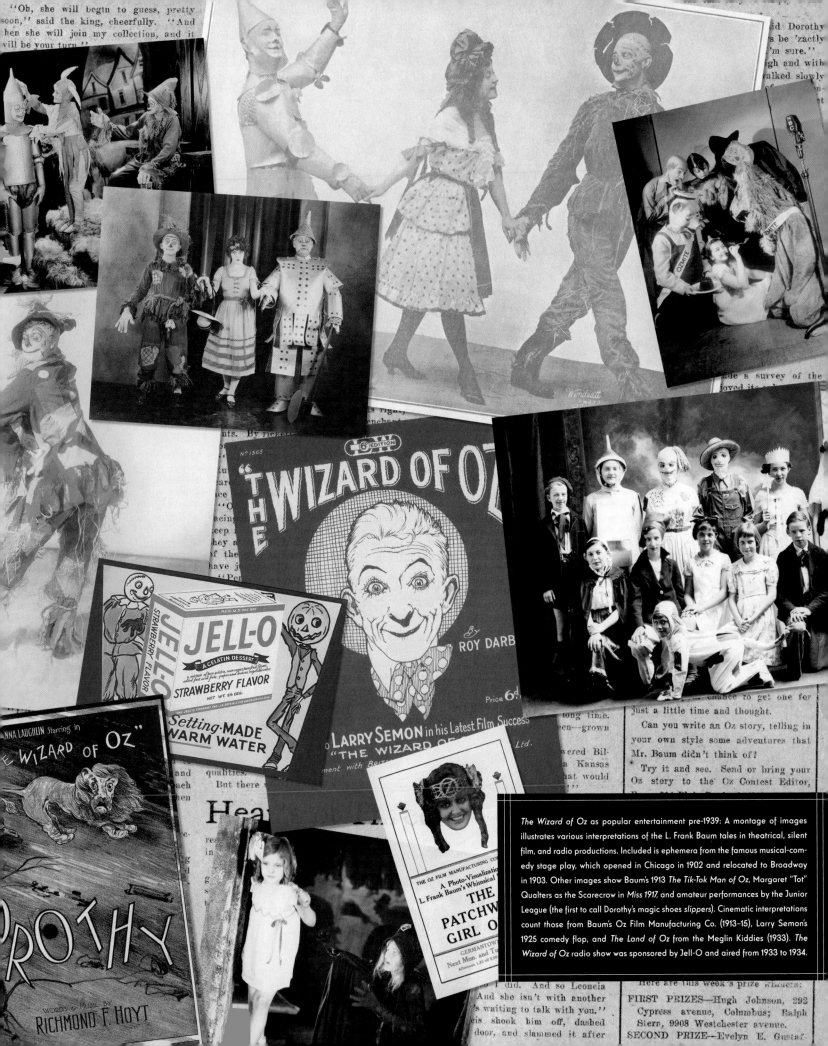

The Wizard of Oz as popular entertainment pre-1939: A montage of images illustrates various interpretations of the L. Frank Baum tales in theatrical, silent film, and radio productions. Included is ephemera from the famous musical-comedy stage play, which opened in Chicago in 1902 and relocated to Broadway in 1903. Other images show Baum's 1913 *The Tik-Tok Man of Oz*, Margaret "Tot" Qualters as the Scarecrow in *Miss 1917*, and amateur performances by the Junior League (the first to call Dorothy's magic shoes *slippers*). Cinematic interpretations count those from Baum's Oz Film Manufacturing Co. (1913–15), Larry Semon's 1925 comedy flop, and *The Land of Oz* from the Meglin Kiddies (1933). *The Wizard of Oz* radio show was sponsored by Jell-O and aired from 1933 to 1934.

A HOLLYWOOD COMMODITY

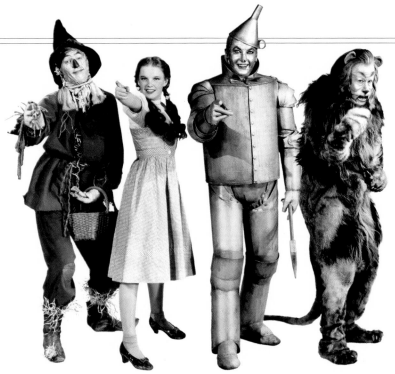

"THE WIZARD OF OZ, WHICH WILL BE FILMED AS AN ELABORATE MUSICAL EARLY NEXT YEAR, WAS PUT ON CELLULOID ONCE BEFORE, BUT NOT WITH THE SUCCESS WHICH ITS NEXT PRODUCER, SAMUEL GOLDWYN, PREDICTS FOR IT."

—JOURNALIST HUBBARD KEAVY, OCTOBER 29, 1933

AT THE TIME, movie mogul Samuel Goldwyn owned the screen rights to *The Wonderful Wizard of Oz*, having acquired them from L. Frank Baum's eldest son in 1933. (The deal was legally sealed January 26, 1934.) But then, as now, rights acquisition didn't necessarily translate into full-fledged productions. Scripts could languish, pictures could be announced and then retracted, and entire productions might be shut down.

By early 1938, no formal production of the film was in the works. And Sam Goldwyn was in a funk over a corporate rift with Mary Pickford, Douglas Fairbanks, and Charlie Chaplin, who collectively represented the United Artists (UA) production company. When negotiating with the Baum family to purchase screen rights a few years prior, Goldwyn had contemplated *The Wizard of Oz* as a Technicolor talkie with UA associate Pickford in the lead. As a preliminary experiment for *The Wizard of Oz*, Goldwyn filmed the seven-minute musical finale to Roy Del Ruth's *Kid Millions* (1934) in Technicolor. In this segment, comedian Eddie Cantor is the Willy Wonka–esque proprietor of a fabulous ice cream factory visited by dozens of

Beginning in 1913, Samuel Goldwyn was a founding father in the burgeoning motion picture industry. Metro-Goldwyn-Mayer was borne of the 1924 merger between his Goldwyn Pictures and Marcus Loew's Metro Pictures Corporation. Then known for his Goldwyn Follies and "Goldwyn Girls," Goldwyn's best-remembered contributions as producer or director include *Wuthering Heights, The Little Foxes, The Best Years of Our Lives,* and *Guys and Dolls.*

children. The *Kid Millions* fantasy sequence cost Goldwyn $200,000; the mogul announced that the following year he would invest "better than a million" to film *The Wizard of Oz* entirely in color for United Artists. But his plans never materialized beyond gossip-column supposition that Cantor would play the Wizard of Oz; that Ann Ronell, who cowrote "Who's Afraid of the Big Bad Wolf?," was doing the music; and that Goldwyn was scouting a writer who could do the Baum story justice.

By the late 1930s United Artists's founding members were scheming to sell off their company stock, buy out Goldwyn as an investor (and one of their independent producers), and sell the business to another film

company. A prospective takeover deal by Goldwyn and director Alexander Korda had just fallen through in December 1937, and by January no equable resolution was in sight. During this impasse, Goldwyn retreated to Honolulu and entered into a self-imposed hiatus, momentarily disenchanted with the picture-making business. Upon his return, he began divesting his story properties, selling *Murder in Massachusetts* to Columbia, among others. Most significantly, he began entertaining offers on *The Wizard of Oz*, and a bidding war fast ensued.

By February 18, 1938, Metro-Goldwyn-Mayer acquired the motion picture rights to *The Wizard of Oz*, outbidding Twentieth Century–Fox, which, the *New York Times* reported, had wanted the story specifically as a vehicle for their star Shirley Temple. Amid rumors and various newspaper editorials that the film should be done as an animated cartoon, executive producer Mervyn LeRoy announced that *The Wizard of Oz* would, in fact, be a live-action musical *simulating* a cartoon.

Set design of the dairy-cow stalls by William "Willy" Pogany for the ice cream factory finale of Sam Goldwyn's *Kid Millions* (1934). The Technicolor sequence was Goldwyn's testing ground in preparation for a full-color, all-star *The Wizard of Oz* that was never produced. The film was slated to follow *Kid Millions* as the next in a cycle of Goldwyn-produced musical comedies starring Eddie Cantor.

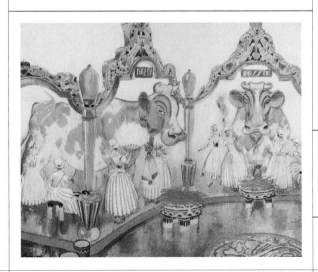

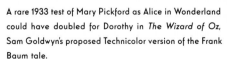

A rare 1933 test of Mary Pickford as Alice in Wonderland could have doubled for Dorothy in *The Wizard of Oz*, Sam Goldwyn's proposed Technicolor version of the Frank Baum tale.

PREPRODUCTION

FROM PAGE TO SCREEN

MERVYN LeROY'S AMBITION to adapt *The Wizard of Oz* into a lavish, full-color musical was motivated by his fondness for the L. Frank Baum book and childhood memories of having seen the theatrical extravaganza. He recalled, "As a boy, I read and loved Baum's books. That wasn't unusual; children of my era and children of all the eras yet to come loved *The Wizard of Oz* and all the others. It had long been an idle dream of mine to take those fantastic, enchanting creatures and turn them into a movie. The dream remained a dream until I found myself at M-G-M." All eyes were on LeRoy to create a picture that would not only replicate the popularity of the Baum book

children and Dorothy as longing for a prince. Other changes included having the characters dress up as members of "Smith's Circus" when they, along with the Wizard of Oz, sneak into the Witch's castle. In this version of the script, Dorothy wears the white tights and ruffled skirt of a bareback rider. The Tin Man is disguised as a mustached ringmaster and the Wizard of Oz plays the part of the circus strong man, complete with a leopard-skin costume. A July 25, 1938, version described the Wicked Witch's obsession with Dorothy's magic shoes as so great that she threatens to *cut* them off Dorothy's feet. One proposed opening title sequence was imaginative, though unnecessarily complicated: a wizard's shadow performed various

> "THE FANTASTIC ADVENTURES OF A LITTLE GIRL WHO FINDS HERSELF
> IN A MAGIC KINGDOM INHABITED BY LOVABLE LITTLE DWARFS.
> SHE MEETS MANY STRANGE CREATURES AND FINALLY COMES TO THE
> ABODE OF THE WIZARD OF OZ. A TRULY MODERN FAIRY TALE."
> —M-G-M'S JUNE 4, 1938, SYNOPSIS OF *THE WIZARD OF OZ*

but would also rival the box-office success of *Snow White*. Everyone—Hollywood insiders, stockholders, columnists, and newspaper editors nationwide—had an opinion about *The Wizard of Oz*.

"[A] lot of people have been writing to tell me what dire punishment is in store for all of us if we were to tamper with the story," LeRoy confessed to the *San Francisco Chronicle*. But that is precisely what occurred as a series of writers tried their hand at translating Baum's prose into a screenplay. Early drafts of the script were overwrought and clunky, and featured Auntie Em as a coldhearted woman who doesn't believe in kissing

sleight-of-hand tricks to make the picture credits magically appear and disappear. While the script underwent numerous revisions, LeRoy had his own conundrum: Toto. LeRoy was conflicted as to how Toto should be portrayed: should an actor play the part of Toto—in the style and manner of the Cowardly Lion—or would an actual canine suffice? LeRoy agonized over every aspect of the film.

Striking a balance between admirers of the Baum books and regular movie patrons was a delicate prospect. LeRoy's philosophy was that any treatment of the source matter should be handled with the awed wonderment of a child. Or, as LeRoy put it, "To make a picture like *The Wizard of*

WALT AND LeROY:

FRATERNITY OF FANTASY

"I HOPE THE GHOST OF L. FRANK BAUM GIVES SAMUEL GOLDWYN A GOOD HAUNTING FOR NOT SELLING THE RIGHTS TO THE WIZARD OF OZ BOOKS TO WALT DISNEY."

—HOLLYWOOD COLUMNIST PAUL HARRISON, MARCH 16, 1938

MERVYN LeROY

WHEN M-G-M ANNOUNCED that Mervyn LeRoy would produce *The Wizard of Oz*, it was widely considered a risky gamble to rival Walt Disney. But Disney was held in highest esteem by LeRoy, who in later years stated that Walt was one of only two geniuses he had ever met—M-G-M producer Irving Thalberg being the second. (LeRoy so admired Disney that he conceived the idea of giving Disney one Oscar® statuette plus seven smaller ones when he was honored for *Snow White* at the eleventh annual Academy Awards® in February 1939.) Historically, film fantasies were tenuous turf, with the exception of cartoon shorts. With so much at stake, the ambitious LeRoy exercised due caution. Dissatisfied with a flurry of wildly meandering *Wizard of Oz* script drafts and rewrites from more than two months prior—all contributed by various screenwriters—the producer sought to revitalize his production team's mind-set about the elements of successful fantasy. On May 10, 1938, LeRoy screened *Snow White and the Seven Dwarfs* at M-G-M, the print on loan directly from Walt Disney himself at LeRoy's request. Among the production staff undoubtedly in attendance were songwriters Harold Arlen and E. Y. Harburg, who had begun their association with *The Wizard of Oz* just the day before.

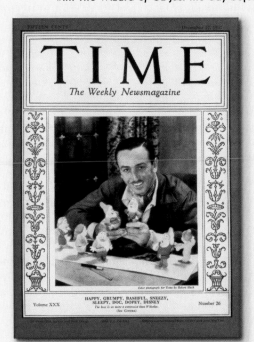

It was not uncharacteristic that LeRoy should have consulted Disney; the two held mutual regard for each other as industry colleagues active in the Academy of Motion Picture Arts and Sciences. Socially, both Disney and LeRoy were avid Thoroughbred racing fans and, in 1938, each was an original shareholder of the new Hollywood Park racetrack. Professionally, a cooperative relationship between Disney and M-G-M had previously been established by Disney's creating animated segments or allowing use of his characters for several M-G-M films, including *Hollywood Party* (1934), *Babes in Toyland* (1934), and *The Women* (1939).

December 27, 1937: Walt Disney officially becomes a movie mogul with this cover for *Time*, which acknowledged *Snow White and the Seven Dwarfs*'s critical and artistic triumph. Among his follow-up projects, Disney was eyeing the Frank Baum *Wizard of Oz* stories.

Oz everybody has to be a little drunk with imagination." It was an approach LeRoy maintained in all his interviews about the film, and it guided the producer in his choice (and dismissal) of directors and scriptwriters.

Screenwriter Noel Langley was one of more than a dozen individuals who had their hand in developing the film's screenplay, but one of only three to receive credit. LeRoy tapped Langley for *The Wizard of Oz* after the writer showed the producer a copy of *The Tale of the Land of Green Ginger* (1937), a fairy tale he had written and illustrated. Chief among Langley's editorial changes was to portray the fantasy portion of the story as Dorothy's concussion-induced nightmare. In Baum's tale, her adventures in the Land of Oz are true. In a February 1939 interview, Langley rationalized the narrative adjustment in terms of box-office insurance:

> **Mankiewicz Leaves M-G-M; LeRoy Will Produce "Oz"**
>
> *West Coast Bureau of THE FILM DAILY*
> Hollywood — Herman G. Mankiewicz, veteran writer at M-G-M, has completed his treatment on "The Wizard of Oz," on which he collaborated with Noel Langley, and has left the Metro studio. "The Wizard of Oz" will be produced by Mervyn LeRoy.

> *The patronage of those who want to see an exact movie of the book wouldn't pay for the picture. If one-third of the audiences knows the book, it's a good percentage. And we have to please the other two-thirds who will expect an entertaining picture rather than a faithful reproduction. So we had to compromise by making the first part of the picture in the Kansas setting quite plausible and introducing characters in it that later appear in the Land of Oz sequences. . . . In the book, you remember, Dorothy goes to sleep during the cyclone and wakes in the Land of Oz. So making the fairy tale a dream sequence is consistent with the story.*

Langley's position wasn't as complacent after he saw *The Wizard of Oz* for the first time and realized the edits that had been made to his script. He wept bitterly and stated that he "loathed the picture" for completely missing the mark, in his opinion. During development of the script for *The Wizard of Oz*, Langley was prone to passionate arguments with his producers and even walked off the picture at one point.

Florence Ryerson and Edgar Allan Woolf were Langley's screen-credited coauthors on *The Wizard of Oz* script. Older and wiser, they understood how to navigate the studio system and its inherent politics. Just prior to the film's premiere, the screenwriting team was savvy enough to take out a full-page ad in *Daily Variety* that read:

"Every moment we worked on the 'Wizard' with Mervyn LeRoy was a moment of joy." (Eventually time mellowed both Noel Langley's temperament and his perception of *The Wizard of Oz*. When he saw the picture again a decade later, he was more objective, saying, "Not a bad picture, you know.")

While the finished script was a fairly faithful rendition of the Baum book, the screenwriters did retain some artistic liberties. Several characters now had Kansas counterparts to their Land of Oz doppelgängers. The Emerald City took on a decidedly British atmosphere not reflected in Baum's original. The sentry at the palace gates was described in one draft as wearing a slightly exaggerated copy of the uniform worn by the guards at Buckingham Palace; and the song "The Merry Old Land of Oz," performed by a Cockney cabby, is a playful spin on the British phrase "Merrie Olde England." But ultimately, *The Wizard of Oz* retained the most important characters and components from its originally published form. All creatures and subplots that were considered superfluous to preserving the humanistic element of Baum's narrative were excised. This film was to be the most authentic attempt in preserving the essence of Baum's original. But public opinion awaited—and the public could be fickle.

THE WIZARD OF OZ FINDS DIRECTION

"[*THE WIZARD OF OZ*] STORIES WERE THE FIRST CHILDREN'S STORIES OF THE FAIRY-TALE TYPE TO BREAK AWAY FROM THE CONVENTIONAL PRINCES AND PRINCESSES, OGRES, GIANTS, AND SO ON. . . . UNTIL BAUM CONCEIVED THE IDEA OF STREAMLINING THEM, THEY WERE CONSIDERED THE ONLY LITERARY FARE FOR YOUNGSTERS."

—VICTOR FLEMING

ONCE THE SCRIPT was acceptable, production began in earnest, albeit in fits and starts. Norman Taurog, known for coaching child actors into stellar performances, was the first director announced in industry trade publications to "meg" *The Wizard of Oz*—"meg" being 1930s show-biz slang for the megaphone used by directors to give instructions on set. Before filming began in mid-October 1938, however, Taurog was replaced by Richard Thorpe, who had a reputation for bringing in pictures on schedule and within budget.

Given that *The Wizard of Oz* was a costly project, it was advantageous that Thorpe was expedient. Within two weeks on the picture, he had filmed Dorothy's introduction to the Scarecrow and all the events in and around the Wicked Witch's castle. He had begun rehearsing scenes in the apple orchard leading to the discovery of the Tin Man when production was halted; LeRoy was dissatisfied with the raw footage and dismissed Thorpe. The directorial seat was next assumed by George Cukor.

Though not intended to helm *The Wizard of Oz* long-term, Cukor

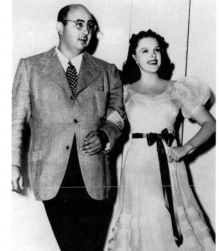

helped LeRoy troubleshoot and recommended revisions for the actors' deliveries and, most significantly, their makeup designs. Within a matter of days, however, Cukor was recalled from his loan-out by David O. Selznick to continue preparations for directing *Gone with the Wind*. Victor Fleming was announced as next in the "pilot's seat."

It has often been suggested that Fleming, the director of record for *The Wizard of Oz*, signed on to the project with paternal instinct as his motivation, attracted by the chance to create a cinematic valentine for his two young daughters. Indeed, Fleming possessed the childlike vision LeRoy valued, and has been quoted as saying, "[I]t is not difficult for adults to accept the [*Wizard of Oz*] story and enjoy it as much as children. For, as you know, we are all Peter Pans to some degree." But it may also be argued that Fleming was equally spurred to accept the project in honor of L. Frank Baum— especially as Fleming and Baum had reportedly met on at least one occasion in Fleming's youth.

As sensational as it sounds, it is not improbable for the two men to have crossed paths: Baum lived in Hollywood from 1910 until his

Norman Taurog and Judy Garland strike a "We're Off to See the Wizard" pose when they reunited to film *Little Nellie Kelly*, September 23, 1940.

death in 1919. Fleming would have been in his twenties and the protégé of director Allan Dwan at the time that Baum was active with his Oz Film Manufacturing Company, 1913 to 1915. The story was planted among the prepared reviews, player biographies, and assorted anecdotes in *The Wizard of Oz* theatrical campaign book: "Fleming knew Baum years ago when the author lived in Hollywood," and Fleming is quoted as saying, "I was a youngster then, intensely interested in the show business. Naturally when introduced to the author, my first remark was about his story and the stage show." According to Fleming, Baum attributed *The Wizard*

GEORGE CUKOR

of Oz musical's longevity to its inspired spark of originality. M-G-M's account concluded that the encounter between author and aspiring director left an impression: "Throughout [Fleming's] career he remembered [Baum's] stories, but he never dreamed that he would one day be chosen to direct one."

Fleming may have seemed an odd choice to direct a fairy tale, the success of which depended largely on the performance of its child lead. Standing six-foot-one and ruggedly handsome with piercing gray eyes, Fleming was a formidable presence with a no-nonsense directing style and a penchant for manly outdoor activities after hours. But it

The Wizard of Oz commences production, October 13, 1938, as director Richard Thorpe, Terry the cairn terrier, and Judy Garland gather for the press. This is the only known photograph to show Thorpe on the film's set. Thorpe was its second director, following Norman Taurog, but the first to begin shooting footage. Thorpe was dismissed after two weeks and reassigned to direct *The Adventures of Huckleberry Finn*. Thorpe is perhaps best known for directing Johnny Weissmuller through four Tarzan pictures and Elvis Presley in *Jailhouse Rock*.

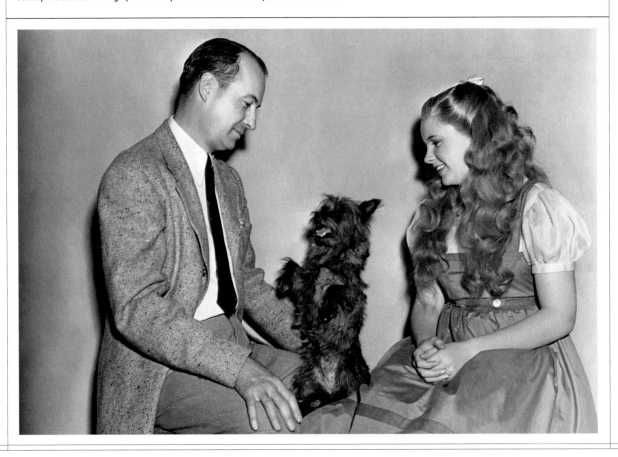

VICTOR FLEMING

DIRECTED

THE WIZARD OF OZ

An
M-G-M
Picture

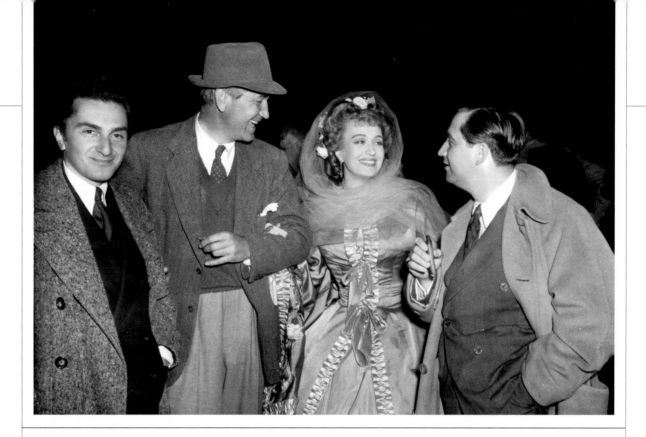

Mervyn LeRoy (far right) and Georgie Stoll (far left), associate conductor on *The Wizard of Oz*, pay a visit to Selznick International Pictures to consult with Victor Fleming about *The Wizard of Oz* on the set of *Gone with the Wind*. They are joined by actress Ona Munson in costume as Belle Watling.

should be remembered that he quite competently handled juvenile actors in M-G-M's *Treasure Island* (1934) and *Captains Courageous* (1937). While making *Test Pilot* in 1938, Martin Spellman recalled that the director took a shine to him and generously arranged for Spellman to have a speaking line in a crowd scene in which he was a child extra. In early 1939, M-G-M announced that Fleming was to direct *The Yearling,* with its boy protagonist, Jody. When critic Wood Soanes reviewed *The Wizard of Oz* in 1939, he noted that Judy Garland's effectiveness as Dorothy was "a tribute to the direction of Victor Fleming."

Fleming directed Garland and the remaining cast through the majority of the film's production, including most of the Technicolor sequences (the only salvageable footage from Richard Thorpe's tenure being a few fleeting shots of

KING VIDOR

Toto escaping the Wicked Witch's castle). During his time on *The Wizard of Oz*, Fleming was recalled as professional but not untenable; his impatience flared only occasionally. In January 1939, after the Munchkinland scenes had wrapped, Robert Kanter, who played a Munchkin soldier, said Fleming was a "darn swell chap." Garland developed a schoolgirl crush on the director and, years later, referred to him as "a darling man." She even threw Fleming a farewell party in February 1939 when he was reassigned to take over directorship of *Gone with the Wind* from George Cukor. (As the party ended, the crew turned on five huge fan machines to jokingly blow Fleming away "with the wind.") The film's remaining Kansas scenes and Technicolor retakes were subsequently overseen, without credit, by director King Vidor.

OPPOSITE: Though King Vidor supplanted Victor Fleming as director in February 1939, his M-G-M contract was not amended until March 8, 1939—the anniversary date of Vidor's tenure with Metro. In addition to overseeing the Kansas scenes, Vidor also directed Technicolor retakes and minor additions to *The Wizard of Oz*, all of which went uncredited per Vidor's amendment.

C U L V E R ~ C I T Y
CALIFORNIA

March 8, 1939

Mr. King Vidor
c/o Metro-Goldwyn-Mayer Studios
Culver City, California

Dear Mr. Vidor:

This will confirm the following agreement between us with reference
to our contract of employment with you dated March 8, 1938:

 1. You are rendering certain services for us in connection
with our photoplay now entitled WIZARD OF OZ, and it is
now agreed between us that said photoplay shall not be considered a
"unit" within the meaning of paragraph 16 of said contract of employ-
ment.

 2. It is, of course, understood and agreed that we shall
be entitled forever to all rights in the results and
proceeds of your services in WIZARD OF OZ without restriction or
qualification whatsoever. You acknowledge that, in accordance with
said contract, we need not give credit to you in connection with said
photoplay and that so far as you are concerned, we may give director's
credit to others.

 3. Except as hereinabove expressly provided, said contract
dated March 8, 1938, as amended, is not further changed,
altered, amended or affected in any manner or particular whatsoever.

If the foregoing is in accordance with your understanding and agree-
ment, kindly indicate your approval and acceptance thereof in the
space hereinbelow provided.

Very truly yours,

APPROVED AND ACCEPTED:

LOEW'S INCORPORATED

King Vidor
(King Vidor)

By *[signature]*
Assistant Treasurer

IHP:ek

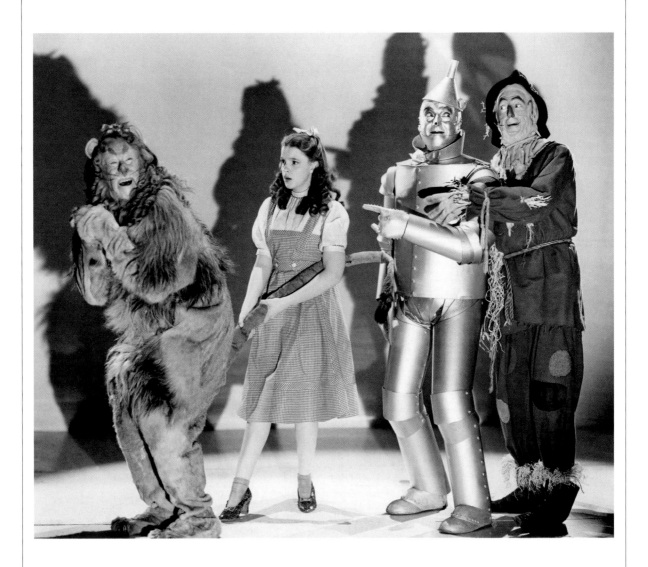

IN ANY FILM production, casting the proper actor in each role is crucial. But as fate would have it, the majority of *The Wizard of Oz* cast was a second or third choice. It is a delicious irony that the actors would become indelibly associated with their screen personas. As is so often true of classic films, the cast and crew of *The Wizard of Oz* were blissfully unaware that they were creating something timeless. This has been echoed over the years in interviews not only with the principals but also with the extras and supporting cast members. While the actors would all find continued professional success outside of their participation in *The Wizard of Oz*, their roles in the film would be their enduring legacy.

THE CAST OF CHARACTERS
(IN ORDER OF APPEARANCE)

JUDY GARLAND
is Dorothy Gale, the young Kansas farm girl
who dreams of a place over the rainbow.

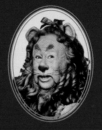

BERT LAHR
is Zeke in Kansas and the Cowardly Lion in
the Land of Oz.

TERRY THE CAIRN TERRIER
is Toto, Dorothy's dog and loyal companion.

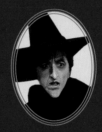

MARGARET HAMILTON
is the villainous Miss Gulch in Kansas, the Wicked
Witch of the East during the cyclone, and the Wicked
Witch of the West in the Land of Oz.

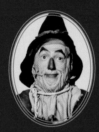

RAY BOLGER
is Hunk Andrews in Kansas and the Scarecrow
in the Land of Oz.

FRANK MORGAN
is Professor Marvel, the Kansas charlatan, as well as
the Emerald City gatekeeper, coachman, and throne
room sentry. He is also the Wizard of Oz.

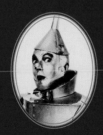

JACK HALEY
is Hickory Twicker in Kansas and the
Tin Man in the Land of Oz.

BILLIE BURKE is Glinda
the Good Witch of the North.

and
THE SINGER MIDGETS
collectively portray the Munchkins, the diminutive inhabitants of Munchkinland.

Dorothy GALE

> "I'VE ALWAYS TAKEN *THE WIZARD OF OZ* VERY SERIOUSLY,
> YOU KNOW. I BELIEVE IN THE IDEA OF THE RAINBOW.
> AND I'VE SPENT MY ENTIRE LIFE TRYING TO GET OVER IT."
> — JUDY GARLAND

MERVYN LeROY CONTENDED that Judy Garland was always his first choice for Dorothy, but Nicholas Schenck, president of M-G-M's parent company, Loew's Incorporated, pressed for Shirley Temple, who was the nation's number-one film favorite in 1938. Schenck wanted a "star" name to fill theatre seats and help recoup his company's substantial investment. In fact, Temple had been suggested for the role several years prior (in November 1935 it had been announced that she would star in a series of *Wizard of Oz* movies). But Temple was under contract to Twentieth Century–Fox; appearing in M-G-M's production could only occur through an arranged loan.

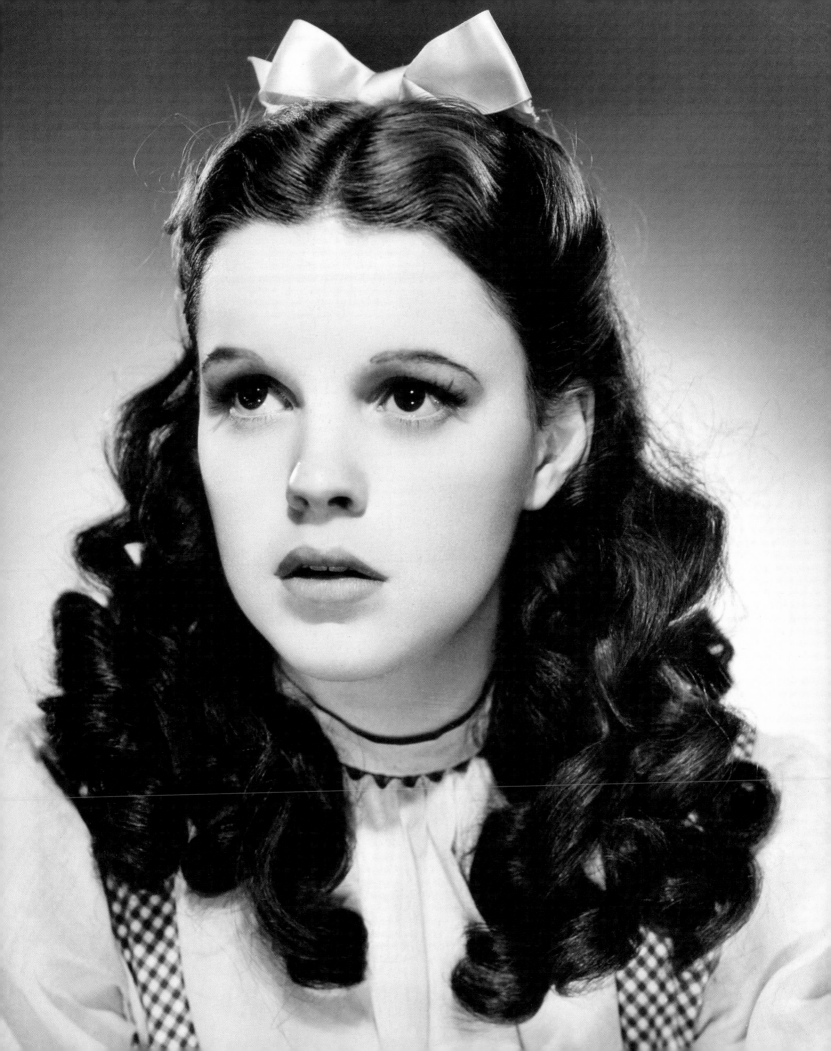

N THE END, the scenario of Fox lending its most valuable player to Metro was not a consideration. Deanna Durbin had also been rumored for the role, but Universal had other plans for the teenage singing sensation; she was to be cast in a Technicolor version of *Cinderella* that was never realized.

Concerned that any deviation from L. Frank Baum's book would signal disaster, young fans were quick to point out that Judy Garland had dark hair and Dorothy had light-colored hair. "They do take *[The Wizard of] Oz* so seriously, bless their hearts," commented author Ruth Plumly Thompson, L. Frank Baum's successor in writing the series. However, M-G-M didn't need to institute a nationwide search for a girl resembling the drawings in the Baum book. Instead, reported the *Montreal Gazette*, "They picked a little girl right from their home lot. Judy Garland . . . needs only years and poundage to become a successor to Sophie Tucker." Though LeRoy was confident in Garland, the press expressed their concern, wondering if she would be accepted in the role.

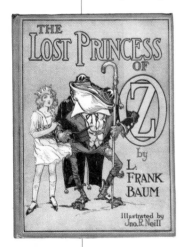

Columnist Paul Harrison wrote, "[Judy Garland] recently was announced for the role of Dorothy in . . . *The Wizard of Oz*. The selection drew a good deal of adverse comment, and as much from Judy Garland fans as from anyone else. She herself seems a little uneasy about it. The Dorothy of L. Frank Baum's stories was a much younger, simpler girl. The assumption is that Judy will introduce swing music into the Emerald City, and will teach the Scarecrow and Tin Man how to do the Big Apple [dance]. Maybe they'll change the title to *The Wizard of Jazz*."

Playing a "much younger, simpler girl" meant that Garland had to forgo the debutante parts she aspired to. Publicly, Garland had expressed her wish to be acknowledged as an ingenue, and privately, she mortified her mother with her desire to emulate the sensual sophistication of

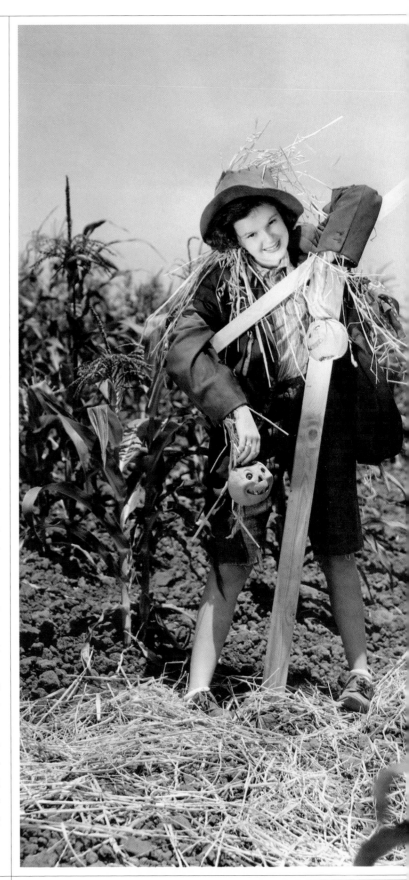

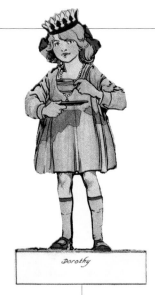

teenage contemporary Lana Turner. Months before *The Wizard of Oz* broke, Garland's romantic crush on bandleader Artie Shaw made news. During filming she was absorbed with writing a screenplay, "Blame My Youth," for herself and her two favorite actors, Robert Donat and Spencer Tracy, in which she plays an aspiring singer who falls for the fiancé of her lady employer (Garland hoped Metro would put it on their 1941 schedule, by which time it had morphed into a radio play, "Love's New Sweet Song"); and she would confide to columnist May Mann, "Now, if I can just grow up faster—so I can get a real big grown-up part!"

But any misgivings Garland may have had about portraying a child were short-lived: she had the lead role in a multimillion-dollar Technicolor film with a cast of seasoned vaudevillians and songs written specially for her. From the outset, it was clear that *The Wizard of Oz* was Garland's vehicle, and its production was carefully crafted to showcase her singing and acting talents as no movie previously had. The gravity of carrying the picture did not escape her, as she reflected in an August 1940 interview with Mann: "When I was first told that I was to play Dorothy in *The Wizard of Oz* with the picture's budget set at three million dollars, I knew that my entire future rested on my ability to play Dorothy convincingly."

In 1939, Garland summarized *The Wizard of Oz* as the most thrilling production of her career, saying, "Firstly,

because I am more or less on my own mettle for the first time, and secondly because the setting is so grotesque that I have to pinch myself to make sure I'm not dreaming." Garland also compared her advancing adolescence with her new role: "It's a lot like in *The Wizard of Oz* . . . The cabin I live in is just plain and drab, y'know, it's all in black and white. Then one day it's blown to the Land of Oz and when I open the door the lovely color of everything is like fairyland. You can't imagine what a contrast it is. That's about the way it feels to me now that I'm sixteen." (Garland's age was shaved by a year in all outgoing publicity to make her considerable talents appear even more prodigious.)

In L. Frank Baum's 1907 book *Ozma of Oz* (second of *The Wizard of Oz* sequels and Dorothy's first return to the Land of Oz), Dorothy is made an honorary princess. In an attempt to stay true to this princess prototype, M-G-M's initial conception of Dorothy's on-screen

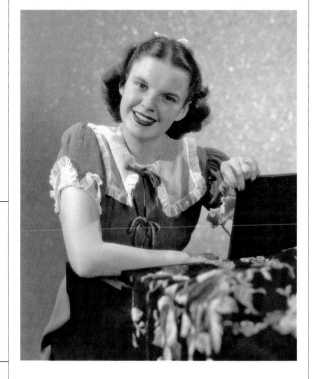

LEFT: Before she was Dorothy, fifteen-year-old Judy Garland portrayed a scarecrow for Halloween 1937. By early 1938, Garland was a viable presence in M-G-M films, known for her sparkling personality, comedic timing, and ability to put over a song with whatever emotional impact was required, though jazzy "swing" was her preference. *The Wizard of Oz* was an important advancement in her career, and she busied herself researching the part. · OPPOSITE AND ABOVE: Illustrator John R. Neill's blond Dorothy appears as an honorary princess on the cover of *The Lost Princess of Oz* (1917) and as a paper cutout (1915).

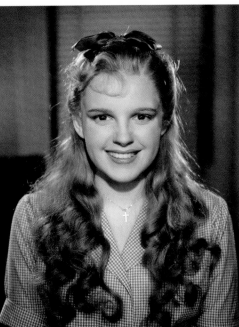

After Judy Garland was cast as Dorothy in February 1938, Max Factor's blond wig was ready for her initial hair-and-makeup test for *The Wizard of Oz* on April 29, 1938. Of her newfound golden tresses, Judy was quoted in October 1938: "I begged Mr. Dawn, head of the makeup department, to let me wear my blond hair to school, but he thought it would be better to wait and spring it as a surprise when the picture starts. I suppose he's right."

character was blond, rouged, and much too precious. From the start of the film's production, it had been LeRoy's intention that life should imitate art, reportedly saying, "If Disney can reproduce humans with cartoons, we can reproduce cartoons with humans." Judy Garland's appearance was to suggest an animation come to life, in keeping with the original thought that everything—from the scenic backdrops to the Munchkins' makeup—should be stylized. Even the famous Yellow Brick Road got the cartoon treatment in its earliest rendition: oval cobblestones painted directly on the M-G-M soundstage floor. (The Yellow Brick Road would later be redesigned to appear as if composed of actual bricks, not cobblestones, and was made of Masonite tiles.)

Garland's transformation as Dorothy, with cascading blond tresses and lacquered cosmetics, was in startling contrast to her prior screen appearances. But several accounts quote her as being tickled with the glamorous look. On May 18, 1938, an M-G-M secretary for Judy Garland sent a prepared letter to newspaper editor Disa Chandler, slated for Chandler's children's-interests page. "Judy" opens the message by writing of her exciting new appearance for *The Wizard of Oz*: "I'll bet when you were a girl, especially if you were brunette, you'd stand in front of a mirror . . . wishing so hard for long blond curls. . . . This morning they took a test of me all dressed up for my role as Dorothy in *The Wizard of Oz*. That was the only time in my whole life I ever looked the way I wanted to look." In an interview with May Mann, Garland said, "[*The Wizard of Oz*] was always my favorite story, only I never dared even dream that someday I'd be playing Princess Dorothy on the screen. And to make things even better, I'm going to be a blond . . . Well, I've tried [the wig] on, and I can't even recognize myself in the mirror."

In the 1960s, however, Garland revealed a different perspective. "They wanted Shirley Temple for the role," she explained to United Press International correspondent Vernon Scott. "But they had to settle for me and tried to make me look as much like Shirley as possible. I was fat, had crooked teeth, straight and black hair, and the wrong kind of nose. So they made me wear a corset and a wig, capped my teeth, and put horrible things in my nose to turn it up like Shirley's. Making that picture was almost the end of me."

In a 1962 TV interview with Jack Paar, Garland recalled—with wry wit—this awkward phase of her adolescence, surmising that M-G-M "didn't know, actually, what to do with [me] . . . you either had to be a Munchkin

Publicity shots such as this gave some Hollywood journalists the impression that Mickey Rooney was a *The Wizard of Oz* cast member. Here, Rooney visits the set during Richard Thorpe's time as director. By one account, Mickey infiltrated a recording session, putting his own energetic spin on the movie tunes in a close-harmony duet with Judy Garland. *The Wizard of Oz* was still within Rooney's consciousness during the making of *Andy Hardy's Private Secretary* (1941), when, for a high school play sequence, he was made up as Apollo in a Greek tunic and skirt with a blond wig and beard. Quoted columnist Harrison Carroll, "Mickey himself thinks he looks like the head Munchkin in *The Wizard of Oz*."

or you had to be *eighteen*." It was reported in September 1938 that to prepare for the role, Garland was "reading every [*Wizard of*] *Oz* book she can get her hands on since

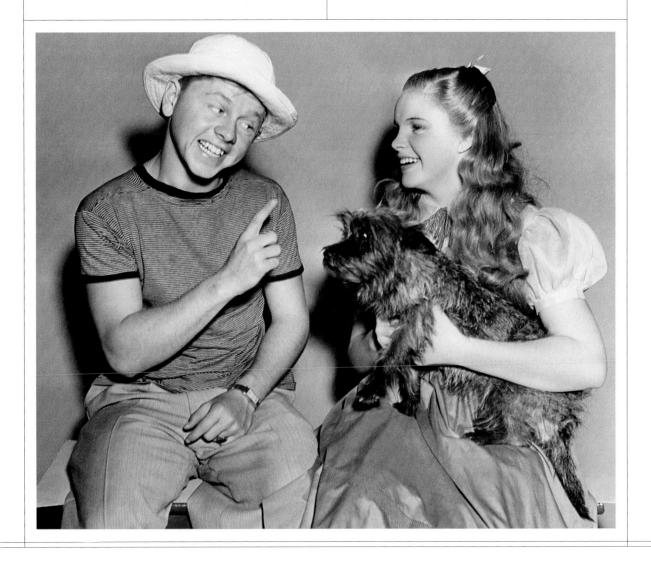

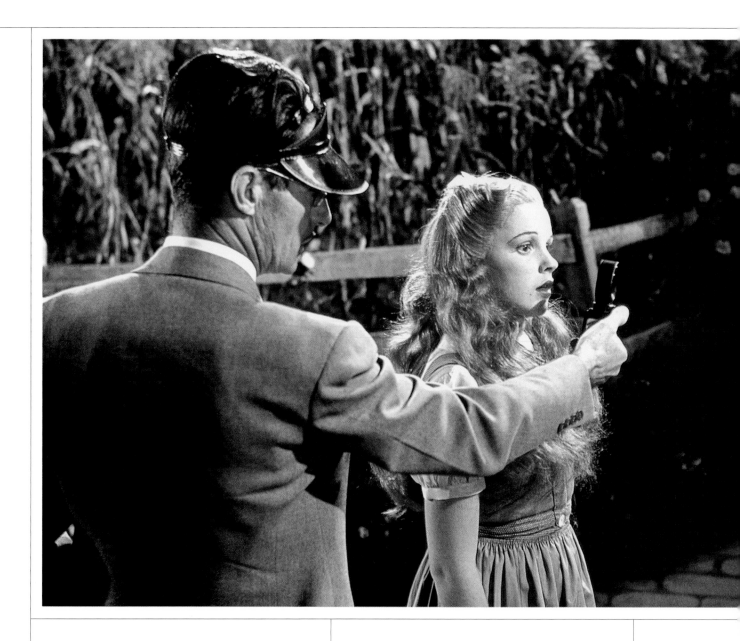

"Princess Dorothy." On the first day of filming, Judy Garland, in her blond wig and lacquered cosmetics, holds her mark as Technicolor cameraman Allen Davey takes a light meter reading just prior to shooting close-ups for the scene when Dorothy first encounters the Scarecrow. This is the only color photograph known to have survived from Richard Thorpe's tenure as director.

she was cast as Dorothy." In order to portray the beloved heroine in the way the public remembered her, Garland aspired to look just as John R. Neill had illustrated Dorothy.

By her own accounting, Garland would drop twelve pounds while making *The Wizard of Oz*, though—in the same breath—she maintained that its production was "the most pleasant time I've ever spent."

A vigorous exercise regime of swimming, tennis, hiking, and badminton was imposed upon Garland by her studio-appointed "athletic conditioner," or personal trainer, Barbara "Bobbie" Koshay. Koshay was on the 1928 Olympic swim team, but she also served as Garland's camera double on *The Wizard of Oz* and, later,

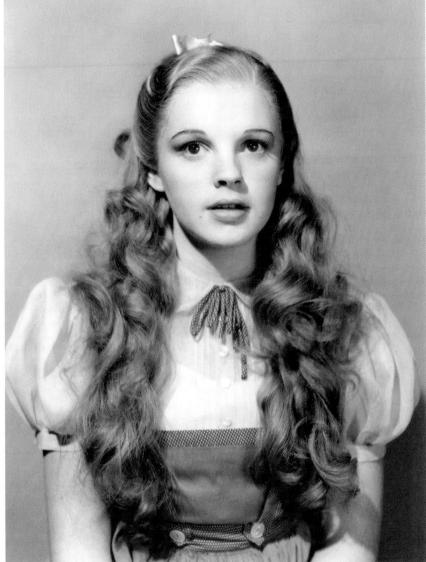

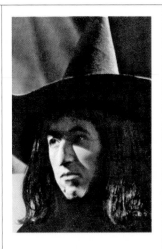

A 1938 advertisement for forthcoming Technicolor productions included *The Wizard of Oz*, accompanied by an illustration of Judy Garland's and Margaret Hamilton's characters as they appeared during tests and preliminary filming that October.

Shooting: "The Wizard of Oz," favorite fantasy of young and old, produced in Technicolor by Mervyn LeRoy. Judy Garland, Ray Bolger, Bert Lahr and Jack Haley head the cast.

Babes in Arms. (Caren Marsh was Garland's stand-in for blocking scenes and lighting tests.) Koshay's qualifications were unique but not coincidental: she was in close proximity to Judy by day and monitored her after hours. Via workouts, boating and diving on Balboa Bay, couture shopping at Bernie Newman's, or taking in the amusement concessions at Ocean Park, Koshay kept Garland under careful watch. (These were not typical "girlfriend" activities; at nearly twice Garland's age, Koshay was not a peer.) Once Garland's ideal weight was achieved—and

Koshay's work on *Babes in Arms* completed in July 1939—Koshay's "duties" were retired and she was said to be opening a Hollywood swim school. The job of keeping tabs on Garland's extracurricular activities then fell to M-G-M publicist Betty Asher, who was just five years Garland's senior.

Thankfully, Garland's unnatural princess look was restored to a more realistic style. In November 1939, *American Girl* magazine reported: "Before the picture started, Judy was thrilled because she was going to be very

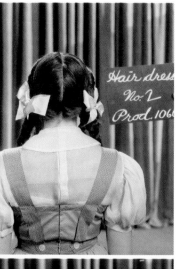

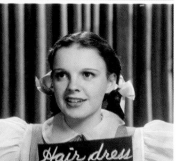

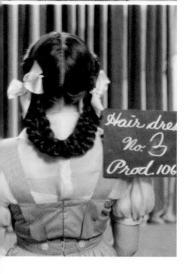

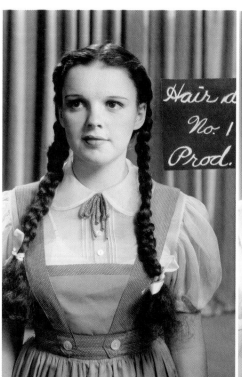

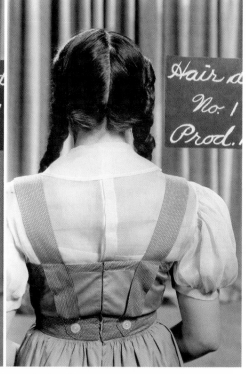

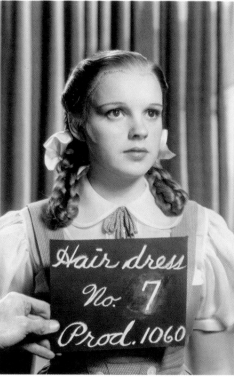

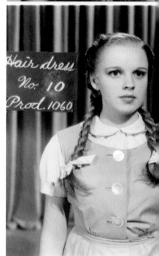

beautiful in a wig of long, golden curls. The wig was made, and the first scenes of *The Wizard of Oz* were shot with Judy proudly wearing it; but after a look at the first preview shots in the projection room, it was decided to scrap all of Judy's scenes and have her do them over again—minus the wig. It made her look beautiful enough, yes—but she didn't look at all like Judy." Nor did she look like Dorothy, who was, as interim director George Cukor said, "just a little girl from Kansas."

Once the blond curls were discarded, Garland was able to abandon the pretentious airs that had affected her performance as Dorothy. As mentored by Cukor, her delivery—like her appearance itself—became more authentic, and members of the *The Wizard of Oz* crew, observing every take from behind the camera, were impressed. Electrician Raymond Griffith recalled Garland's tear-jerking performance, saying, "I remember her . . . locked up in the castle by the old witch, singing 'Over the Rainbow' [in reprise]. Boy, it really got you." Web Overlander, Garland's makeup artist, inscribed Garland's own copy of *The Wizard of Oz* with a drawing of a miniature

Oscar® engraved "Judy Garland," accompanied with the notation, "1939 for you, I hope." Garland would, in fact, win a juvenile Academy Award®.

Even before *The Wizard of Oz* was released, buzz about Garland's performance motivated M-G-M to proclaim in its campaign literature, "Judy Garland gives one of the screen's greatest child performances of all time

as Dorothy." Such plaudits were a mixed blessing for the child star, who desired the acting caliber of Bette Davis. Though she played the role of a simple country girl, her performance forecast adult-sized talent. Reporter Paul Harrison wrote, "Metro kept her in pigtails and short skirts as long as possible, but the cleverest movie magicians on *The Wizard of Oz* couldn't make her look little-girlish in the role of Dorothy. She'll have only ingenue parts from now on." Journalist Lucie Neville reported, "There'll be no more pigtailed little girl parts such as Dorothy in *The Wizard of Oz*—just starring roles as near her own age and type as Metro can find." And indeed, with the exception of portraying *Meet Me in St. Louis*'s teenage Esther Smith (who at least had a love interest), Garland would never again be expected to act a part considerably younger than her own age.

It is inconceivable today to imagine anyone other than Judy Garland as Dorothy. Her performance has endeared her to millions worldwide; children seem to love her most of all, both then and now. (In December 1939, actor Spencer Tracy's six-year-old daughter, Susie, had seen *The Wizard of Oz* three times. When Tracy asked, "Won't you see my picture three times?" Susie replied, "I will if you'll make one with Judy Garland.") As Garland herself noted, "[*The Wizard of Oz*] covers all ages—little children, people my own age, and older people. It pleases them. I think Dorothy is a darling character. Just darling."

OPPOSITE: At interim director George Cukor's advisement, Garland's appearance was simplified, though her hair, makeup, and wardrobe as Dorothy still seem the subject of indecision in no less than ten trials on October 26, 1938. Cukor also coached Garland into simplifying her delivery by reminding her to play it straight; she was to be awed by the Ozites—not be akin to them—as though she was truly an average Midwestern juvenile displaced into the Land of Oz.

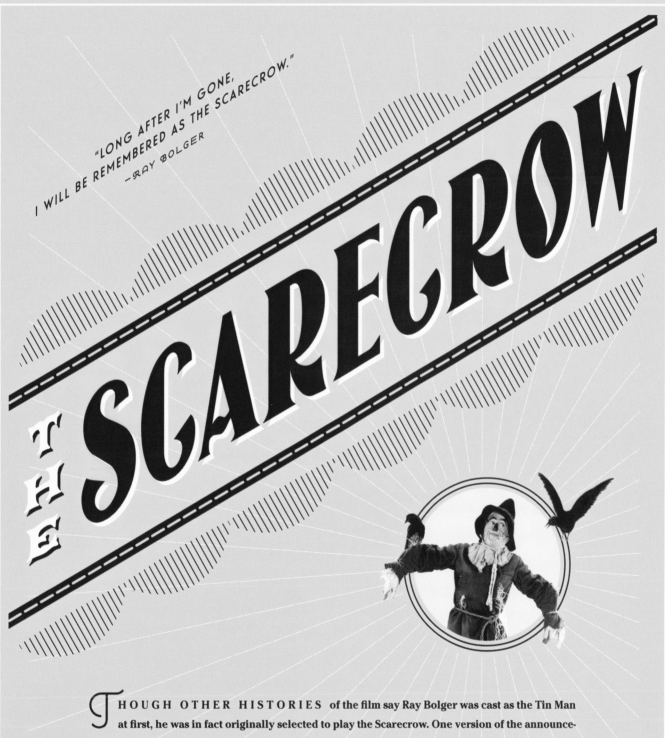

"LONG AFTER I'M GONE, I WILL BE REMEMBERED AS THE SCARECROW."
—RAY BOLGER

THE SCARECROW

Though other histories of the film say Ray Bolger was cast as the Tin Man at first, he was in fact originally selected to play the Scarecrow. One version of the announcement was headlined in Edwin Schallert's March 7, 1938, column, "Bolger Scarecrow in *The Wizard of Oz*"—published long before the Tin Man role was formally filled. (In fact, the only two actors Schallert cites as officially set for *The Wizard of Oz* are Garland and Bolger.) But at some undetermined point, Bolger was recast as the Tin Man.

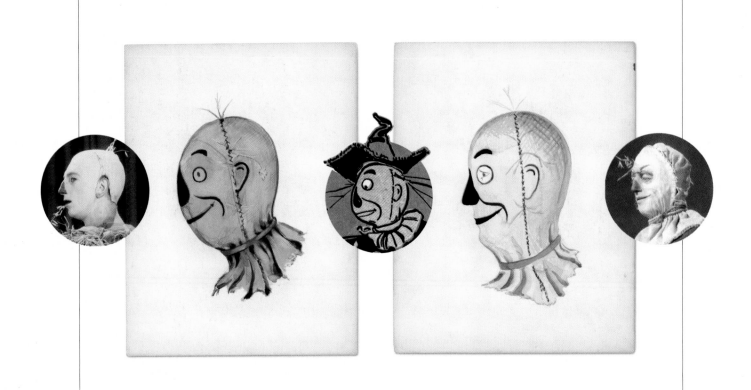

The Wizard of Oz presented M-G-M's makeup chieftain Jack Dawn with his greatest challenge: how to transform actors into fictional creatures without masks or head coverings that would conceal their identities and facial expressions. Light makeup was first considered for the Scarecrow, in keeping with the concept that the character was just a human dullard capable only of monitoring cornfields. Once this idea was abolished, Dawn next determined how Ray Bolger could inhabit a burlap sack but still resemble Ray Bolger. His watercolors, inspired by W. W. Denslow's illustrations, provide a rare glimpse of the artist's creative evolution from drawing board to reality. Pages 49–50 show additional early makeup and wardrobe tests for the Scarecrow.

Buddy Ebsen was then slated to play the role of the straw-stuffed Scarecrow before he swapped parts one last time with Ray Bolger. One 1938 account describes an early Ebsen/Scarecrow test: "They gave [Buddy] some raggedy clothes and had tufts of straw sticking out here and there. He said he felt like he was going to a party. The suit has been remade, of quilting, and the straw seems to be falling out of it. Shaggy-haired Ebsen actually looks like a scarecrow (although an awfully well-fed one) now."

Once he was permanently assigned to the Scarecrow role, Bolger began

RAY BOLGER

wardrobe tests wearing the heavily padded outfit Buddy Ebsen had also test-worn for the same part. But Bolger was known for his limber "rubber legs," and the quilted costume was not conducive to his style of dancing. Less restricting jackets and trousers were designed to accommodate Bolger's eccentric movements. The dancer reportedly lost nine pounds during the course of filming—those loose-limbed movements required much exertion. "The looseness of the costume helped give the jointless effect which is further carried out by tricks in posture," Bolger

The TIN MAN

"IT IS ALWAYS A GREAT PLEASURE TO KNOW THAT MY WORK
HAS BROUGHT PLEASURE AND SATISFACTION TO PEOPLE.
THE PART OF THE TIN WOODMAN WAS ONE THAT I ENJOYED
AND FELT A SYMPATHY FOR, AND IF THIS FEELING WAS
CONVEYED TO MY FANS, I AM MORE THAN GRATEFUL."

—JACK HALEY

AS WAS TRUE for the wardrobe and makeup of each of the outlandish characters, Buddy Ebsen's Tin Man costume underwent extensive experimentation. Journalist Paul Harrison wrote, "Would it be better to have the Tin Man a completely impersonal robot billed as an unseen Buddy Ebsen, or would it be better to have the face of Ebsen, proving the existence of a dancing star inside the shell of L. Frank Baum's woodchopper?" Meanwhile, Ebsen made the best of his assignment. Assuming that he was made of tin and put together by a plumber, he worked out a step in imitation of the movements of a plumber's pipe wrench in action.

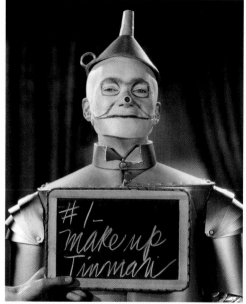

As seen in Jack Dawn's concept painting (above, right) and a test still of Buddy Ebsen (above, left), the Tin Man's initial makeup reflected a simplistic approach that emulated W. W. Denslow's original ink sketches (right).

"I called in the studio plumber as technical adviser, and he okayed it as authentic," added Ebsen. After the notions of a mask and a suit made of aluminum were rejected—the suit was too noisy—Ebsen's face was augmented with foam-rubber appliances and silvered with a healthy dose of aluminum powder. The powder, however, was anything but healthy, and Ebsen's near-fatal poisoning in reaction to inhaling it caused him to forfeit the role.

When it was reported that Ebsen was felled by "pneumonia" and forced to relinquish the Tin Man role, Metro hastily contracted Jack Haley, who had comparable song-and-dance talents.

His son Jack Haley, Jr., a sometime visitor to *The Wizard of Oz* movie set, told *Lefthander* magazine in 1989, "My father . . . said it was the toughest job he ever did in his life." Oblivious to his father's angst at the time, Haley, Jr., was five years old when he saw his father attired in full Tin Man regalia for the first time. He recalled, "When I first saw my father dressed in the Tin Man outfit, he had his [tin] pants off. I remember it so vividly . . . When they were shooting close-ups of him, they didn't have to put the whole bottom on. He couldn't sit down in that costume."

In addition to the uncomfortable suit, Haley endured taxing makeup and elaborate head appliances: a bald cap formed the top of his head and went down his neck; Haley's nose was extended to a funnel shape; and his jaw was outfitted with a hinge-like piece of "tin." Upon reviewing Technicolor takes, the makeup department realized Haley's Tin Man looked polished, not rusted. Further makeup was added to effect "rust accents," in addition to eye shadow and dark lipstick. A series of rubber rivets adhered around his ears and down the back of his head completed the look.

JACK HALEY

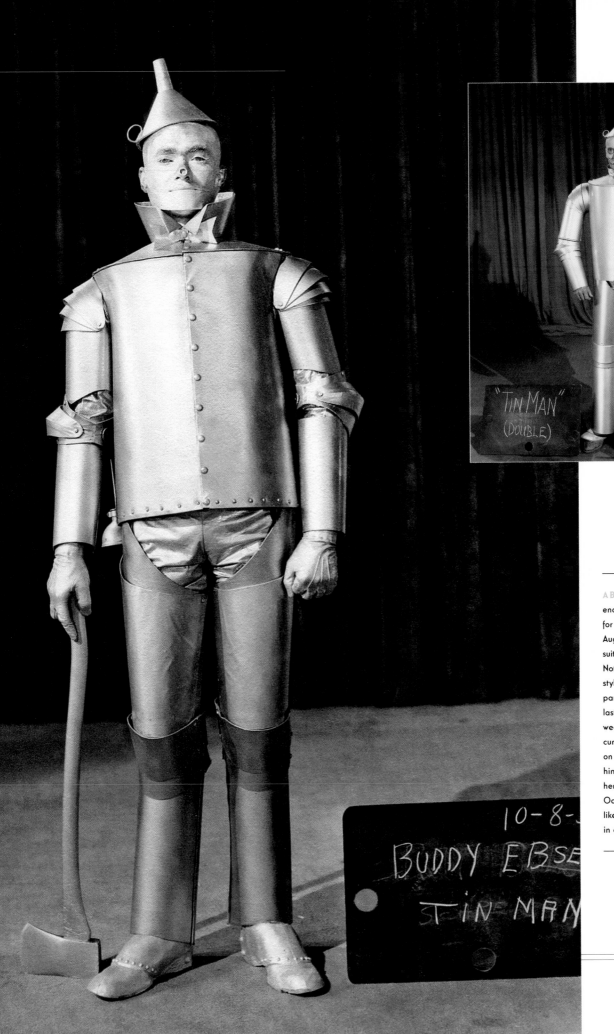

"TIN MAN"
(DOUBLE)

10-8-3

BUDDY EBSE

TIN MAN

ABOVE: Buddy Ebsen's double endured uncomfortable wardrobe tests for prototypes of the Tin Man's armor, August 27, 1938. This version of the tin suit appears robotic as well as confining. Note the rudimentary "line-drawing"–style makeup. • LEFT: Buddy Ebsen's participation in *The Wizard of Oz* lasted only through rehearsals and two weeks of filming, after which he succumbed to an allergic reaction brought on by the silver makeup, which caused him to bow out altogether. Ebsen is here shown in his near-final wardrobe, October 8, 1938. (Note the oilcan, hung like a flask, at his right hip, as indicated in a version of the script.)

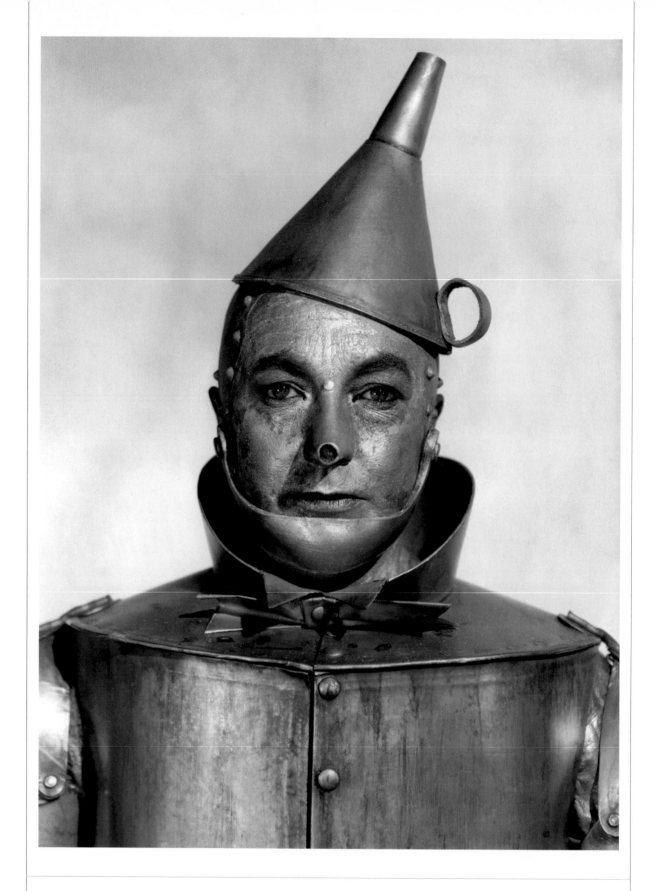

Two views of Jack Haley's Tin Man makeup and costume, revised to appear rusty, mid-November 1938. Because the aluminum used to tint Haley's makeup was potentially toxic, makeup men were assigned to shadow the actor and daub away with cotton any sign of perspiration to prevent the aluminum from running into his eyes.

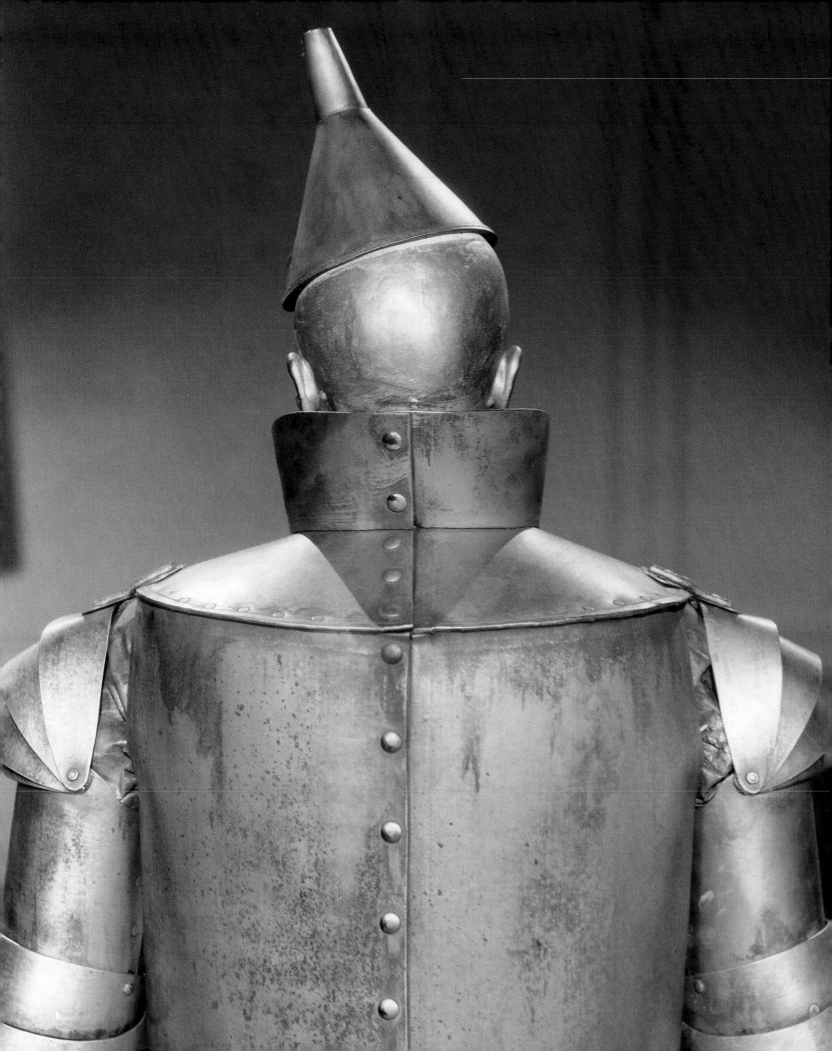

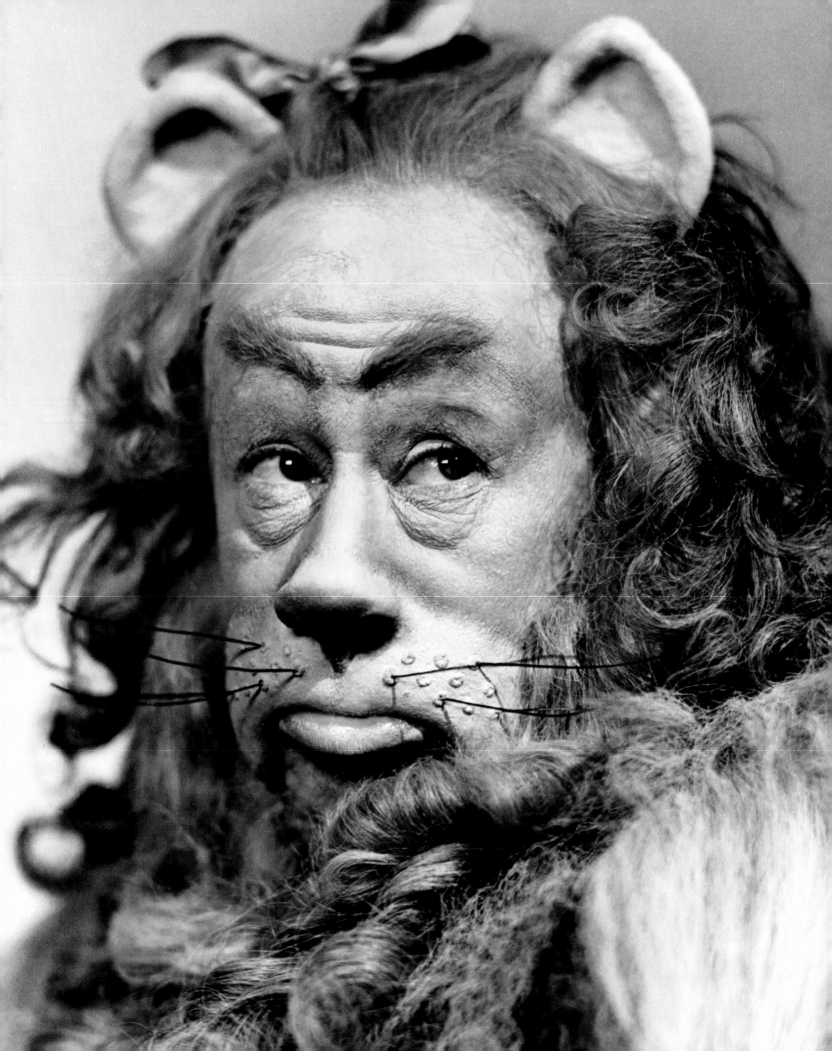

The Cowardly Lion

"**I**T IS BERT Lahr's picture," declared critic Wood Soanes of the actor's performance as that most timid king of beasts, the Cowardly Lion. That Lahr's role was singled out is significant in that the Cowardly Lion was absent, minor, or secondary to the Scarecrow and Tin Man in previous productions of *The Wizard of Oz*. Though more than one critic thought Lahr deserved the lion's share of all the plaudits, Lahr himself was preoccupied with his fur getup: "I felt just like a stevedore [dock laborer] carrying the boat on my back." Lahr further lamented the part's challenges to journalist Duncan Underhill:

Adhering to W. W. Denslow's pictures of the Cowardly Lion (below), Jack Dawn drafted a watercolor of his version (top) before translating his literal interpretation of pen-and-ink strokes directly to Bert Lahr's face (right).

"A line in the script will give you a rough idea of what a cinch I had. '*The Cowardly Lion*,' he quoted, '*seems to walk on all fours standing up*.' Trim that. Also, I have to register a silly expression through a makeup that would make Leo the Lion tear up his union card. When a little girl slaps my face I have to shriek and shudder and cry hysterically. After a couple weeks of that I'm qualified to do a sister act with Ferdinand the Bull."

Lahr's ongoing grousing drew the sympathy of assistant dance director Dona Massin, who reported, "I can remember one thing—Bert Lahr . . . The only one I really had to work with was Bert—he

wasn't a dancer. Even in rehearsing he had two left feet! He'd go to practice his song . . . and he'd ask if it was all right. When I'd tell him it was, he'd ask, 'Really?'" Despite his anxieties, the role's comedic factor—as Lahr put it— was ready-made. "People know the saying 'brave as a lion' by heart," he said in 1939, "hence, a lion running away from anything at once strikes the risibilities."

Lahr's physical attributes contributed to his humorous delivery as the Cowardly Lion, particularly his facial features, which were singled out by M-G-M as already leonine in appearance before makeup. The resemblance even became the punch line of a barb

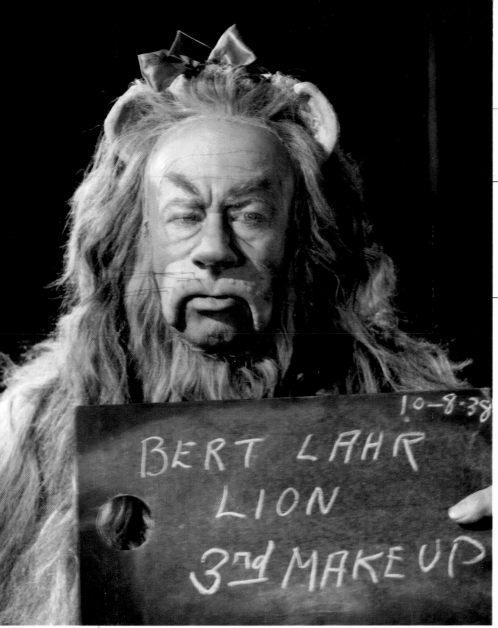

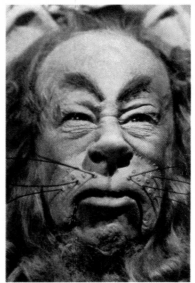

As makeup experimentation continued (left), Lahr's appearance grew closer to the final look (below). Lahr was an imported Broadway comedian who infused his brand of physicality into the role, and walked off with the majority of critics' praise.

when Lahr guested on Fred Allen's radio show in 1939. When fellow comedian Allen commented on Lahr's performance, he said, "You still look like a lion to me," to which Lahr retorted, "That's the trouble. I got too far into character. Why, I was even startin' to molt!"

When principal photography concluded, Jack Haley, who offset his chagrin during the shoot with one-liners about being vacuum-sealed, couldn't shed his Tin Man suit fast enough. Ray Bolger kept a copy of his Scarecrow ensemble as a memento, and made the most of his connection to the film

BERT LAHR

for his musical-variety national tour in 1940; all the ads pictured and mentioned his Scarecrow character. And the long-suffering Lahr may have had a change of heart come July 14, 1939, when *Daily Variety* commented on his "fascination with the lion skin he wore in *The Wizard of Oz* . . . he's trying to buy it from Metro for stuffing purposes." While each actor would move on to other projects and enjoy professional success beyond the film, their roles in *The Wizard of Oz* would cement their places in the canon of cinematic history forever.

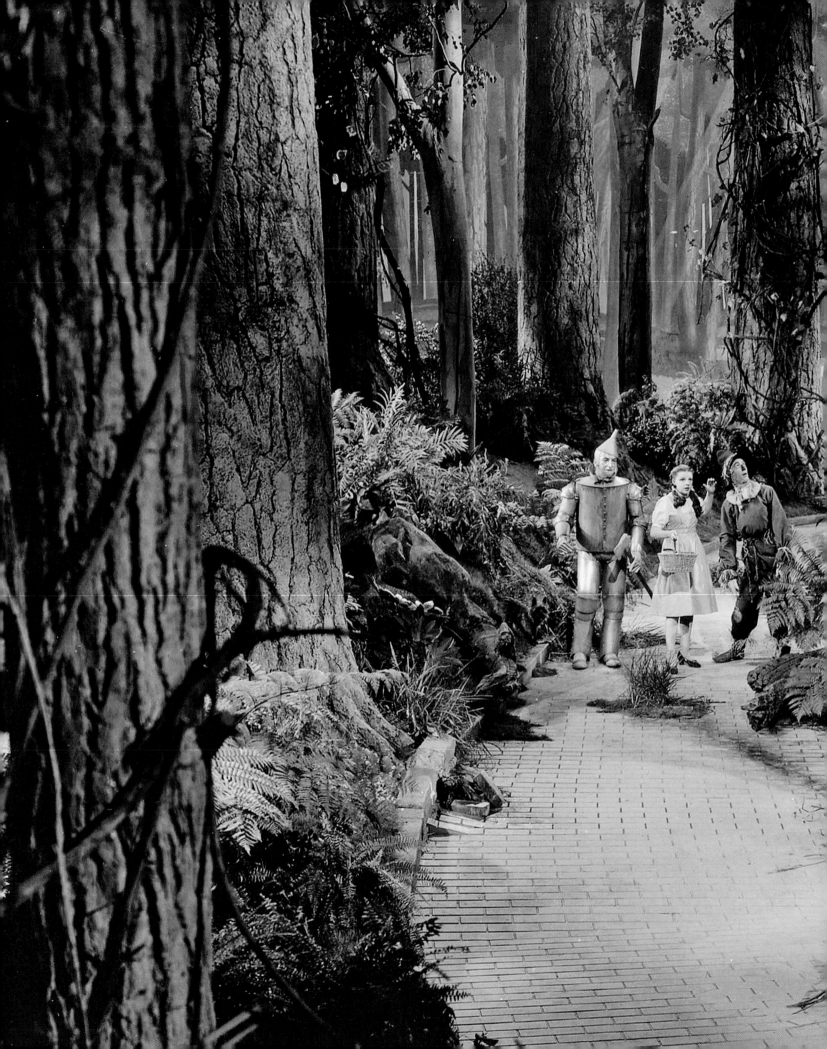

RESPITE

ALONG THE

YELLOW BRICK ROAD

JUDY GARLAND KNEW most of her coworkers prior to *The Wizard of Oz*, so that there was a playful camaraderie among them between scenes. Several contemporary reports from the set of *The Wizard of Oz* make reference to the levity of the cast during the strenuous shooting schedule. For example, when Buddy Ebsen was still among the cast members, he and Judy were practicing an eccentric dance routine that called for an exchange of slaps on the back. When Ebsen, encased in his sweltering Tin Man costume, enviously appraised Judy's thin gingham frock, Judy was quick to retort, "You big softie, you ought to try getting your back slapped—when you've got a sunburn like mine."

During breaks, Lahr, Bolger, and Haley instructed Garland in what they termed "balladry of Broadway," while she in turn gave them pointers on "swing" singing. When she wasn't being tutored, Garland purportedly occupied her time sketching Toto's portrait in pastels, reading the Baum books, knitting (a pink wool sweater for a crew member's newborn), and deciphering the rebus charm bracelet given to her by Artie Shaw, which, when decoded, spelled out, "You are my lucky star."

Bolger "played the ponies," placing racehorse bets with his bookie, and Haley napped whenever possible, since preparations for *The Wonder Show Starring Jack Haley*, his weekly radio series, kept him busy after hours. Haley, Lahr, and Bolger otherwise maintained morale with practical jokes: Haley bribed the hairdresser touching up Lahr's mane to short-circuit the curling iron, giving Lahr a shock. Lahr retaliated when Haley snoozed on a reclining board in his Tin Man suit; Haley awoke to discover his outfit papered with tomato-can labels.

In this previously unpublished scene still, Jack Haley, Judy Garland, Ray Bolger, and Toto (to the left of Haley in the photo) rehearse on the vast Lion Forest set, November 1938. Omission of L. Frank Baum's Kalidahs, menacing half-tiger, half-bear chimeras, was compensated for by the characters' chant, "Lions and tigers and bears, oh my!"

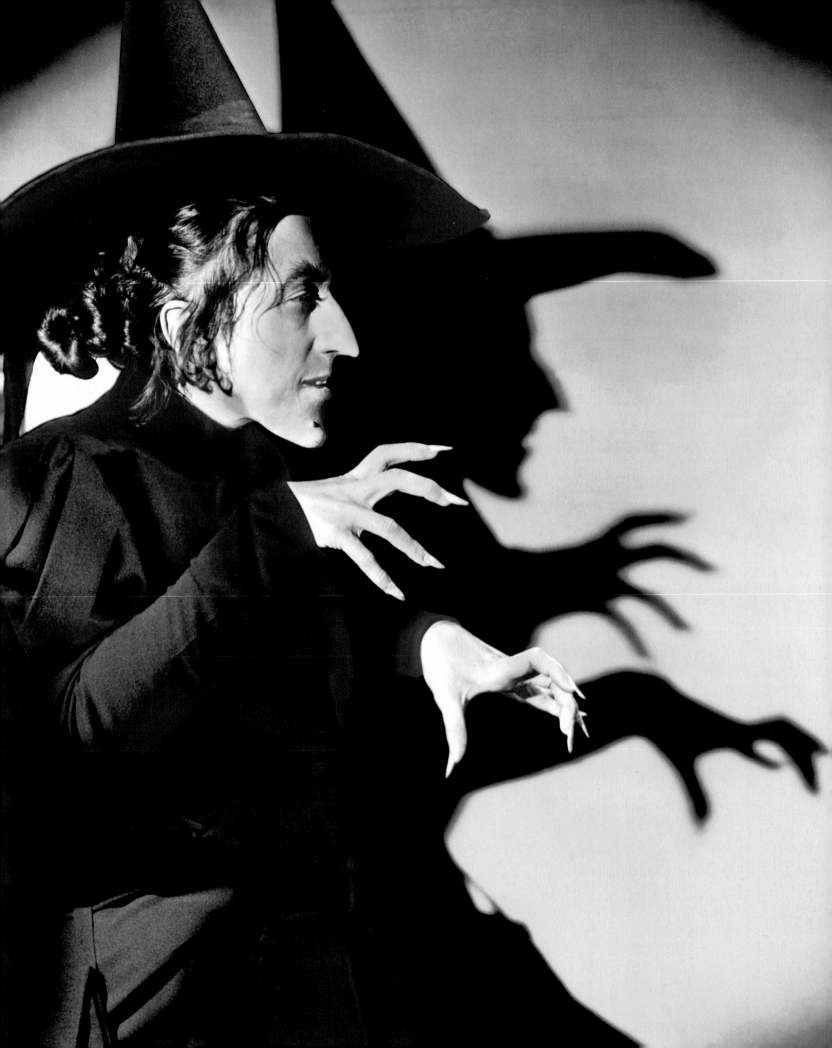

THE WICKED WITCH OF THE WEST

IN L. FRANK Baum's original tale, the Wicked Witch of the West is depicted as a crone, in the fairy-tale sense of the term, but graced with a few eccentricities: she wears a patch over one eye, clutches an umbrella to ward off rain showers, and is afraid of the dark. When sultry actress Gale Sondergaard was cast in the role of the Witch, M-G-M was following a cinematic trend of depicting screen villainesses that were as seductive as they were sinister. (These included the coldly cruel Hash-A-Mo-Tep, Queen of Kor, in *She* (1935), the icy beauty of Gloria Holden as *Dracula's Daughter* (1936), and the Evil Queen in *Snow White*.) Dressed in head-to-toe black sequins, even to her peaked witch's hat, Sondergaard's wardrobe and makeup epitomized a beautiful but malevolent nemesis.

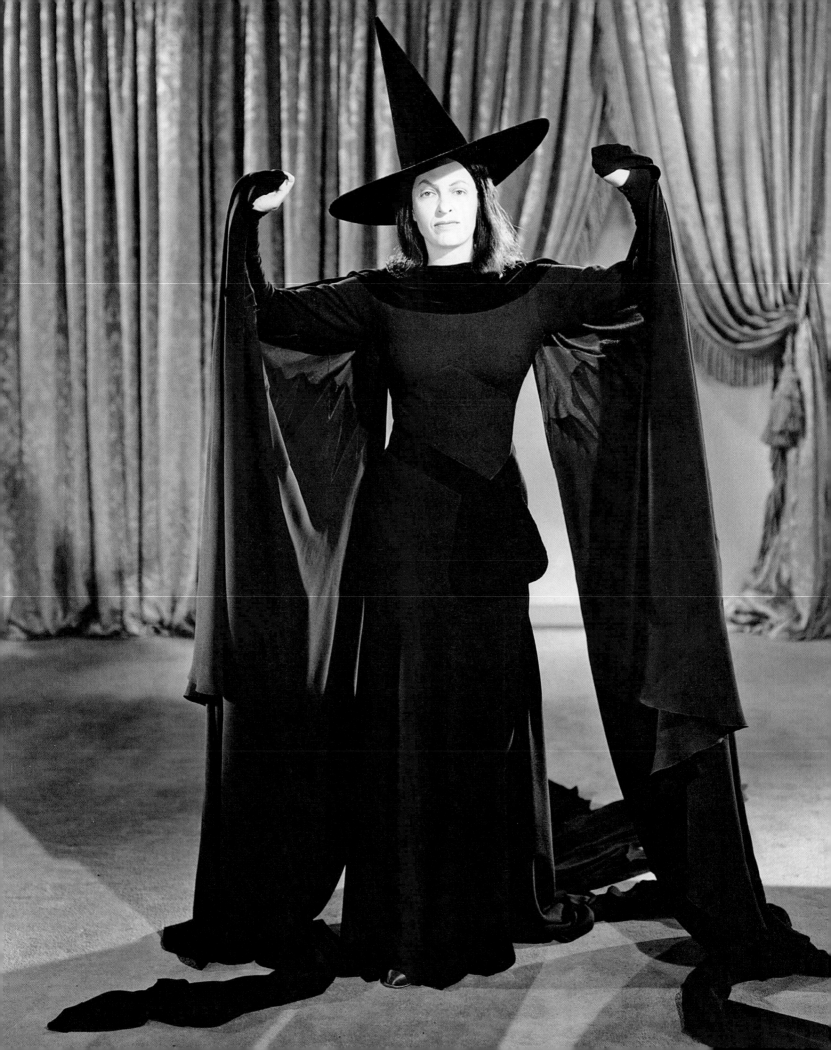

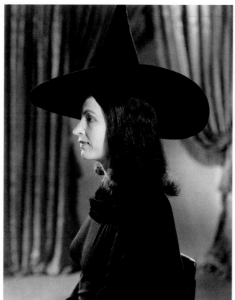 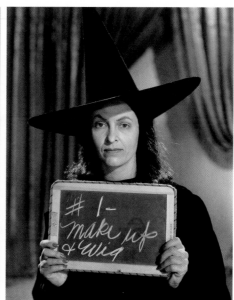

The Wicked Witch of the West was originally conceived as a traditional, but comedic, harridan. But taking a cue from the vain and haughty Evil Queen in *Snow White*, Mervyn LeRoy next requested that the Witch receive the glamour treatment. In the end, it was decided that the Wicked Witch should match the crone of the L. Frank Baum story. Jack Dawn's watercolor sketch of the latter (below) was designed with actress Gale Sondergaard in mind, replete with pointed nose, as seen in makeup and wardrobe tests. (Once Sondergaard abandoned her part, this look was adapted for Margaret Hamilton.) The press noted that Sondergaard, an Academy Award®-winning actress, forfeited the role because she was "too pretty."

But under protest from Baum fans, LeRoy recanted his witch "with class, and maybe sex appeal . . . a 1938 version" for a crone rather than a queen. Sondergaard was next photographed wearing less overt wardrobe—including a form-fitting velvet ensemble—before testing as a storybook hag. However, she and LeRoy agreed that it was not the image she wanted to project on film, so she resigned. In hindsight, one cannot imagine the indignity of Sondergaard's witch liberally doused

with water and vanquished in a slush of sequins.

The role of the Wicked Witch of the West was, of course, recast with character actress Margaret Hamilton, who was selected by LeRoy after he screened scenes of her role as Beulah Flanders in Sam Wood's *Stablemates* (1938). Hamilton's appearance as the hideous witch, coupled with her terrifying performance, scared generations of impressionable young viewers. Hamilton didn't exactly consider the role Shakespeare, saying, "It's not a

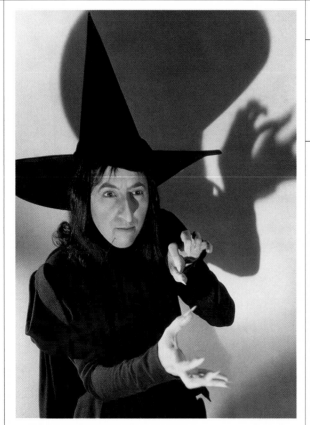

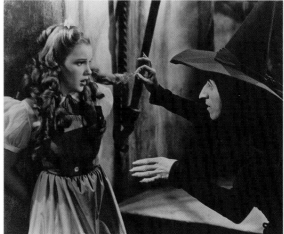

By October 10, 1938, thirty-five-year-old screen comedienne Margaret Hamilton had replaced Gale Sondergaard as the Wicked Witch of the West in *The Wizard of Oz*. As shown in these stills, Hamilton began filming her scenes in a page-boy wig like that previously worn by Sondergaard, but this look was scrapped after two weeks.

particularly difficult role, and there's not much you can do to make it different . . . You just wring your hands and roll your eyes, and rant and rave and shriek a bit." But the actress was far from oblivious to the effect of her shrieking. "I used to recommend that children under five years not be allowed to see [*The Wizard of Oz*]," she told *Photoplay* in 1974. "It gives them nightmares"—an understatement thoroughly comprehended by countless adults who, as youngsters, buried their faces or ran from the room during *The Wizard of Oz* telecasts.

The psychological reverberations from Hamilton's ferocious delivery began almost immediately. Among others, one reviewer expressed concern for the realism of the

MARGARET HAMILTON

Wicked Witch, and compared the character's intensity to the witch from *Snow White* in affecting the psyches of both children and adults: "The usual explanation the wise parent makes to children before pictures containing such witches should be made before *The Wizard of Oz*." Mrs. T. G. Winter, of the Community Service division of the Motion Picture Producers and Distributors of America, summed it up best in her September 1, 1939, review: "Perhaps the Wicked Witch is a bit scary for ultra-nervous children, but she is part of the stock-in-trade of fairyland, and her comeuppance is part of the joy."

Margaret Hamilton accepted her horrific on-screen appearance—replete with

OPPOSITE: Margaret Hamilton's Wicked Witch calculates her next evil scheme. November 9, 1938, was the actress's first day of filming in revised hair and makeup. Her nose and chin were sharpened and her hair was styled in a chignon.

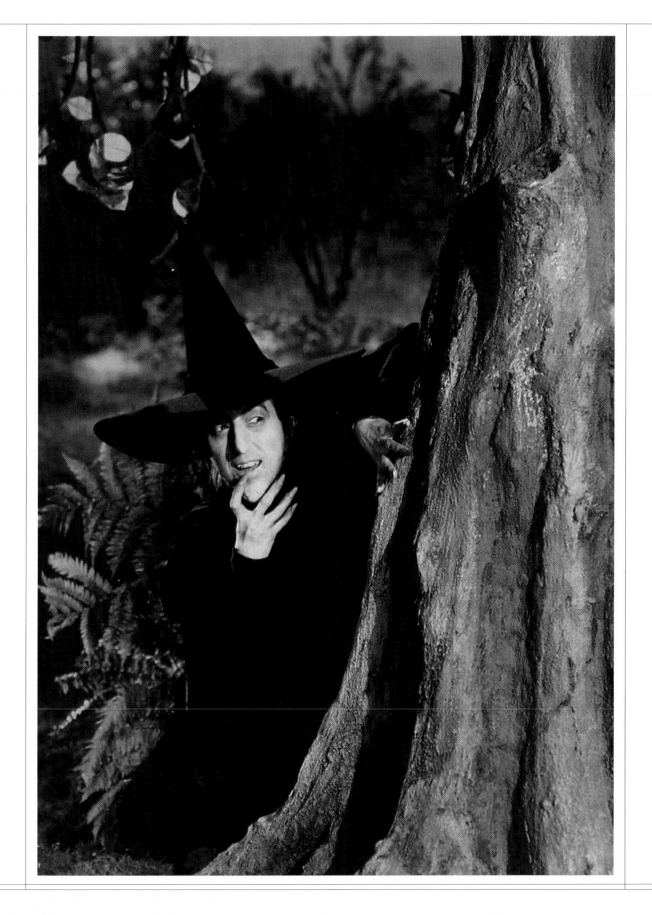

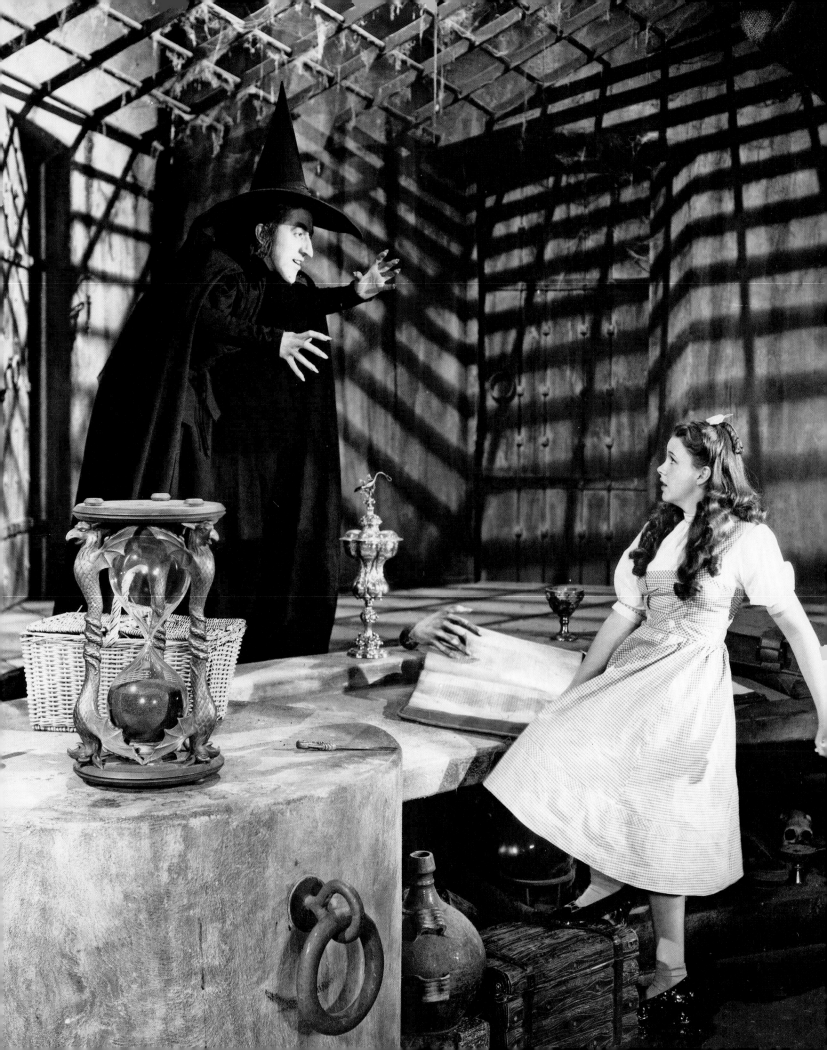

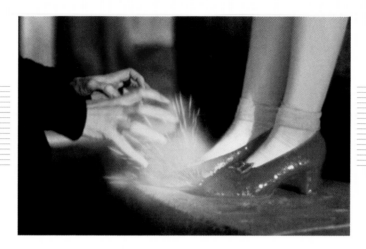

THE PSYCHOLOGICAL REVERBERATIONS FROM HAMILTON'S FEROCIOUS
DELIVERY BEGAN ALMOST IMMEDIATELY.

gangrenous skin, a jutting jaw, and a sharply hooked nose—having long ago made peace with her lack of physical beauty. "I'm glad I'm homely . . . My face has given me lots of work," she confessed twenty-two years after playing the film's heavy. With good humor, Hamilton recalled one instance of on-set ribbing to *Parade*'s Karl Kohrs: "They put a sign on my chair, 'Mag the Hag.' Why, I just loved it. I'm not sensitive about my looks." She had stubbornly defended her appearance from the time she was a little girl. Her father wanted to take her to a plastic surgeon to have her large nose altered, but she refused, saying, "It was mine, and I wanted to keep it."

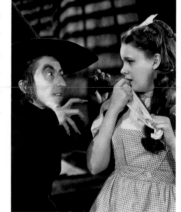

Admirers of Margaret Hamilton's performance will appreciate her role in *Comin' Round the Mountain* (1951), with comic team Bud Abbott and Lou Costello.

She plays backwoods gypsy Aunt Huddy, and her makeup and delivery strongly evoke the Wicked Witch (Costello even test-drives her flying broom). By the time of her appearance as Elaine Zacharides, the intimidating housekeeper in *13 Ghosts* (1960), Hamilton had become familiar to audiences through TV showings of *The Wizard of Oz*.

Elaine is accused of being "a witch" several times throughout the picture, and in the closing scene she picks up a broom, smirks directly at the audience, and walks off camera, leaving viewers to speculate whether the accusations are true. Margaret Hamilton's Wicked Witch of the West remains one of the highlights of *The Wizard of Oz*, and her depiction ranks fourth on the American Film Institute's June 2003 list of the fifty best movie villains of all time.

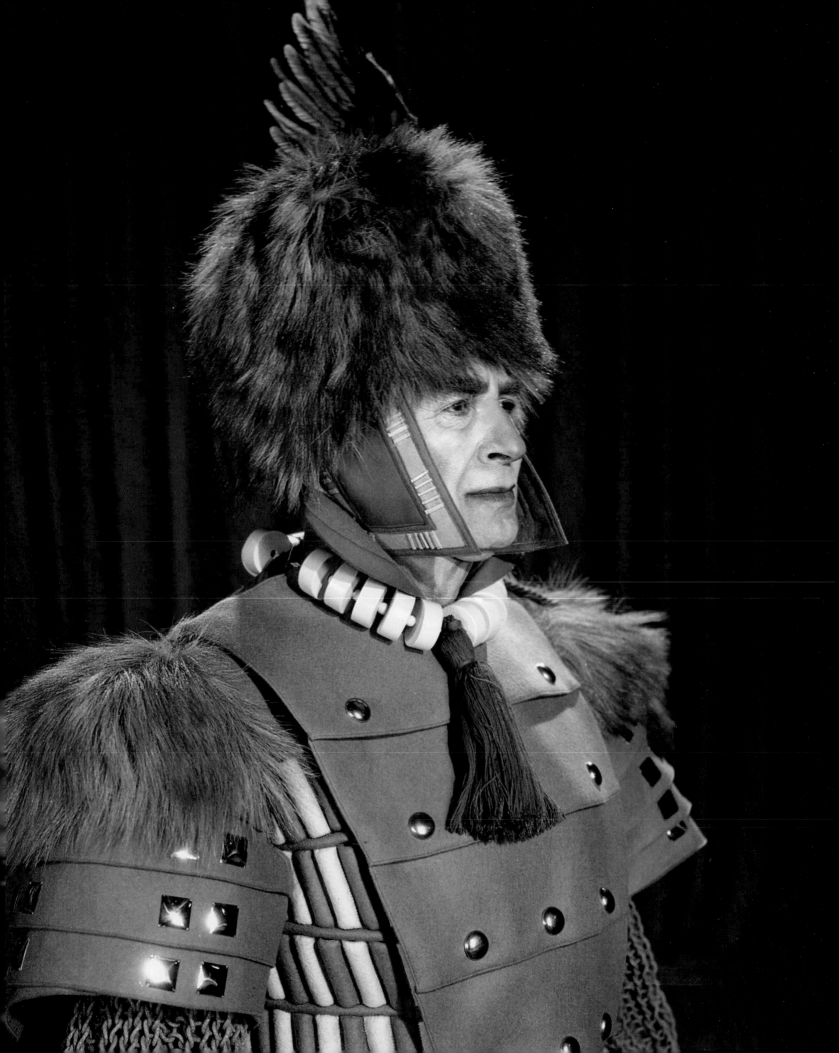

WINKIES & WINGED MONKEYS

"O-Ee-Yah! Eoh-Ah!"

—CHANT OF THE WINKIE GUARDS

IN *THE WONDERFUL* *Wizard of Oz*, the Winkies are the Wicked Witch's slaves. The motion picture's Winkie soldiers, however, are far more menacing than the passive, Munchkin-size natives of Baum's book. In 1938, the picture's Winkies were described as having long noses, green complexions, fur hats, and gigantic gray overcoats with red stripes. Their costumes were made of "the finest grade of heavy felt, buttoned tight from neck to tie, and the Winkies all nearly died from heat prostration" working under the huge arc lights necessary for Technicolor filming. Reportedly, there were twenty-eight Winkies who all looked exactly alike.

OPPOSITE: Character actor Mitchell Lewis poses in his uniform as Captain of the Winkie Guard, August 27, 1938. (The final Winkie makeup would resemble the Wicked Witch's complexion and proboscis once Margaret Hamilton assumed the role.) • ABOVE: Winkie art from a 1940 Portuguese photoplay edition of *The Wizard of Oz* matches the on-screen look of the imposing militia.

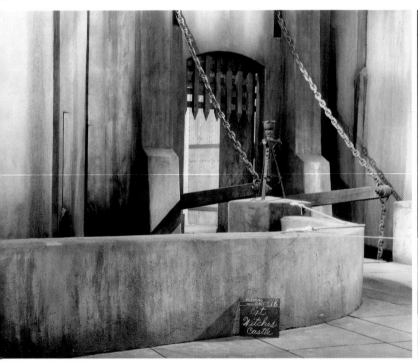

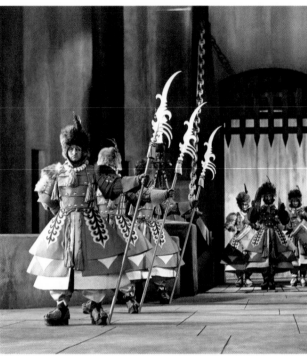

ABOVE: A set still documents the drawbridge entrance to the Wicked Witch's castle, where the Winkies stage their military maneuvers. • BELOW AND OPPOSITE: Generations of movie-watchers will forever shudder at the thought of the grotesque Winged Monkeys who wreak havoc upon Dorothy and her companions in the Haunted Forest. Wardrobe tests for the creatures were the subject of much trial and error in autumn 1938. Pat Walshe expertly pantomimed the part of Nikko, monkey aide to the Wicked Witch.

The Winged Monkeys in *The Wonderful Wizard of Oz* must obey the wearer of the Golden Cap, who commands the three wishes that such ownership imparts. By the time Dorothy encounters her, the Wicked Witch is in possession of the cap and controls the monkeys. The Golden Cap was scripted into the motion picture but reference to it was excised, though it is still seen briefly on screen. Men with slight builds donned hair suits and facial appliances to portray the army of Winged Monkeys; motorized wings completed the effect. In his October 3, 1938, column, Jimmie Fidler put out the call, "If anyone has a pair of condor wings for sale, he should contact M-G-M; they're trying to outfit the Winged Monkeys for *The Wizard of Oz*."

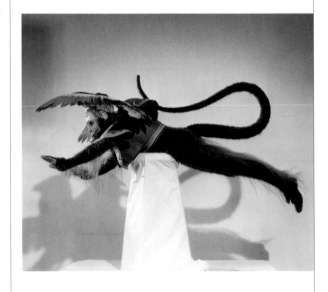

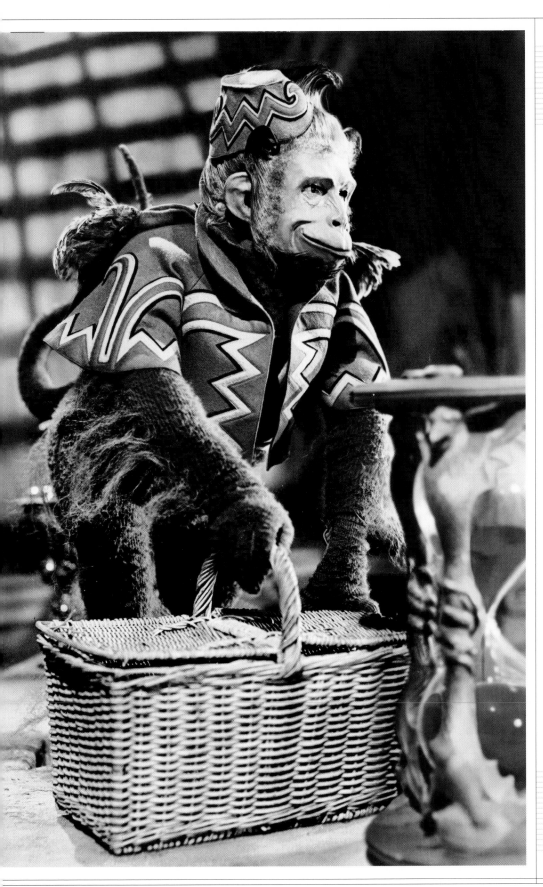

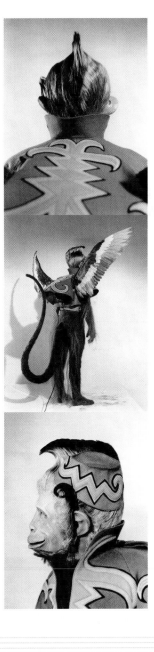

The WIZARD of OZ

"AND REMEMBER, MY SENTIMENTAL FRIEND, THAT A HEART IS NOT JUDGED BY HOW MUCH YOU LOVE, BUT BY HOW MUCH YOU ARE LOVED BY OTHERS."

—FRANK MORGAN AS THE WIZARD OF OZ, 1939

CHARACTER ACTOR W. C. Fields was favored for the part of the Wizard of Oz by both Arthur Freed, the film's uncredited associate producer, and lyricist E. Y. Harburg. (Harburg had even contributed dialogue of the Wizard of Oz bestowing gifts to Dorothy's friends with Fields in mind.) Despite LeRoy's wanting fussbudget comedian Ed Wynn for the Wizard of Oz, Fields could easily have answered LeRoy's call. "I'm looking for a little shrimp," said the producer in August 1938, "but just any kind of little shrimp won't do; he's got to have ability and personal magnetism." After a scheduling or salary conflict precluded Fields from taking the role, Frank Morgan was cast.

 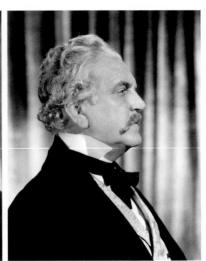

Frank Morgan models one look for the Emerald City Gatekeeper on November 6, 1938 (above, left). By January 7, 1939, the final choice for the character was decided (opposite). Morgan also portrayed Kansan Professor Marvel (above, center and right). *Movie Mirror* magazine reported, "Frank Morgan is in a pretty pother . . . it's his moustache. In *The Wizard of Oz* he wears a dandy moustache, but in *Broadway Serenade*, which he is making at the same time, he wears none. It means he must pop in and out of moustaches until he is dizzy."

A veteran of vaudeville and debonair leading man of the New York stage and silent pictures, Morgan brought his own patented spin of confused doublespeak to the part of the Wizard of Oz. His comedic timing also lent itself to witty ad-libs. When the Wizard of Oz's throne caught fire during an overzealous blast of pyrotechnics, Morgan riposted, "Ah—the hot seat!"

At the time of *The Wizard of Oz,* Morgan, born Francis Philip Wuppermann, was vice president of the family business, Angostura-Wuppermann, the largest bitters firm in America. Morgan came to work with a portable black cabinet—a miniature stocked bar—that he consulted in his dressing room as necessary in order to project the bewildered milquetoast persona, which he had perfected by the late 1930s. Judy Garland affectionately recalled that Morgan "nipped a bit . . . most of the

FRANK MORGAN

time I'm not sure he knew what he was doing. And he did it so damn well!"

Despite being Academy Award®-nominated two times in his life—for Best Actor in *The Affairs of Cellini* (1934) and Best Supporting Actor for the Victor Fleming–directed production *Tortilla Flat* (1942)—Morgan's most famous and beloved role was that of the Wizard of Oz. (In an odd bit of trivia, Morgan plays a Spaniard simpleton in *Tortilla Flat* who presides over a band of stray dogs—among them, Toto from *The Wizard of Oz.*) Morgan died in 1949, and was the one major player from the film unable to see the cultural fixture it would become, though his official press obituary did acknowledge his part in *The Wizard of Oz.* He is buried in Brooklyn's Green-Wood Cemetery, with both names—Wuppermann and Morgan—on his tombstone.

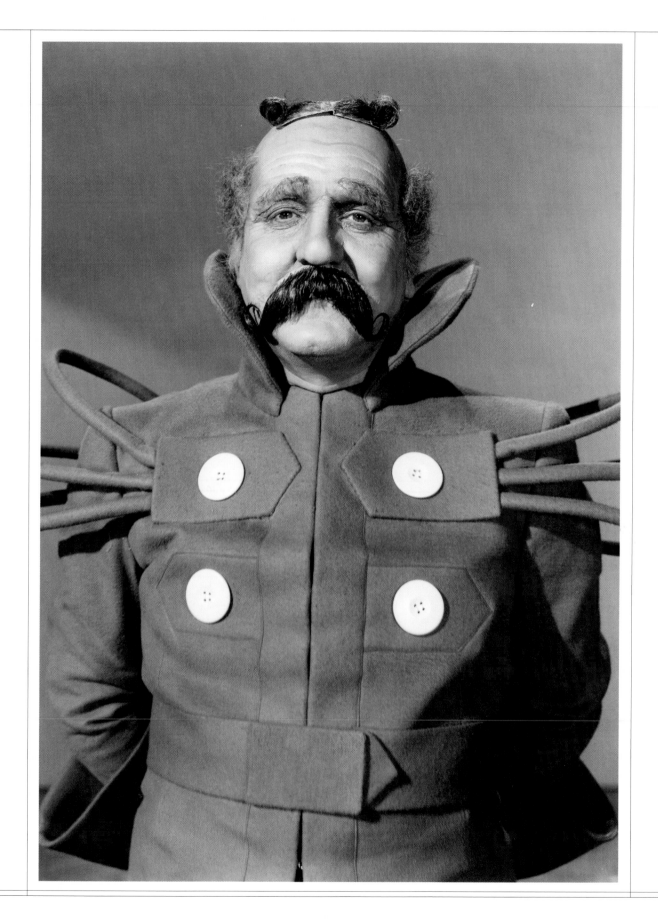

T
O
T
O

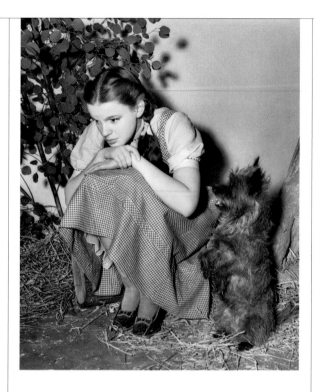

WHILE FRANK MORGAN'S reputation for scene stealing was legendary, he might have met his match in his canine cast mate. According to Beverly Allen, kennel man to Toto's trainer and owner, Carl Spitz, Dorothy's little (female) cairn terrier was not above upstaging a costar. Allen reported, "[Spitz] used to say little Toto would steal a scene from Judy Garland."

A November 8, 1938, M-G-M press release explained that Dorothy's pet was discovered "after a search that covered all parts of the country, the testing of hundreds of dog actors, and receipt by Mervyn LeRoy, the producer, of letters and pictures from every city in the United States." But Toto was found closer to home; Spitz's Hollywood Dog Training School was located right in the San Fernando Valley. The five-year-old, seventeen-pound pup was no stranger to working in motion pictures, having gotten her start opposite Shirley Temple in *Bright Eyes* (1934). At the time, Toto's name was Terry, but following the popularity of *The Wizard of Oz* her name was permanently changed.

The Wizard of Oz brought Toto newfound fame, prompting some theatres to raffle off look-alike dogs as publicity stunts. The hottest "signature" among autograph collectors quickly became Toto's paw print. Tongue in cheek, Toto's cotrainer Jack Weatherwax told the International News Service, "She's a wonderful little dog; everybody's friend, always a kind bark for every other dog; very stylish when dressed up; and a great little actress." In autumn 1940, Spitz took Toto on the road with five other famous canines in a tour that played theatre stages nationally. Spitz answered questions about proper feeding and training before putting his dogs through reenactments of their on-screen stunts, which climaxed in his Great Dane, Prince Carl, simulating a ferocious attack on a man.

Child actor Martin Spellman worked with Toto when they appeared together in *Son of the Navy* (1940). He attested to the little dog's appeal, saying, "I have always had dogs my whole life and many were very smart, but Toto was the smartest dog I have ever known." He continued: "I was aware that I was working with Toto [from *The Wizard of Oz*]. What I wasn't aware of is that I would fall in love with her and she with me. For three wonderful weeks she was my dog. And I missed her when the picture ended like I hoped she missed me." Judy Garland was similarly affected. When she arrived in New York to promote *The Wizard of Oz* in August 1939, she told interviewer Julia McCarthy she was sad because she missed Toto and even longed to get a dog of the same breed for her very own.

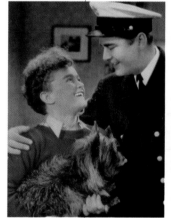

After *The Wizard of Oz*, Toto continued performing in other pictures, including a 1942 Three Stooges comedy. As was true of all dog actors, she only responded to silent hand cues given from out of camera range (watch her carefully in *The Wizard of Oz* to see her look off camera for her trainer's direction). Toto passed away during the World War II years, but on June 18, 2011, a permanent memorial honoring her was erected at the Hollywood Forever Cemetery in Los Angeles.

ABOVE RIGHT: **Martin Spellman with Toto and James Dunn, 1940.**

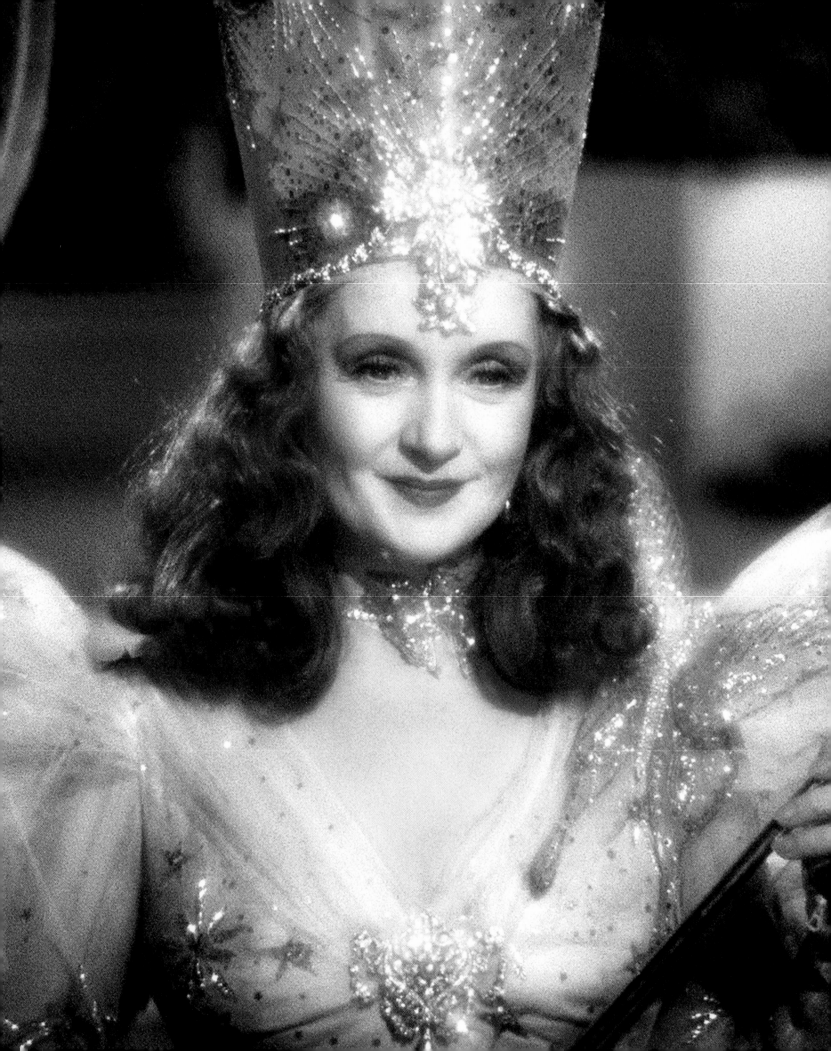

GLINDA

"SHE WAS BOTH
BEAUTIFUL AND YOUNG TO
THEIR EYES. HER HAIR WAS A RICH
RED IN COLOR AND FELL IN FLOWING
RINGLETS OVER HER SHOULDERS. HER
DRESS WAS PURE WHITE; BUT HER
EYES WERE BLUE, AND THEY LOOKED
KINDLY UPON THE LITTLE GIRL."

—DESCRIPTION OF GLINDA FROM
*THE WONDERFUL WIZARD
OF OZ,* 1900

THE PRECEDING ATTRIBUTES could just as easily have appeared in any turn-of-the-century theatre critic's praise for actress Billie Burke. A famous stage beauty renowned for her melodious diction and flaming red locks, Burke made her theatrical debut in 1903, was celebrated on Broadway, and appeared in silent films beginning in 1916. However, she was best known as the wife, and later widow, of the fabulous theatrical impresario Florenz Ziegfeld.

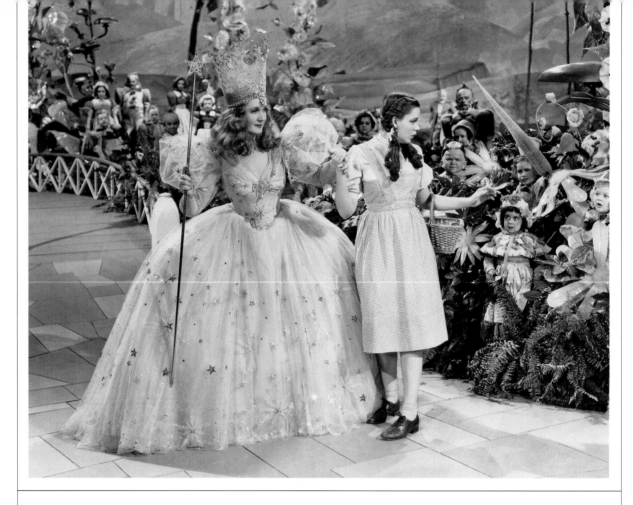

A famous beauty of stage and silent films, Billie Burke reinvented herself in the 1930s as a perpetually befuddled comedienne in films such as *Dinner at Eight*, *Everybody Sing*, and *Topper*. The widow of impresario Florenz Ziegfeld, Burke was portrayed by Myrna Loy in *The Great Ziegfeld* (1936). As Glinda, Burke expressed a gentleness that was the perfect foil to the Wicked Witch of the West.

For the character of Glinda the Good Witch, the screenwriters combined the *two* good witches who befriended Dorothy in Baum's book: the Good Witch of the North and Glinda, who resides in the southern region of the Land of Oz. In creating Billie Burke's costume, M-G-M's premier designer, Adrian, combined the descriptions of Baum's witches, too. In a nod to the Good Witch of the North, Burke's gown was made of layers of delicate pink tulle sprinkled with "northern stars" and frosty snow crystals. Adrian added a butterfly motif and gave Glinda "wings" in homage to the script's description of Glinda's gift of flight. (Glinda's snow crystals would further foreshadow the storm she creates to wake Dorothy and her friends from the deadly poppy field.) The June 9, 1938, script described Glinda as a "lovely vision—tall,

BILLIE BURKE

sweet-faced—graceful—in other words—a child's idea of 'the good fairy.'" Burke herself referred to Glinda as a "fairy" rather than a "witch."

Burke's performance as Glinda the Good Witch in *The Wizard of Oz* is often underrated by modern critics. But watch her delivery as a flighty, melodramatic matron in *Dinner at Eight* (1933) or *Everybody Sing* (1938) with Judy Garland to appreciate how restrained a performance she gives as the Land of Oz's all-knowing and serene sorceress. Some fans will be astonished to know that Burke was fifty-four when she portrayed the ageless Glinda the Good Witch. At the time, the *Los Angeles Times* reported, "[Burke] appears almost like a being eternally young." Burke ranked Glinda as her favorite part because it was reminiscent of the grander days and resplendent costumery of her stage roots.

FLIGHT of FANCY

"MY! PEOPLE COME AND GO SO QUICKLY HERE!"

—JUDY GARLAND AS DOROTHY, 1939

IN TURNER ENTERTAINMENT Co.'s *The Wizard of Oz*, Glinda the Good Witch of the North effortlessly materializes and vanishes in an airborne sphere. In the Baum book, Glinda is a beautiful witch who governs over the Land of Oz's southern territory. It is another good witch, described as a little woman whose "face was covered with wrinkles, her hair was nearly white, and she walked rather stiffly," who hails from the northern region in the Land of Oz. For the film version of *The Wizard of Oz*, the two sorceresses were simply merged to create a single character.

Baum's Glinda doesn't demonstrate any mystical ability to teleport herself, but the north witch disappears on the turn of her heel. However, the old cinematic trick of now-you-see-it-now-you-don't dates back to filmmaking's earliest experimentations with stop-motion photography; something more unique was needed for Glinda, whose costume had a butterfly motif. In Baum's 1909 book *The Road to Oz*, guests at an Emerald City celebration (including Santa Claus) are safely returned home by means of the Wizard of Oz's ingenious bubble-making invention, which operates using bellows and soapsuds strengthened with glue. A similar flying device was decided as an elegant means of transporting Burke's Glinda in and around the Land of Oz.

A 1939 edition of *Citizen Magazine* described the challenge of making Glinda's bubble float into a scene, burst, and reveal Burke as the "[m]ost difficult laboratory job" on set. Hollywood insider Paul Harrison described how this effect was achieved, writing, "The only instance of successful double-exposure [in a Technicolor film] is a bubble that comes bouncing along Munchkinland, changing color and growing larger until finally it stops and out steps Billie Burke

. . . This was done by photographing a dangling, jet-black ball and then, on the color negative, hand-tinting the white circle that resulted." Other accounts tell of photographing a silver ball by zooming in and out with the camera to minimize or expand its size and shape before layering its image in a double exposure. Electrician Raymond Griffith claimed that the ethereal effect was enhanced with yet another double-exposure by manually spinning huge lights that were situated in the four corners of a room but aimed directly at the room's center. And indeed, such shifting lights can be seen as Glinda's bubble descends into Munchkinland for the first time.

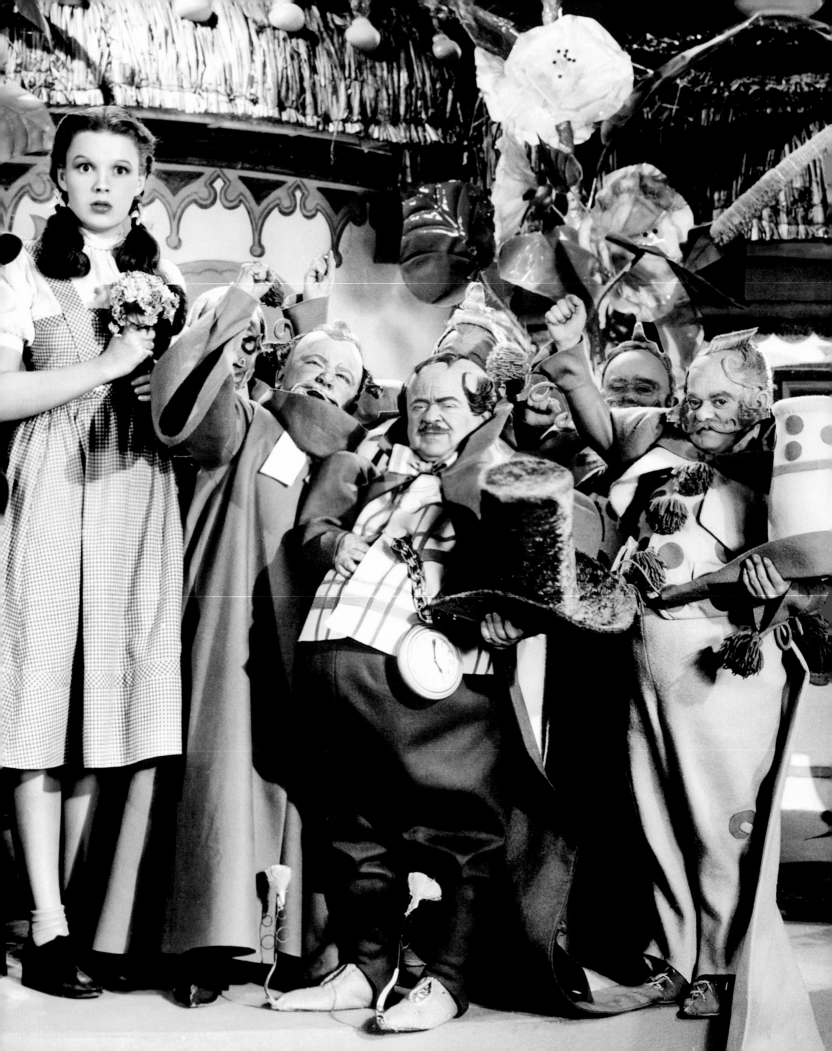

The Munchkins

IN *THE WONDERFUL WIZARD of Oz*, Baum describes the first citizens Dorothy encounters in the Land of Oz as being "not as big as the grown folk she had always been used to; but neither were they very small. In fact, they seemed about as tall as Dorothy, who was a well-grown child for her age." To portray the 124 Munchkins in the film, Mervyn LeRoy at first considered casting children, most of whom could be readily recruited from local dance schools, such as the Meglin Studios. One account suggested that LeRoy would be assigning Munchkin parts to M-G-M child stars Mickey Rooney and Freddie Bartholomew. But the demands and restrictions of casting, rehearsing, and filming that many minors made the notion infeasible. A nationwide call was put out through booking agents, carnival and circus owners, and newspapers for perfectly proportioned little people, or midgets, as they were once commonly called.

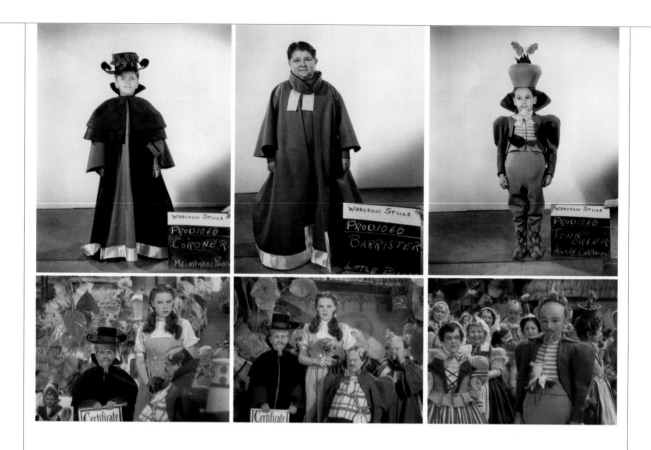

On December 13, 1938, all the Munchkins who were prominently featured, or had on-camera "bits," in Munchkinland were tested in their wardrobe. • TOP, LEFT: *"She's really most sincerely dead."* Meinhardt Raabe as the Munchkin coroner; the decorative laurel around his scrolled cap was replaced with a simple hatband. • TOP, CENTER: Munchkinland dignitaries included the barrister, as personified by "Little Billy" Rhodes. • TOP, RIGHT: Mickey Carroll, as the town crier, wears an urn-like hat from which lilacs sprout, which went unused in his on-film scenes. • BELOW, FAR LEFT AND SECOND FROM LEFT: "Prince Leon" Polinsky and Frank Cucksey were the first and second townsmen Munchkins who welcome Dorothy with a bouquet. • BELOW, RIGHT: John "Johnny" Leal as the deaf townsman. Leal's humorous refrain, "Which old witch?," was cut from the song "Ding-Dong! The Witch Is Dead." • BELOW, FAR RIGHT: *"And oh, what happened then was rich!"* Billy Curtis poses as the Munchkin town braggart.

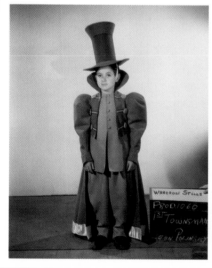

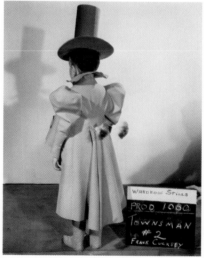

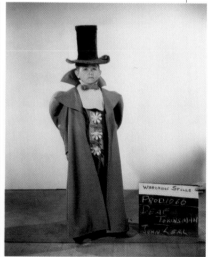

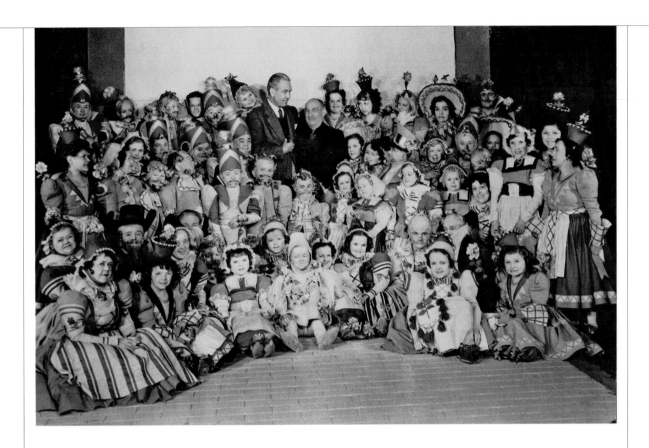

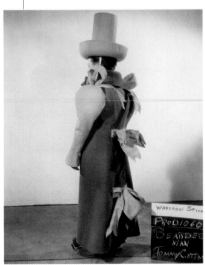

ABOVE: Director Victor Fleming poses with Leo Singer and roughly half of the extras portraying Munchkins. Although impresarios Nate Eagle, Harvey Williams, and Henry Kramer were among those agents representing some of the little people required for the 120-odd inhabitants of Munchkinland, the diminutive actors were collectively billed as "Singer's Midgets." · BELOW, LEFT TO RIGHT: Tommy Cottonaro in costume as the "bearded man" Munchkin. · As in the L. Frank Baum story, the film's Dorothy is entertained by five Munchkin fiddlers. Here, Friedrich "Freddie" Ritter models the rear view of Adrian's fiddler wardrobe. · Murray Wood as Munchkinland's lord mayor.

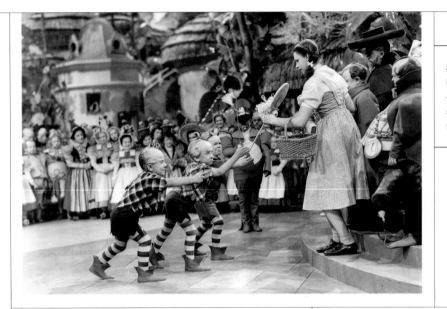

An autographed portrait of Judy Garland is identical to those she inscribed to each of the Munchkin players, as well as to studio visitors, during the 1938–39 production of *The Wizard of Oz.*

Stage magazine detailed M-G-M's plight in accommodating more than a hundred Munchkin actors in a 1939 column: "Since the studio was constructed with players of normal height and weight in mind, there was some difficulty in finding chairs and dressing tables and bathroom fixtures of sufficient nearness to the ground to be utilitarian." Beyond this challenge, however, was an even more obscure one; the account also revealed how it was necessary to hire a man for the sole purpose of picking the Munchkins up and putting them down again on designated spots: "He was called the 'midget elevator,' and the local unions were in a temporary dither over his salary classification."

Judy Garland was fondly recalled by all the Munchkin players, who enjoyed their on-set rapport with the child star between takes. In 1938, Meinhardt Raabe, who played Munchkinland's coroner, was twenty-three and a recent University of Wisconsin graduate. At the time, Garland was mulling over her own college options—a conceivable point of discussion between the two on break from their scenes together. (By October 1, 1939, Garland had nixed higher education, saying, "I don't see any sense in my trying to go to college. If I did and worked in pictures too, I wouldn't have time to have any fun.") During a personal appearance in Lock Haven, Pennsylvania, in October 1941, Raabe told the *Lock Haven Express* of an after-hours "date" with Garland while making *The Wizard of Oz,* and called it "the high spot" in his life.

There are varying accounts concerning the purported antics of the little people, assuredly the case of a few bad eggs incurring ill repute on the bunch. Makeup artist Jack Young remembered the rabble-rousers. "The [*Wizard of Oz*] Christmas party was really a ball," penned Young in his unpublished memoir. He recalled seeing two small actors "staggering down the studio street, each one clasping a bottle

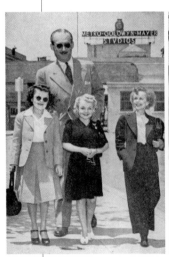 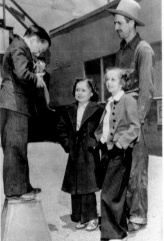

Back lot snapshots: LEFT: Nate Eagle, Munchkin agent, strolls the M-G-M lot with three of his stars. · RIGHT: Jakob Hofbauer readies his camera for Margaret Williams and Nita Krebs, who flank Freddy Gilman, wrangler of the Munchkinland ponies and the steeds who posed as the Horse of a Different Color.

The morning of December 23, 1938. Judy Garland peruses the latest issue of *Life* as several Munchkin players take a smoke break while awaiting a camera setup. Several papers carried an item about how the young actress was also spending her down time: "Judy Garland is busy between scenes in *The Wizard of Oz* knitting a tiny sweater of soft, fluffy pink wool for an electrician's baby." Judy was otherwise preoccupied with schoolwork and studied best with her left shoe off.

of champagne almost as big as they were." In 1998, Ann Rutherford, an M-G-M contract player who played Scarlett O'Hara's younger sister, defended the Munchkins and their alleged escapades, saying, "You get that many of anybody together, you have a few that are off-center—they give the whole bunch a bad name . . . they had such an enthusiasm because they had never encountered anything like the glamour of a studio. And they had never seen that many of their ilk."

After *The Wizard of Oz*, some of the Munchkin players found related work, either locally in Los Angeles or in their hometowns. One account from January 1, 1939, said that the entire troupe would live in a complete Munchkin village at the New York World's Fair; M-G-M was to dismantle the Munchkin set and ship it in crates, and the midgets would all travel east by train. (There was a "Little Miracle Town" at the Fair peopled by some of M-G-M's

midgets, but it did not have a known association with *The Wizard of Oz*.) Oakland, California's, J.C. Penney held a "Wizard of Oz" party for schoolchildren, which was attended by some of the Singer Midgets dressed as Munchkins. Olga Nardone, the tiniest member of the Munchkin Lullaby League, made supper club appearances performing at the Blue Room in Lowell, Massachusetts, billed as "Olga the Dancing Doll from . . . *The Wizard of Oz*." And Meinhardt Raabe returned to Wisconsin and made personal appearances in connection with showings of the film. "Added Attraction," read one 1939 ad from Madison, "On Stage—In Person . . . Forty-two-inch midget, direct from his performance as the coroner in *The Wizard of Oz*. Hear him tell of his experiences behind the scenes in Hollywood." Raabe gave speeches prior to the show that, by one report, kept two thousand children "speechless" and in awe.

MAKEUP ARTIST JACK Dawn's early life was not as picturesque as his studio-composed M-G-M biography related, with its recollections of the bluegrass meadows of his father's Kentucky estate and his adolescent ambitions to become a sculptor. As Dawn told it in 1939, "I ran away from home when I was thirteen . . . I was always down by the creek chipping things out of rock when I was supposed to be carrying buckets of goo to the hogs. When I didn't feed 'em I got a whaling." Indeed, by the time Dawn worked his way through the industry ranks to become M-G-M's makeup department chief, he had cultivated a reputation for being a rigid disciplinarian when overseeing his young makeup apprentices. As an actor in his early career—initially as a silent movie cowboy and a Keystone Cop—Dawn applied his own makeup and that of his coworkers. When the first Makeup Artists' Association was organized in 1926, he became its charter president.

THE ART OF TRANSFORMATION

> "DAWN GETS TOUGHIES SUCH AS *THE WIZARD OF OZ*—A LION FACE FOR BERT LAHR, TURNING MIDGETS INTO WINGED MONKEYS, MAKING SCARECROW RAY BOLGER'S HEAD LOOK AS IF IT WERE A STRAW-STUFFED BAG BUT ABLE TO SHOW EXPRESSION. AND LET MR. BOLGER BREATHE."
>
> —LUCIE NEVILLE, *EVERYWEEK MAGAZINE*, JUNE 18, 1939

Ordinarily, Dawn was charged with cosmetically accentuating the assets—while minimizing the flaws—of M-G-M's leading ladies, such as Norma Shearer, Myrna Loy, and Hedy Lamarr. But as motion-picture making became more demanding and sophisticated, Dawn found himself challenged to excel in effecting realism through the use of bald caps like those in *The Good Earth* (1937) or facial appliances that altered actors' appearances in *Marie Antoinette* (1938). However, *The Wizard of Oz* was Dawn's biggest assignment at that time. Writing for the book *Behind the Screen* (1938), Dawn said of his method for makeup design, "Paintings in color enable me to visualize makeups before putting a finger to the human face, and I believe that whatever success I have attained is due to the fact that I am by early training and inclination an artist."

It is believed that Margaret Hamilton's green-complexioned Wicked Witch is the first screen character to have unnaturally tinted flesh. Max Factor created the sickly tinge by mixing copper into the makeup ingredients for its cosmetic base. Except for Ray Bolger's eyes and mouth, his face was covered with a thin rubber mask molded like burlap on its surface to give the Scarecrow's head the appearance of a textured bag. The edges of the mask were glued solidly to Bolger's skin so that he could register unrestrained expressions. Back toward his ears, the makeup resembled a coarsely sewn sack with pieces of straw sticking through the seams. The silver-toned face of Tin Man Jack Haley was metallic looking but had the ability to also smile and frown, and was augmented with foam-rubber rivets, a protruding nose, and a hinged jaw-piece that moved when he talked. A bald cap concealed Haley's scalp, which was topped with the Tin Man's trademark funnel cap. Bert Lahr's Cowardly Lion makeup consisted of a bald cap and wigged mane, overhanging rubber jowls with whiskers, and a broadened nose that extended into an upturned snout.

Jack Dawn, chief of M-G-M's makeup department. To the immediate left of Dawn, on the wall, is Judy Garland's plaster life mask. Dawn created it for *The Wizard of Oz* so he could experiment with foam-rubber appliances on the bridge of her nose, which, Garland claimed, dipped in too much.

ADRIAN ADOLPH GREENBERG—known in the film industry as Adrian—was M-G-M's top costume designer from 1928 to 1941. During his tenure, Adrian attired Metro's most popular leading ladies, including Greta Garbo, Norma Shearer, Jean Harlow, Myrna Loy, and Jeanette MacDonald. He was the couturier of choice for Joan Crawford and started a fashion trend by adding shoulder pads to the actress's wardrobe. Adrian was delighted to be assigned to *The Wizard of Oz*, as the story had been his boyhood favorite.

The sheer fantasy of *The Wizard of Oz* was also a welcome diversion from designing historical costumes for period pictures such as *Romeo and Juliet* (1936) and *Marie Antoinette* (1938). In its 1939 publicity for *The Wizard of Oz*, M-G-M noted, "Adrian reports that designing for the picture was the greatest fun he has ever had in film work. He could let his imagination run free since there were no formulas, no restrictions." In particular, Adrian was most taken with the creative challenge of dressing the Munchkins, and the designer's efforts proved noteworthy. An unnamed reporter, writing for *Stage* magazine's May 1, 1939, issue, concluded after visiting the set that the Munchkins were "the most utterly enchanting" of the entire cast, "with their doll faces, their plastered hair that looked as though it had been painted on their heads, the little felt flowers that grew out of their shoes, [and] the bells that jingled from their sleeves."

ABOVE: An extravagant military design that did not end up being featured in the film was that of the Munchkin commander of the navy, here modeled by John "Johnny" Winters. • **BELOW:** Adrian's wardrobe sketches for Munchkins include the commander of the navy (second from left) and the drummer of the Munchkinland army (far right), which was ultimately not used in *The Wizard of Oz*.

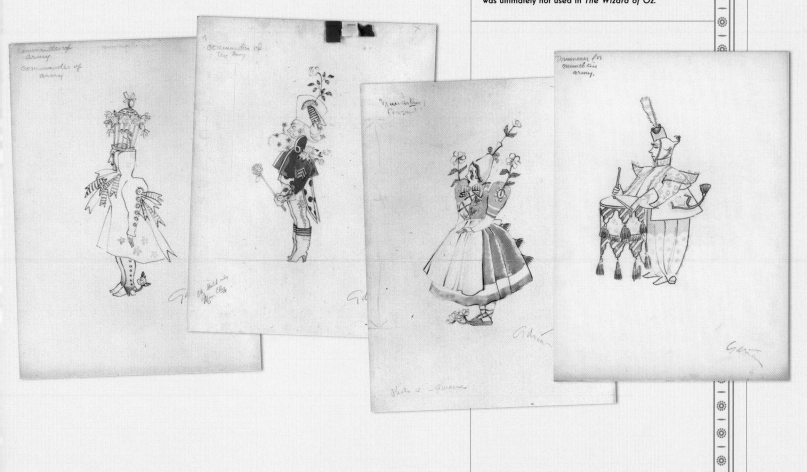

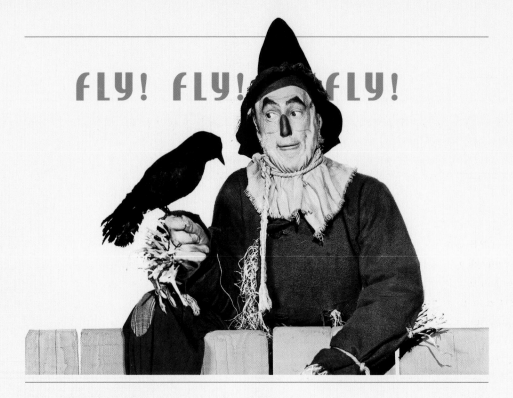

FLY! FLY! FLY!

CERTAIN SUPPORTING PLAYERS among *The Wizard of Oz* cast may go unnoticed, except perhaps by the most eagle-eyed of viewers. In keeping with Baum's description that "birds of rare and brilliant plumage sang and fluttered in the trees and bushes," the motion picture's Land of Oz is populated by a number of exotic birds. At an estimated value of $15,000, the studio rented the birds from the Los Angeles Zoo, which, according to publicity, "represented ninety-eight species from four continents," although this is an exaggeration. The group included a South American toucan, golden pheasants, and African and Saurus cranes—one of which spreads its wings in the background during a chorus of "We're Off to See the Wizard," giving rise to the urban legend that the motion is a suicide-hanging in progress. The rare birds were handled by bird wrangler Bill Richards.

A raven named Jimmy, owned and trained by Curley Twiford, makes his appearance in the Scarecrow's cornfield. (Jimmy was originally discovered by Twiford as a half-starved chick in the Mojave Desert.) Jimmy's first day of filming was November 4, 1938; the setup was for him to perch on Ray Bolger's shoulder, peck a piece of straw loose from Bolger's tunic, and fly back to Twiford off camera. According to script clerk Wallace Worsley, Jimmy "was controlled by a black thread so that if he flew too far from Bolger's shoulder, Curley, hiding in the cornfield, could retrieve him." After several successful takes, the thread broke and the liberated raven flew up into the rafters fifty feet over the set. That was at two in the afternoon, as Worsley recollected, and by five, the company went home, having been entertained to the point of hysterics at the sight of Twiford up in the rafters coaxing and cajoling an uncooperative Jimmy. (Jimmy was finally captured at midnight!) This memorable incident no doubt inspired Ray Bolger to gift Judy Garland with a copy of Edgar Allan Poe's *The Raven* that Christmas.

Outside of the fantasy scenes in the Land of Oz, the Kansas farm set called for a roosting hen and other assorted poultry. According to an anonymous 1939 notice in *The San Antonio (Texas) Light*, one such chicken "took a fancy to Jack Haley and insisted on being in every shot with the actor." Judy Garland was said to have adopted another as a pet.

To augment the avian atmosphere, *Boxoffice* magazine reported, on April 15, 1939, that an M-G-M sound crew had just returned from a trip to Catalina Island, having recorded fifteen thousand feet of tape of assorted bird songs to blend with the film's sound track.

THE LAND(SCAPE) OF OZ

IN THE LATE 1930s, Metro-Goldwyn-Mayer's filmmaking resources were unmatched. If the best wasn't to be found on the lot, it was outsourced or imported, including script doctors, scenarists, and song composers. Many of the artisans and craftsmen involved with set design, scenic backdrops, and set dressing came from theatrical backgrounds, and most referred to *The Wizard of Oz*, among other Metro musicals, as a "show."

At its peak, and as touted by *Screen Guide* magazine in 1939, not only was M-G-M home of the reigning movie stars of the day, but its property also covered 117 acres,

weeks.) If any of the prominent studios could do *The Wizard of Oz* justice, it was Metro.

M-G-M was proficient in constructing whatever environment a film scenario called for. Often, its back-lot streets, storefronts, and houses doubled for any variety of on-screen locales. But *The Wizard of Oz* was totally unique in that respect: there were no fantasy facades that could be recycled.

Despite its farm, forests, and poppy field, *The Wizard of Oz* was filmed entirely indoors on soundstages. (During preproduction, a suitably Kansas-like farm was identified fifty miles from the studio, but the idea of a location shoot

> "SO THEY GAVE US A SCRIPT IN WHICH A LITTLE GIRL FROM KANSAS LIVES A GREAT ADVENTURE IN A COUNTRY OF HER OWN IMAGINATION. BUT NEITHER IN THE SCRIPT NOR IN THE ORIGINAL BOOK WAS THERE ANY DESCRIPTION TO INDICATE ALONG WHAT LINES HER IMAGINATION MIGHT BUILD SUCH A COUNTRY! WHICH LEFT US, FIRST OF ALL, TO DO SOME IMAGINING OURSELVES!"
>
> —CEDRIC GIBBONS, M-G-M ART DEPARTMENT CHIEF

housed 135 buildings, and employed more than 4,500 people. Its lot included a reservoir and underwater tank, a railroad station, a park and zoo, and modern houses and streets to create the realism of, for example, Mickey Rooney's Andy Hardy pictures. Metro's arts and crafts departments encompassed a lumber mill and carpentry shop, a plaster shop, warehouses, music buildings and rehearsal halls, costume and makeup departments, and thirty soundstages. (So vast was M-G-M's inventory of antiquities, furniture, automobiles, equipment, miniatures, boats, and wardrobe that its liquidation in a highly publicized 1970 auction ran the course of nearly three

was tabled when it was figured out that the three-hour-and-twenty-minute round-trip left Judy Garland with only forty minutes of work time after schooling and recreation.) The only hint of authentic exterior footage is the streaming cloud montage over which the main titles are printed. The construction blueprints were laboriously detailed, from the Kansas farmhouse, purposely distressed to look "heavily aged and weathered with paint blistered," to Munchkinland, with its pavilion and pond, civic center, gatehouse, town hall, rows of huts, and stream.

The Emerald City's architecture was designed in the elegant art moderne style of the futuristic metropolises

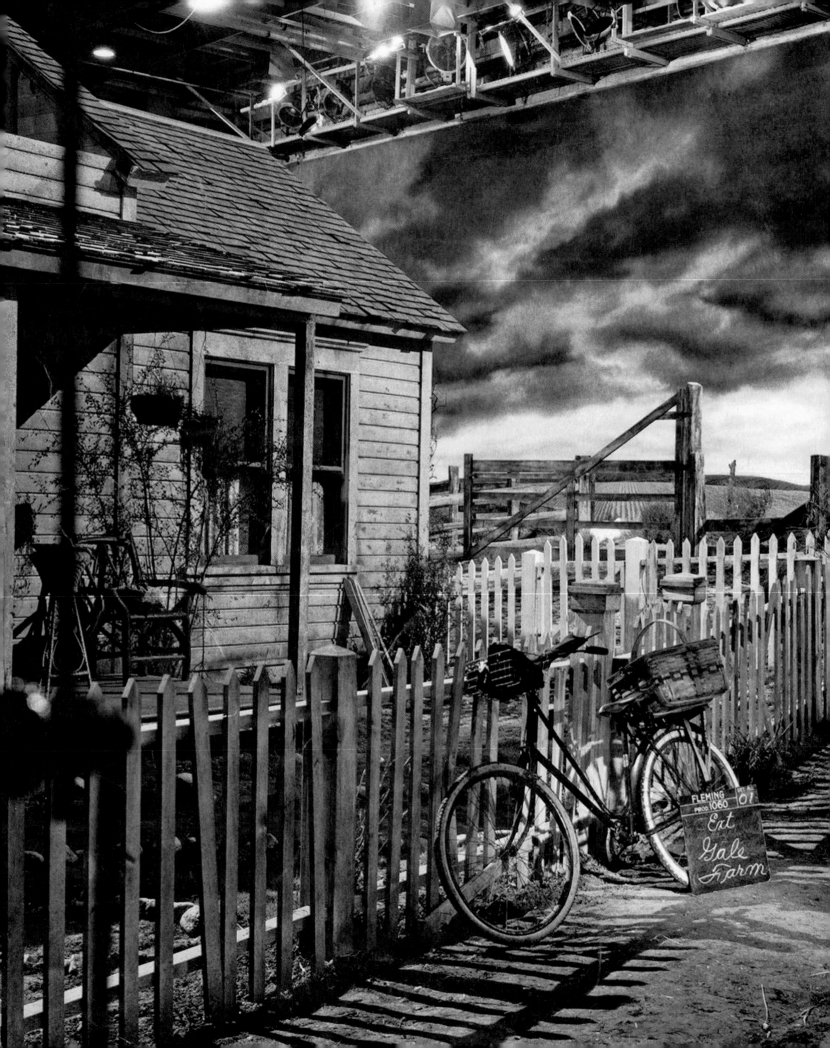

FLEMING
PROD 1060
Ext
Gale
Farm

ABOVE: Fifty-six-year-old actress Sarah Padden made a screen test as Aunt Em, January 3, 1939. She modeled at least two different aprons and posed for reference stills. The part of Aunt Em was ultimately assigned to Clara Blandick. • BELOW: Hollywood columnist Merle Potter visits with Margaret Hamilton and Charley Grapewin, in character as Almira Gulch and Uncle Henry, respectively. According to an August 8, 1938, account, Grapewin had appeared in a road show company of the early stage musical of The Wizard of Oz.

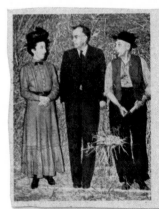

Original 'Oz' Script Is Gift From Actor

A souvenir that is also a practical aid has been received by Mervyn LeRoy, producing "The Wizard of Oz," at Metro-Goldwyn-Mayer. It is a much-used, dog's-eared copy of the original script of the Montgomery and Stone stage show based on the Frank Baum fairy tale.

Charley Grapewin, veteran character actor, who played in the original stage presentation, had kept the script during all the years that have elapsed since the production, and presented it to LeRoy. The script is by Paul Tietjens.

OPPOSITE: Dorothy's farmhouse was intended to evoke a Depression-era setting typical of the 1930s. Here, note the Gale family name on the mailbox; a distant neighboring farm; and Miss Gulch's bicycle, parked for the moment. Though the slate indicates Victor Fleming's directorship, the Kansas scenes were overseen by King Vidor in February 1939, after Fleming departed to take over Gone with the Wind. While filming farm scenes for Summer Stock in December 1948, Judy Garland told reporter Harrison Carroll that the only other farm she ever knew anything about was the one in The Wizard of Oz.

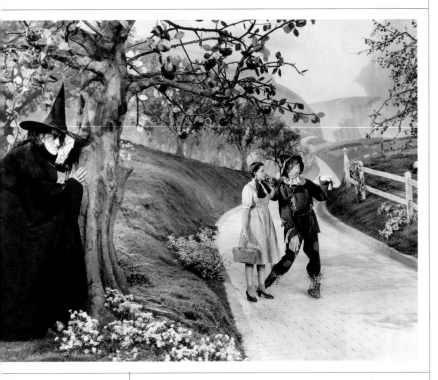

seen in *Things to Come* (1936) and *Lost Horizon* (1937).
Other sets were deceptively simplistic: Set #23 was con-
structed just for costume and makeup tests, and another,
for "Good Witch in Sky," consisted of a black velvet scrim,
a two-foot-square black velvet platform upon which Billie
Burke would perch, and a fan to simulate a breeze—all for
the brief, superimposed shots of Glinda summoning a snow
shower to squelch the poppies' poisonous aroma. A min-
iature set of the Wicked Witch's Jitter Forest (unused in
the final cut), with trees six feet tall rather than twelve feet,
as on the full-scale set, included a backdrop with the Emer-
ald City and its ethereal halos visible in the distance.

A November 9, 1938, reference still of the Apple Orchard (right) reveals
far more of the left edge of the set than is seen in the film (above). The
talking apple trees were made of rubber and animated by men from within.

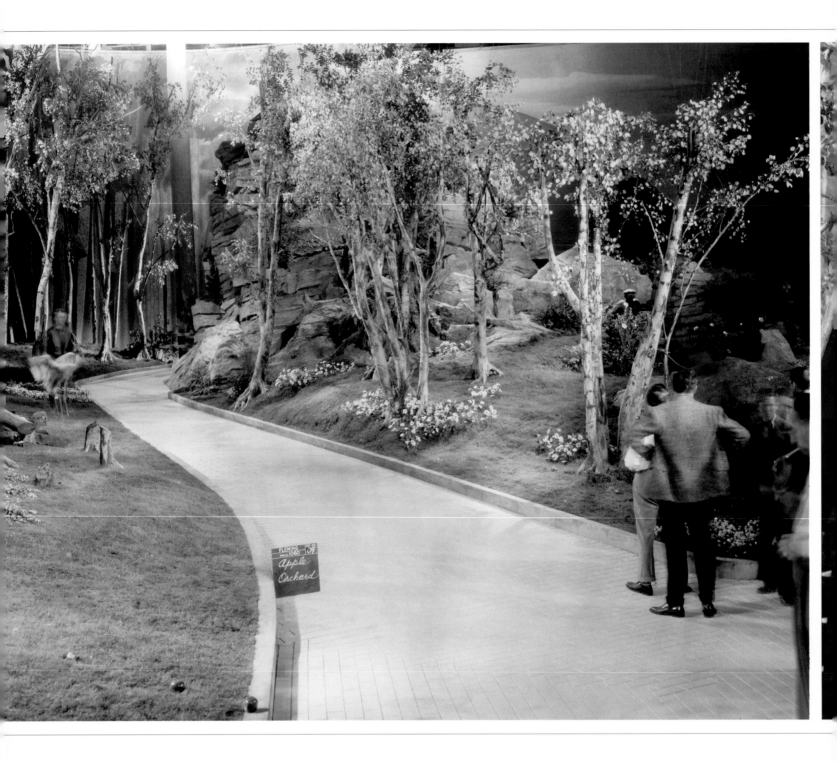

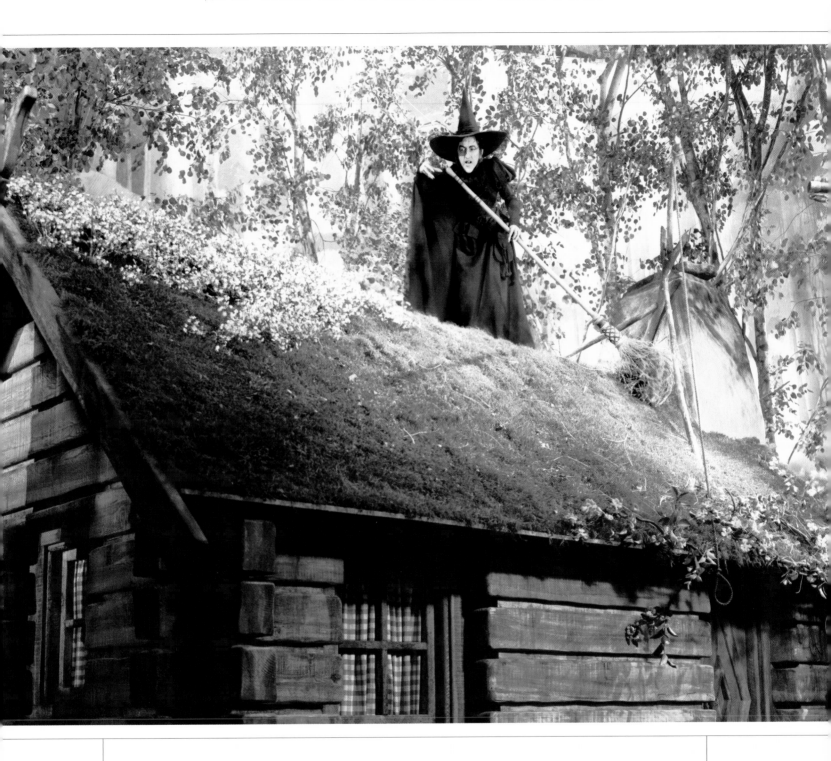

OPPOSITE: During a break in filming on the Apple Orchard set, bird wrangler Bill Richards (far left) steadies the stork whose on-screen motions have given rise to rumors of a mysterious suicide in the background. (The time lapse of the camera shutter speed when taking such stills occasionally resulted in random instances of double exposure, capturing studio personnel in motion.) · **ABOVE:** The Apple Orchard set extended to include the Tin Man's cottage.

The poppy field was said to cover more than an acre and a half on one of M-G-M's largest soundstages. A poppy prototype was drafted in blueprint and then re-created by the thousands over a three-month period. The artificial flowers were described in 1939 as being "dusty rose in color." Installing the poppies individually by hand took a week, but the end result was that of a veritable sea of blossoms.

IT WAS DETERMINED early on that the Kansas scenes, which bookend the adventures in the Land of Oz, would adhere to L. Frank Baum's description—and illustrator W. W. Denslow's accompanying pictures—as barren and drab. Those opening and closing scenes were shot in what was then called "Technicolor black and white," standard black-and-white film processed and printed in monochromatic amber and brown tones. An accidental stain of chemical salt on celluloid gave John Nickolaus, head of M-G-M's film lab, the idea for the specialized toning of sepia, platinum, and pastel tints first used on *The Good Earth* (1937) and *The Girl of the Golden West* (1938). It was an enhanced form of presentation familiar to most Americans in the 1930s through pictorial layouts in magazines and newspaper supplements (called *rotogravures*) tinted in sepia shades. For practical purposes, this coloring also allowed for the use of a single Technicolor camera for the transition from Kansas to the Land of Oz, whereby Judy Garland's double (wearing a sepia-tinted costume) matched the monotone

hues of the scenery when she and Judy, fully ready for Technicolor photography, quickly switched position off-screen as film rolled. This eliminated the need for a cut-away shot, a double exposure, a lap dissolve, or hand-coloring individual frames to achieve the effect.

There is a misconception that *The Wizard of Oz* was among the earliest—if not *the* first—Technicolor films. As with any fledgling technology, Technicolor hadn't yet been perfected in 1938, but its use in Hollywood filmmaking dates to the early 1920s. It was, though, cumbersome, tedious, and expensive, and the results were criticized by some as vulgar and eye-straining. But in the end all obstacles were overcome, and even journalist Paul Harrison, a premature dissenter, became a convert by February 1939, saying, "If the customers have been worrying about what the movies are doing to *The Wizard of Oz*, I can assure them that the story is well in hand—and in very sympathetic and capable hands, too."

The technicians, artisans, and craftspeople who brought the Land of Oz vividly to life were skilled experts adept in their respective trades. The sets in *The Wizard of Oz* are stunning achievements when one appreciates that *everything* was constructed from the ground up to create the illusion of an otherworld realm, but with enough realism to be plausible. If Dorothy could be transported from her Kansas farm to experience a land of Lilliputians, travel the Yellow Brick Road, and skip through poppy fields, then so might we.

ABOVE: In *The Wonderful Wizard of Oz*, Dorothy is carried from the Deadly Poppy Field to safety by the Scarecrow and Tin Man; the Cowardly Lion is hoisted from the flowers on a cart pulled by hundreds of field mice. For practical purposes, the mice were supplanted in the 1902 stage musical by the Witch of the North, who summons a snow shower to quell the poppies' poison and revive the travelers. For Turner Entertainment Co.'s film, Dorothy and her friends are once again rescued by the Good Witch with a refreshing snowfall in a bit borrowed from the play. · OPPOSITE: In the set still, note the track laid for the path of the camera to capture the action in the poppy field scenes.

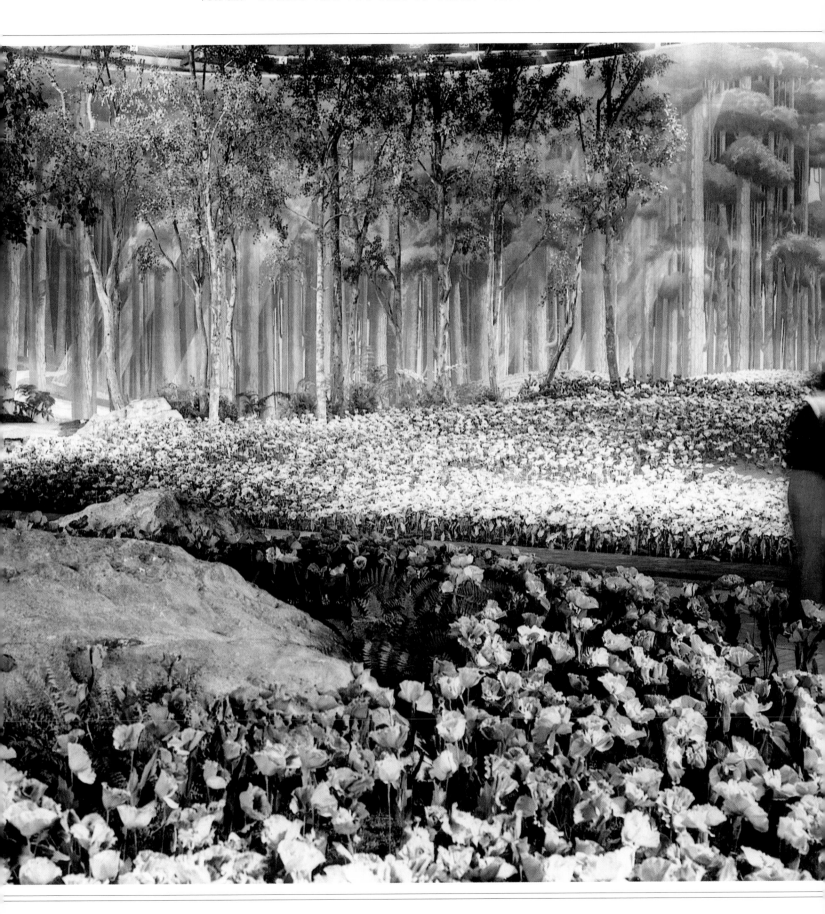

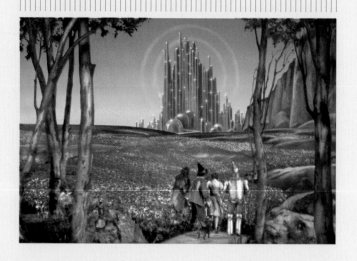

THE EMERALD CITY

L FRANK BAUM'S MAGNIFICENT
Emerald City was most likely
inspired by the author's visit to the
Imperial White City, the core attraction
at Chicago's six-hundred-acre Colum-
bian Exposition, in 1893. At night, the
pristine buildings were illuminated by
electric lights, which caused them to
shimmer with effervescence, not unlike
Baum's fictional mecca. To those unac-
customed to electricity, it was an extraor-
dinary sight to behold.

Baum's Emerald City was not totally
monochromatic throughout; before
being admitted through its gates, Doro-
thy and her companions are obliged to
put on spectacles with green lenses that
cause everything to *appear* tinted to their eyes. (One can imagine
the dazzling effect if Chicago's White City were viewed through
similar glasses.) Movie screenwriters dispensed with Baum's spec-
tacles in favor of portraying a literal Emerald City in which even
the inhabitants' clothing was shades of green.

ABOVE: Dorothy and her companions are
dazzled by their first glimpse of the Emerald
City in a memorable scene from *The Wizard
of Oz.* · RIGHT: The guardian of the
gates (opposite) and the Emerald City
coachman (right) were two of five disguises
Jack Dawn envisioned for Frank Morgan,
who also portrayed the Wizard of Oz. The
coachman was a design entirely of Dawn's
creation, with no references to the *Wonder-
ful Wizard of Oz* book.

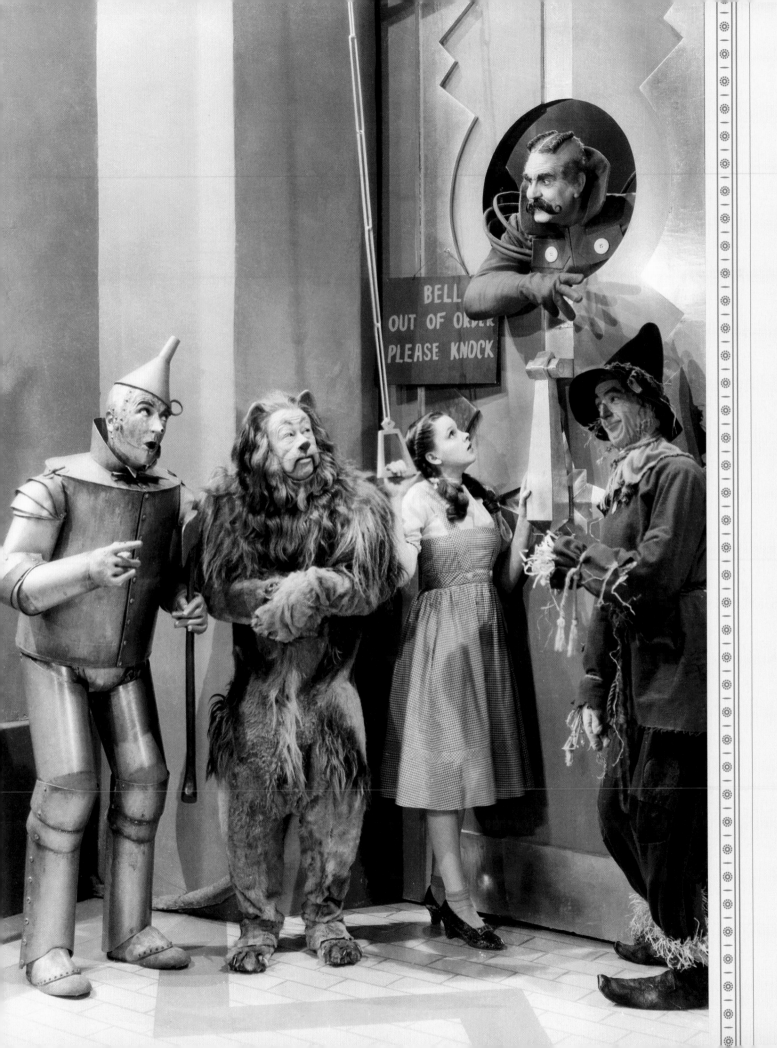

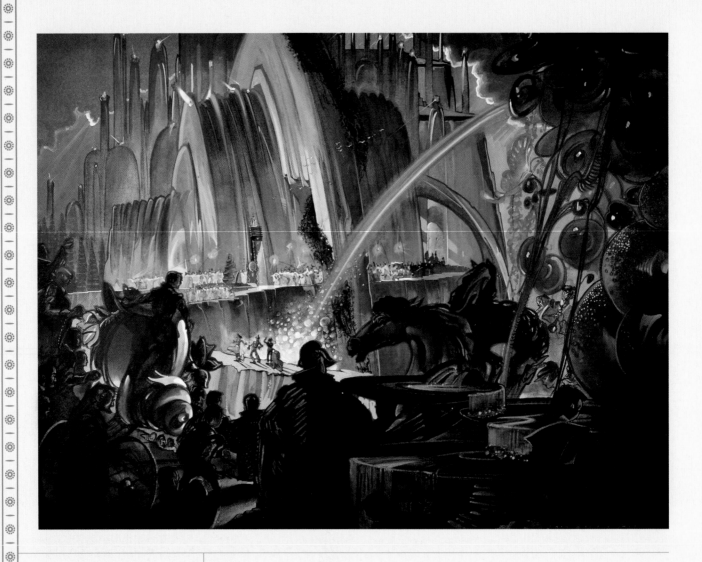

The motion picture's Emerald City was peopled with several hundred extras, a few of whom had close-ups or a line or two on camera; but where movie extras were concerned, any notion of scene stealing was forbidden. Still, Dorothy Barrett, who played an attendant in the Emerald City salon, wished for foresight. She explained, "We didn't think of [The Wizard of Oz] as a great lasting movie," adding that if she had, she would have tried to appear more conspicuous to the camera. "But then, one could lose work that way because of being too obvious or creating continuity issues." Meredythe Glass, also an Emerald City extra, concurred, saying, "You kept your place. The last thing I ever wanted to do was embarrass Mervyn [LeRoy]." (Glass was of Hollywood pedigree by relation; she got the acting gig on The Wizard of Oz because LeRoy was her mother's cousin.)

The Emerald City interior was said to be the most expansive of all the sets in terms of size and layout. After paying a visit, columnist Milton Barker noted, "[It] covers a stage three hundred feet square and is the most beautiful set your reporter ever has seen. There is every shade of green imaginable and the floor glistens like a mirror. After every shot a dozen men with huge mops go over it carefully to remove every fleck of dust."

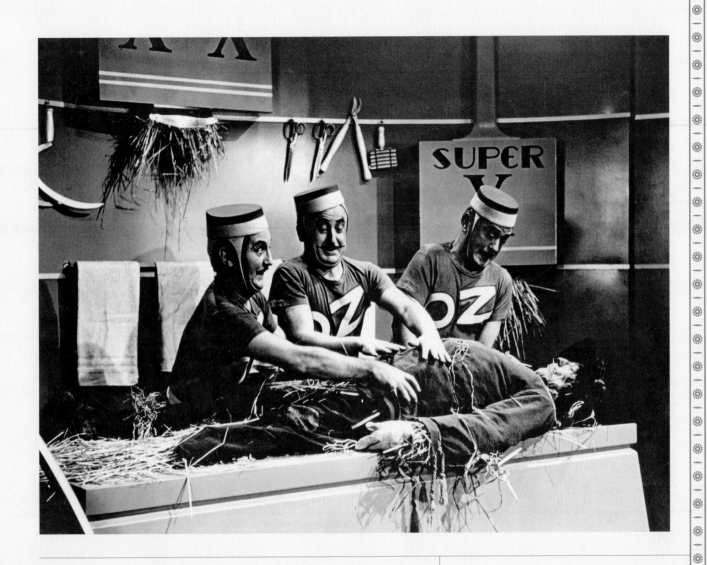

Inside Emerald City, the travelers are given a tour of the town in a carriage drawn by the Horse of a Different Color (the carriage was a rental from Overland Stables). • **LEFT:** During a pause in shooting, doubles for Judy Garland and Ray Bolger chat with each other. • **ABOVE:** The first stop on the tour is the Wash & Brush Up Company, where the group can "tidy up a bit." Bit player Albert Morin (who was an extra in *Gone with the Wind*'s Atlanta Bazaar scene) is one of the Scarecrow's attendants. • For the "Merry Old Land of Oz" number, Mervyn LeRoy explained, "We figured the picture has to be more than just a fairy tale, so we are treating it like a Ziegfeld show—having the characters sing and dance."

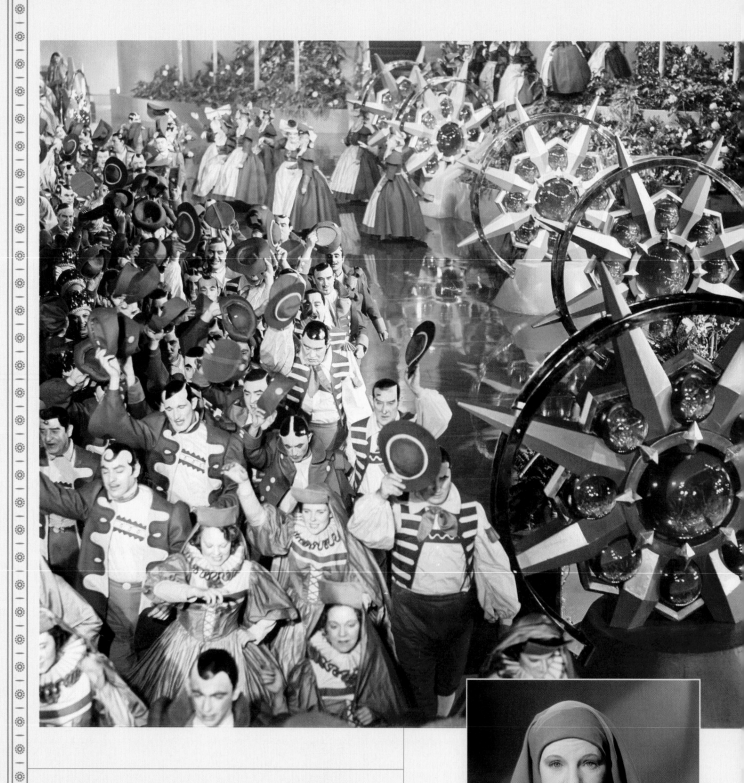

ABOVE: Three hundred extras attired as Emerald City peasants parade through the streets in a musical scene cut from *The Wizard of Oz*. Note that each townsman has a uniquely painted hairline—indicative of the motion picture's attention to detail. Some of the men complained that the regular use of bald caps made their hair fall out. • **RIGHT:** An extra poses for an early makeup test as an Emerald City townsman's wife, October 8, 1938. • **OPPOSITE:** The Wizard of Oz's inner sanctum and throne room. Illuminated fabric was designed to look like columns of light.

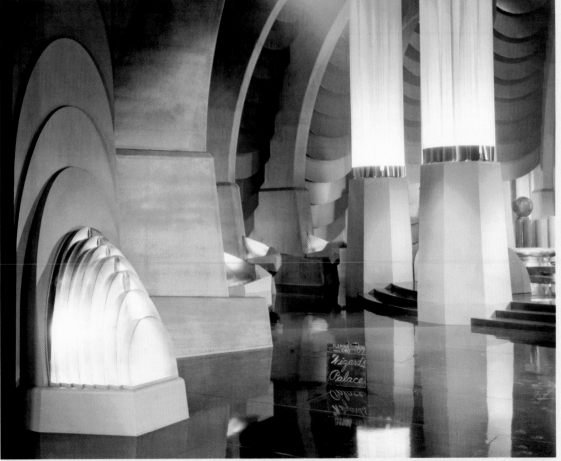

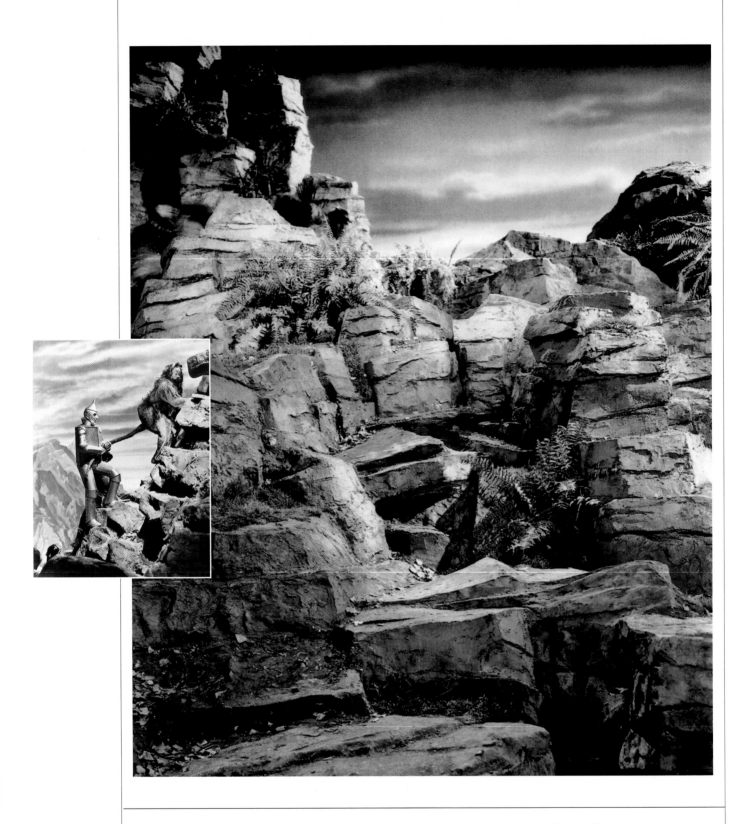

Richard Thorpe shot footage of Dorothy's three friends scaling the cliff (inset). Afterward, they are apprehended by three Winkies. The heroes overwhelm the guards and don their uniforms to infiltrate the Wicked Witch's castle in disguise. Sharp-eyed viewers will note Buddy Ebsen, Bert Lahr, and the top of Ray Bolger's fur headdress, in addition to a prop man. • OPPOSITE: Dorothy's rescue from the Wicked Witch's tower room was originally filmed on this set by director Richard Thorpe, October 19, 1938. Note Judy Garland's T-shaped positioning mark in front of the slate, and the hamper used to hold Toto hostage. The characters then reunited (inset) after the Tin Man, here portrayed by Buddy Ebsen, used his ax to rend the barricade, freeing Dorothy.

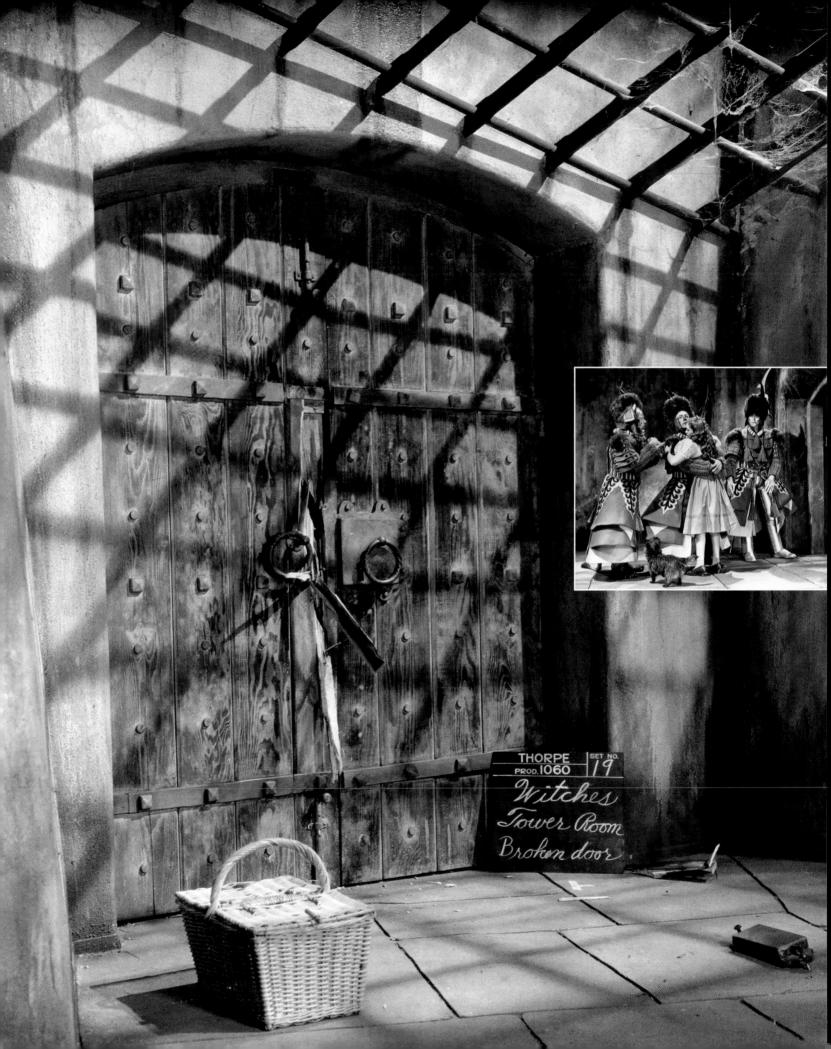

THORPE PROD. 1060 SET NO. 19
Witches
Tower Room
Broken door.

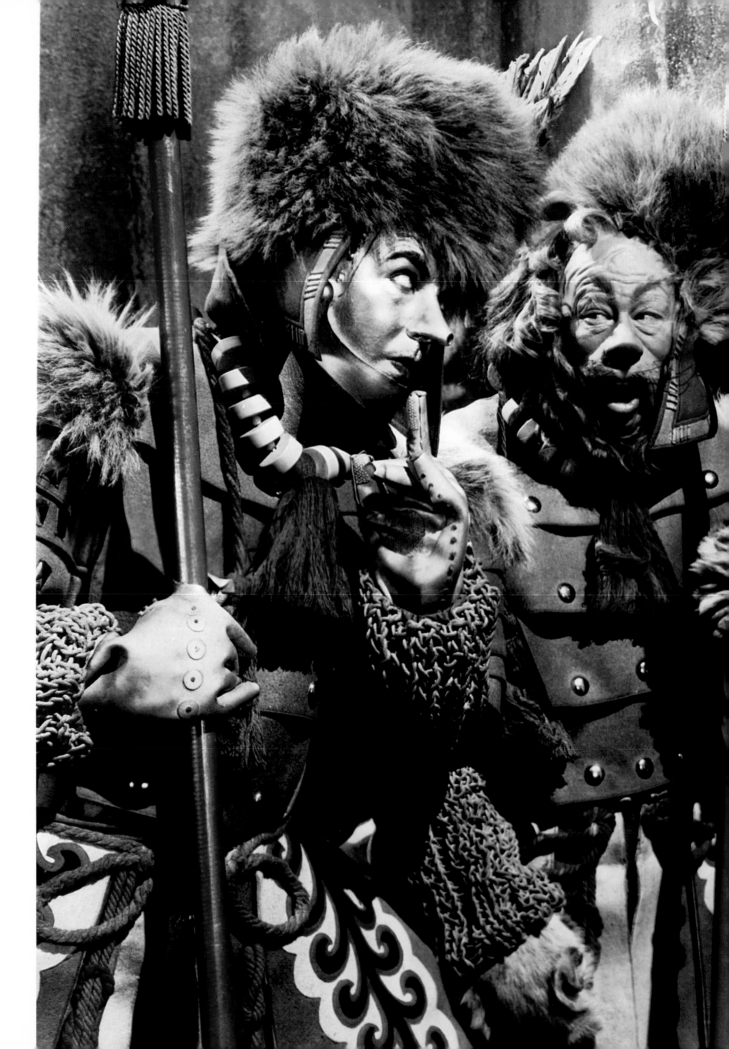

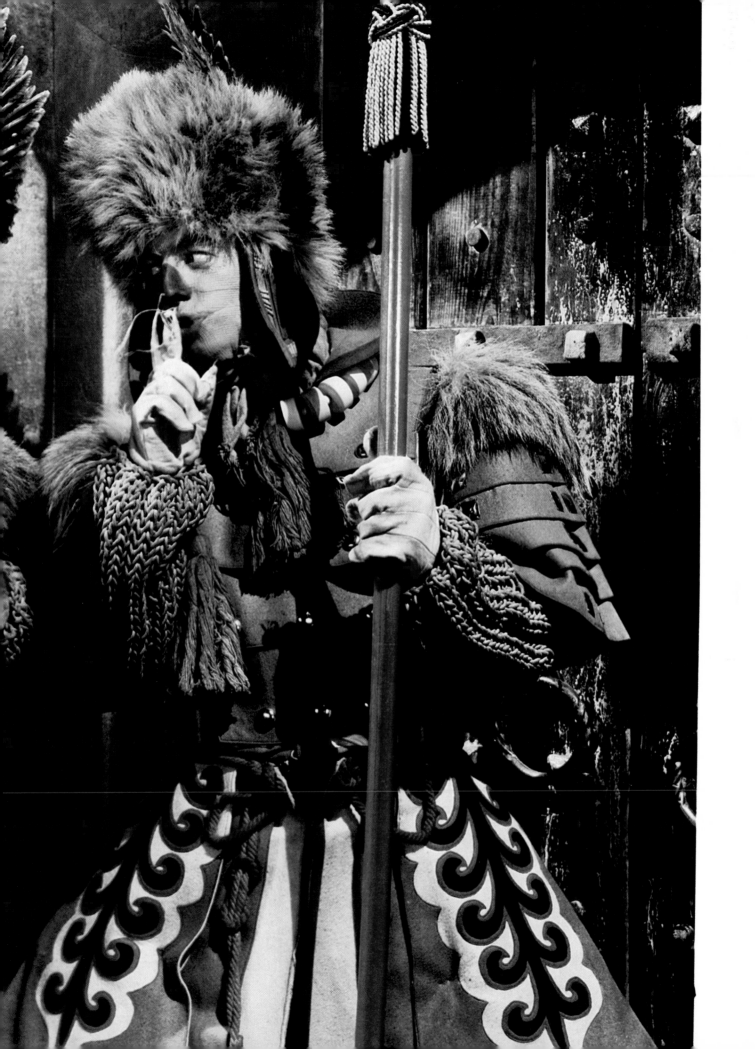

ABOVE: A set reference still from the M-G-M Property Department documents the tower room of the Witch's castle on the third day of Richard Thorpe's direction, October 15, 1938. Typed notations on the back of the photo indicate rented accoutrements: "2 small hand bellows," "1 brass sundial globe of world," "1 silver chalice with lizard top," and "1 jeweled box with snake and eagle top." · **OPPOSITE:** The entrance hall to the Witch's castle as arranged under Richard Thorpe's directorship (above). Scenes were reshot on the entrance hall set after Victor Fleming's appointment as director (below). Tests (inset, above and below) document the set's chandelier and cleat.

GLINDA: The sooner you get out of Oz altogether, the safer you'll sleep, my dear. · DOROTHY: Oh, I'd give anything to get out of Oz altogether—but which is the way back to Kansas? . . . · GLINDA: The only person who might know would be the great and wonderful Wizard of Oz himself! . . . He lives in the Emerald City, and that's a long journey from here. · DOROTHY: But, how do I start for Emerald City?

GLINDA:

It's always best to start at the beginning— and all you do is follow the

Yellow Brick Road.

DOROTHY: How can you talk if

YOU HAVEN'T GOT A BRAIN?

SCARECROW: I don't know. But some people without brains do an awful lot of talking, don't they?

WE'RE OFF TO SEE

PART

2

DOROTHY: Why, it's a man!

A MAN MADE OUT OF TIN!

TIN MAN: AND **BEARS.**

SCARECROW: AND **TIGERS?**

DOROTHY: **LIONS?**

THE WIZARD

Put 'em up!

Put 'em up!

The Great Wizard of Oz Revealed

COWARDLY LION, TRYING TO SCARE THE SCARECROW AND TIN MAN: Which one of you first? I'll fight you both together if you want. I'll fight you with one paw tied behind my back. I'll fight you standing on one foot. I'll fight you with my eyes closed. Oh, pullin' an axe on me, eh? Sneaking up on me, eh? Why, I'll . . . ruff!
· DOROTHY, TO THE COWARDLY LION AFTER SMACKING HIM: Why, you're nothing but a great big coward! · COWARDLY LION: You're right, I am a coward!

I haven't any courage at all.

I even scare myself. Look at the circles under my eyes.

So! You won't take warning, eh?
And now, my beauties!

Something with **POISON** in it . . .

POPPIES. . .

. . . POPPIES WILL PUT THEM TO SLEEP. . .

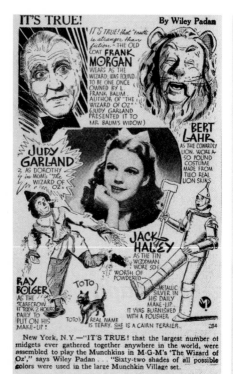

ACCORDING TO *FILM Daily,* the average feature film took twenty-two days to shoot in 1938. *The Wizard of Oz,* however, far exceeded all projected deadlines. In particular, Judy Garland's schedule would be tied up beyond expectation. When she was cast as Dorothy in February 1938, she was also slated for the films *Wonder Child* and M-G-M producer Harry Rapf's *Circus Days*; but her unavailability led to the abandonment of both projects. The production time for *The Wizard of Oz* lasted a total of twenty months: eight months of prep time prior to filming (from the point of acquisition); six months before the cameras; and an additional six months in postproduction. Garland was fifteen when she was cast as Dorothy and began wig and makeup tests; she was sixteen throughout the majority of filming; and she would have been seventeen on June 30, 1939, when the assistant director log for *Babes in Arms,* her project after *The Wizard of Oz,* noted, "Judy Garland working on *[The] Wizard of Oz* retakes."

During the film's lengthy shooting schedule, tidbits about the production and its players were trickled to the press to fuel public appetite for M-G-M's forthcoming Technicolor epic. The smallest bit of gossip was considered newsworthy: Garland's case of the sniffles set Metro back five days of shooting at $30,000 a day. Jack Haley joked about needing to carry a can opener in case he should tip over in his Tin Man costume. Garland was visited on the set by former silent-screen star Colleen Moore. The sound of Ray Bolger's clicking pocket change spoiled a take during his scarecrow dance. Garland was compiling a keepsake album of stills from her time on the film. Bert Lahr brought a crate of avocados to the set from his ranch and distributed them to cast and crew.

After setbacks, delays, and much troubleshooting, *The Wizard of Oz* was at last prepared to move into its postproduction phase in March 1939. And M-G-M's publicity machine was soon pressed into action in order to generate excitement and anticipation for *The Wizard of Oz,* its most expensive, complex, and glorious production to date.

ABOVE, LEFT: Artist Wiley Padan's "It's True!" cartoon panel was along the lines of "Ripley's Believe it or Not!" and featured tidbits about *The Wizard of Oz* to whet public interest for the forthcoming picture. • ABOVE, RIGHT: The *Film Daily Yearbook* for 1939 was published in late 1938, and featured a section promoting the forthcoming production of *The Wizard of Oz.*

POSTPRODUCTION

WITH PRINCIPAL photography completed, April to July 1939 news briefs about *The Wizard of Oz* focused on its postproduction—dubbing, background scoring, and the synchronization of an estimated two hundred thousand sound effects. "Ever since *The Wizard of Oz* finished shooting in March," wrote journalist Paul Harrison, "sounds have been in the process of creation at the Metro-Goldwyn-Mayer Studios, and the man who has to be the testing ground for them is producer Mervyn LeRoy." M-G-M's technicians conducted ingenious experiments to create the sounds heard in *The Wizard of Oz*. While the Scarecrow's rustling swishes and the Tin Man's clinks and clanks were elementary, other noises—from weird bird calls in the Haunted Forest to the strange speech of the Winkies and Munchkins—had no precedent.

The film's fantasy sound effects were likely to be accepted by audiences as otherworldly without question. But the cyclone's mighty roar required total authenticity to be believed. Its noise was stringently researched even before filming began: in the August 27, 1938, edition of *Boxoffice* magazine, it was reported that O. O. Ceccarini, a sound designer for the film and a mathematician whom Albert Einstein had pronounced a genius, was conducting mathematical experiments having to do with pressure, velocity, air density, and electrical characteristics in order to replicate the volume and pitch of cyclones.

Getting the sound—and other postproduction effects—just right further contributed to delays in the film's release date. Journalist Jimmie Fidler quipped, "*The Wizard of Oz* . . . has been in production so long that only Hollywood veterans remember the starting date." Like every other

> "ALL THE SCENES FOR *THE WIZARD OF OZ* HAVE BEEN 'IN THE CAN,' AS THEY SAY, FOR A COUPLE MONTHS. BUT THE SOUND EXPERTS ARE STILL WORKING FULL BLAST . . . THEY'RE BOOMING AND BUZZING, CLANKING AND SWISHING, HOWLING AND THUNDERING. THEY'RE MAKING NOISE THAT NOBODY EVER HEARD BEFORE . . ."
>
> —JOURNALIST PAUL HARRISON, MAY 8, 1939

Dozens of real rockets, for example, were set off and recorded to create the *swoosh* sound as the Wicked Witch flew on her broomstick. Then there was the unearthly whine of the jitterbug, an entomologic bit of cinematic license that paralleled the Wicked Witch's swarm of bee-slaves in the Baum book. In the film, the mosquito-like critter incited "The Jitterbug," a (deleted) song-and-dance precursor to the Winged Monkey attack. The jitterbug music was full of eerie effects, such as a man beating a xylophone contraption born of a small upright piano with retrofitted strings; the hum of the bug itself was the amplified zing of bullet slugs ricocheting off an ax blade.

studio, M-G-M closely guarded most of its technical secrets and only revealed enough to generate mystique. Fidler wanted the studio to reveal all of its secrets, including how the special effects team made Winged Monkeys fly and melted the Witch. "I think too much secrecy is a mistake," he opined, "for the average fan would enjoy the picture more if he realized the magic—and the headaches—involved in its making." (M-G-M was not forthcoming.) In the interim, a steady stream of publicity bits and "coming soon" teaser ads served to entice moviegoers prior to the picture's unveiling.

IT IS GENERALLY agreed that *The Wizard of Oz* was innovative for its time, particularly where its special effects are concerned. The fearsome cyclone was the result of much trial and error to create as realistic a screen illusion as possible. The most obvious solution would have been for M-G-M to repurpose amateur footage of a twister or film the real thing in progress themselves; but tornadoes in Los Angeles were a rarity, and it wouldn't be until 1951 that the first live tornado was filmed in America. On October 8, 1938, then-director Richard Thorpe, assistant director Al Shenberg, and unit production assistant Joe Cook were said to be searching Southern California for suitable Kansas-like settings. Also on that date, *The Hollywood Reporter* noted that the *Wizard of Oz* company would travel to Kansas to shoot the "dramatic scenes." There is evidence to suggest that M-G-M dispatched a camera crew to Kansas early on, primarily to scout locations that resembled an average Dust Bowl farm while anticipating the off chance that an authentic twister might materialize. (The trip was a "location expense" line item in M-G-M's budget for the film.) But Mervyn LeRoy reported that no real Kansas tornado cooperated, so Buddy Gillespie was charged with devising the next best thing—a process he had already been experimenting with since the previous August.

MOVIE-MAKING WIZARDRY

"IT SEEMED IMPRACTICAL TO SEND A CREW TO
A FARM IN KANSAS TO AWAIT A TORNADO.
AND MORE IMPORTANTLY, IT SEEMED ADVISABLE TO
BE ABLE TO *CONTROL* OUR TORNADO."

—A. ARNOLD "BUDDY" GILLESPIE, M-G-M SPECIAL EFFECTS DEPARTMENT CHIEF

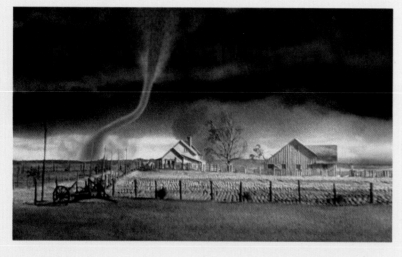

Gillespie was a man known for his technical expertise and problem-solving capabilities, but at first the Kansas cyclone had him stumped. On August 20, 1938, Gillespie photographed a water vortex in a tank—a clever thought at the time, though impractical. This was followed by unsuccessful simulations using a large rubber cone (which lacked fluidity) before he hit upon the idea of a cloth "tube," which was tested the following November 5. Additional tests were made in January 1939 before he successfully captured the proper effect on film between then and mid-February. Gillespie explained that the on-screen storm cloud was a thirty-five-foot elongated canvas sleeve shaped like the funnel of a real tornado (*not* a lady's silk stocking, as has been misreported, though the concept was similar). A mechanized crane that traveled the length of the stage was hung from the bottom of the roof trusses. The crane supported the canvas cone, which was then rotated by a D.C. motor on a speed control dial. The motor assembly was also arranged to tip at an angle. The base of the canvas cone was attached to another car on the stage floor that would travel a predetermined course. When compressed earth and dust, wind fans, and cotton clouds attached to shifting glass panes were added to the setup, the effect of a Kansas cyclone was complete. This footage could then

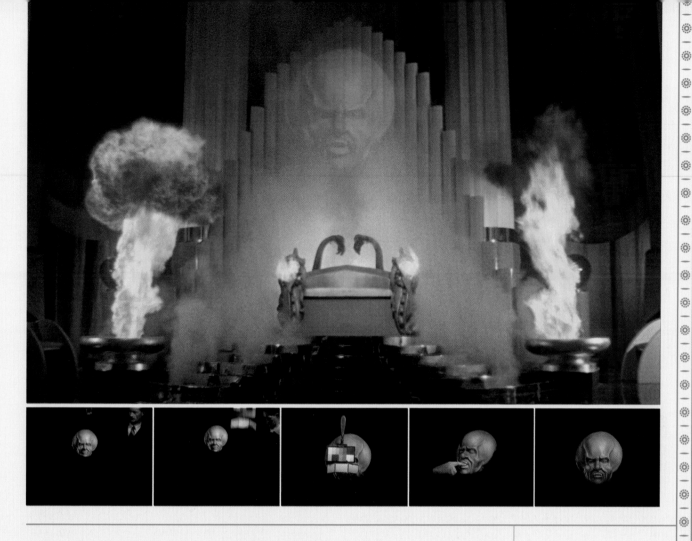

be projected onto a background screen while Judy Garland and the other actors fought against its "life-size" winds in the foreground for a single camera shot.

Gillespie recalled that the first attempt by M-G-M's cartoon department to make the Witch's squadron of monkeys soar resulted in failure—it was too jarring when intercut with live-action footage of the actors. Finally, both miniature rubber monkeys and stuntmen dressed as monkeys were suspended by thin wires from the soundstage and flew on cue. The Wicked Witch's gradual melting was a glorified version of the old magician's ploy of a hidden trapdoor in the floor supplemented with dry-ice vapors for a steam effect.

The phantom Wizard of Oz's head that looms menacingly above the Emerald City throne room was originally to be presented in two variations. In Paul Harrison's March 8, 1939, summary of his visit to the film set, he related that in long shots, an oversize artificial head hanging from wires was used, but "where it must be shown talking, close-ups will be made of an identical rubber mask worn by a man." The artificial head was found to be too static when intercut with footage of the talking head, so only shots of the actor were used (likely not Frank Morgan, though Morgan voiced the Wizard of Oz's booming dialogue). The result was grotesque enough for director Victor Fleming to be "a little worried that [the head] may be a bit too terrible, especially since it will be able to grimace and mouth its words."

And finally, for the record, the *two* white steeds, named Jake and William, who alternated posing as the chameleon-like Horse of a Different Color, were *not* painted with Jell-O, as is often cited. They were colored with the same vegetable-dye pigments found in Jell-O ingredients—which passed ASPCA approval. The task of humanely pigmenting the horses' hides fell to Jack Dawn, M-G-M's makeup department chief.

TOP: The Wizard of Oz initially appears as an enormous disembodied head towering over the throne. The billowing clouds of colored smoke for these scenes were devised by Anthony D. Paglia, formerly of New Castle, Pennsylvania. · ABOVE: A series of Technicolor tests of the monstrous Wizard of Oz (likely an anonymous actor and not Frank Morgan) were filmed against black velvet and shot in close-up, medium, and long shots to reproduce as double-exposure overlays on-screen.

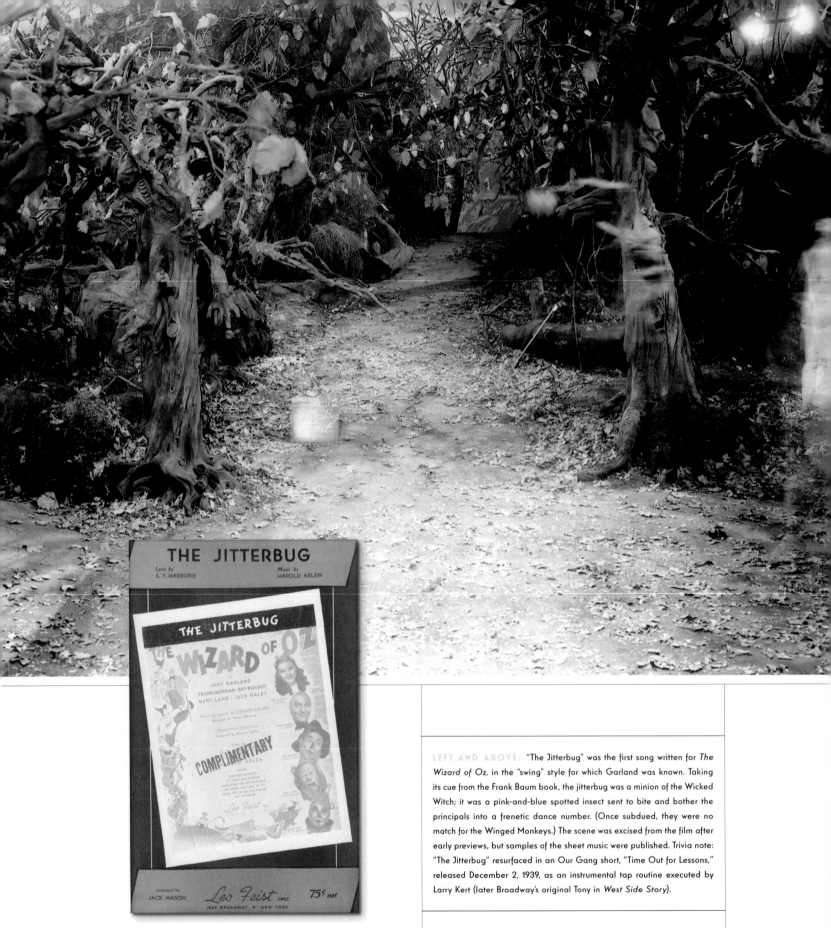

LEFT AND ABOVE: "The Jitterbug" was the first song written for *The Wizard of Oz*, in the "swing" style for which Garland was known. Taking its cue from the Frank Baum book, the jitterbug was a minion of the Wicked Witch; it was a pink-and-blue spotted insect sent to bite and bother the principals into a frenetic dance number. (Once subdued, they were no match for the Winged Monkeys.) The scene was excised from the film after early previews, but samples of the sheet music were published. Trivia note: "The Jitterbug" resurfaced in an Our Gang short, "Time Out for Lessons," released December 2, 1939, as an instrumental tap routine executed by Larry Kert (later Broadway's original Tony in *West Side Story*).

ABOVE: Also relegated to the cutting room floor after previews was an extended version of Ray Bolger's "If I Only had a Brain" number in which the Scarecrow collapses in a series of splits, as seen in this publicity photo. Production stills such as this were generated to the press and often carried with them an attached paper caption called a *snipe* (inset), which would describe the scene and provide studio credits. • BELOW: Two Technicolor outtakes from the excised Scarecrow sequence in which a wayward pumpkin collides into the weightless straw man, propelling him airborne. (The large pumpkin can be seen on the Yellow Brick Road in the background of one shot.) Here, Ray Bolger's aerial-suspension wires are adjusted. The routine was deleted for adding unnecessary length to the picture as well as inserting too much fantasy too early on in the proceedings.

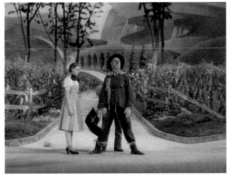

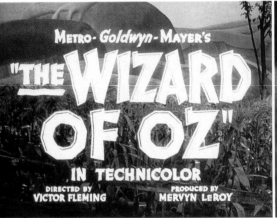 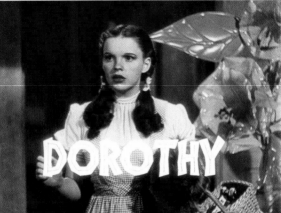

RIVATE SCREENINGS AND select previews for *The Wizard of Oz* had taken place since June 1939, after which tweaks and edits were made to trim its running time and tighten its narrative prior to its public reception at large. It was a procedure crucial to the editing process of any A-list picture but especially for *The Wizard of Oz*, as one reporter noted: "M-G-M is staking a lot on the public's reception of Mervyn LeRoy's *The Wizard of Oz*."

During one of these editing sessions, an elderly man shuffled into the projection room on the M-G-M lot. He was about to leave with an apology when LeRoy invited him to sit down and see the picture. "Thanks," the man said. "I'm one of the janitors and I don't work for two hours." Every night thereafter, the man stopped by the room to monitor LeRoy's progress. Intrigued by his interest, LeRoy asked the man how he happened to come to work early enough to view *The Wizard of Oz* every night. The man admitted that he had planned his day that way, motivated by old-fashioned sentiment. "You see," he

explained to LeRoy, "I almost played the Wizard of Oz thirty-seven years ago." The man's name was Bert Outay, and he revealed that he once knew L. Frank Baum and was the understudy for John Slavin, who played the Wizard of Oz in the 1902 musical production of the book featuring David Montgomery and Fred Stone—only he never got the chance to play the role.

The *Good News of 1939* radio program previewed *The Wizard of Oz* on June 29, with most of the main cast participating, sans Jack Haley, whose proxy on the show was M-G-M leading man Robert Young. Billie Burke, also not present, was inadvertently listed among the stars appearing. Judy Garland introduced "Over the Rainbow," and her costars each sang their respective character's

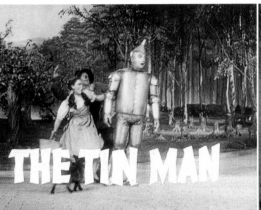

song and bantered about the new picture. While it is believed that this broadcast marked the public debut of the songs from *The Wizard of Oz*, an intriguing historical discrepancy was recently uncovered. A *Tune-Up Time* radio spot Garland made the previous April 6 for CBS in New York was heralded on that date by its Charleston, West Virginia, affiliate as follows: "Dorothy, the little Kansas girl whisked away to the wondrous Land of Oz in *The Wizard of Oz*, comes to life again over WCHS . . . through the lilting voice of Judy Garland. The youthful screen star sings selections from M-G-M's forthcoming Technicolor version of the children's classic as a feature of *Tune-Up Time*." (As recordings of two non–*Wizard of Oz* songs Judy sang on the program are extant, it is unclear whether her performance of numbers from *The Wizard of Oz* was a case of misreporting or a programming change.)

By the end of July, M-G-M's film-processing laboratory had worked overtime to produce 550 prints of *The Wizard of Oz*. Following the protocol of the time, when the film was entered for copyright with the Library of Congress, on August 7, 1939, it was registered with a cache of production stills (rather than with a print of the film); these stills remain in the library's collections to this day.

The theatrical trailer for *The Wizard of Oz* was presented in travelogue format. It began, "Many, many miles east of nowhere lies the amazing Land of Oz . . ." and continued, "Metro-Goldwyn-Mayer, joining the world in the celebration of the Golden Jubilee of Motion Pictures, climaxes a half century of entertainment progress by presenting its miracle in celluloid, the Technicolor extravaganza, *The Wizard of Oz*."

The Wizard of Oz, at last, was here.

PAGES 126–127: One of the earliest pieces of prerelease publicity for *The Wizard of Oz* was this syndicated article by Clarke Wales, illustrated with colorized production stills and a candid of Fleming, LeRoy, and choreographer Bobby Connolly in conference.

OZ

Hollywood Discovers a Very Wonderful Land

By Clarke Wales

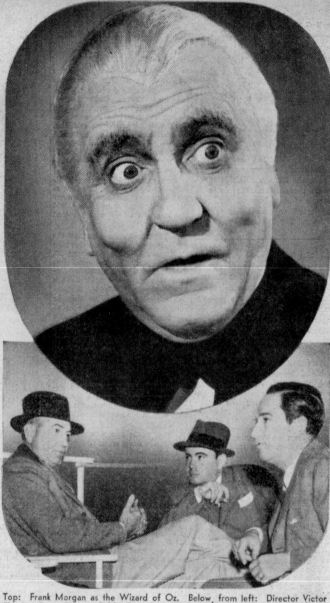

Top: Frank Morgan as the Wizard of Oz. Below, from left: Director Victor Fleming, Dance Director Bobby Connelly and Mervyn LeRoy, producer of the film.

IT TOOK Hollywood 39 years to discover "The Wizard of Oz" and for a time it looked as though it were going to take 39 more to make a picture of the story which L. Frank Baum created in 1900.

For months whole departments at Metro-Goldwyn-Mayer were lost in a mist of mild insanity, while artists sought to create settings and makeups and costumes that would be suitable for a story which Metro says has been read by 80 millions; while songwriters turned out musical rhymes which would be just as suitable and while Mervyn LeRoy, the producer, combed midgets out of his hair.

At long last, however, there is a picture called "The Wizard of Oz" and because it brings to the screen the best loved and most famous book of its kind, it is in its way as important an event as was "Snow White and the Seven Dwarfs" — the success of which must have had a lot to do with "The Wizard" finally coming to the screen.

It is not remarkable that Hollywood took so long to find out about "The Wizard of Oz." Everybody else knew about it and it was a naturally suitable vehicle for a movie. But Hollywood is leary of such obvious things. Besides, L. Frank Baum lived in Hollywood from 1911 until his death in 1919, and his widow still lives here. Doing honor to a local prophet is a very rare event indeed in Hollywood.

Also "The Wizard of Oz" had been a highly successful stage production. Dave Montgomery and Fred Stone started playing it in Chicago in 1902, took it to New York in 1904 and had a four-year run on Broadway. Then they played on the road for a year, and second companies toured for seven more years with the show.

Even with all this precedent, making "The Wizard of Oz" into a picture was still one of the toughest jobs Hollywood ever tackled. LeRoy, who says he has wanted to make the picture for 20 years, started working on it last summer. He had Victor Fleming ("Captains Courageous" and "Test Pilot") for director; Adrian to design 3,000 costumes; Jack Dawn to create 2,000 makeups; Cedric Gibbons to design 68 sets. And for cast he had Judy Garland as Dorothy, Jack Haley as the Tin Woodman. Frank Mor-

gan as the Wizard, Ray Bolger as the Scarecrow, Bert Lahr as the Cowardly Lion, Billie Burke as Glinda the Good and Margaret Hamilton as the Wicked Witch. Then he had to make a picture.

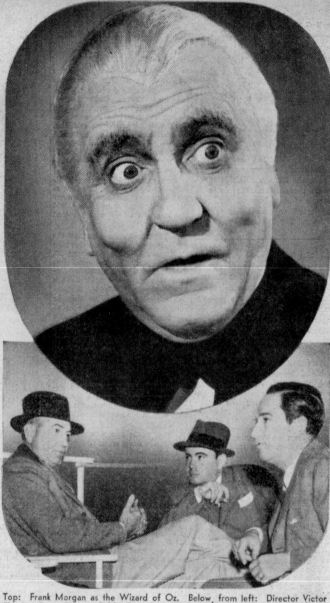

Bolger and Judy in the apple tree episode.

LEROY explains it: "We had to make something both real and unreal, and we had to do it with a story so familiar that we didn't dare meddle with it. The characters and events had to be as Baum conceived them.

"So what change there is in the story is psychological. To begin with, Dorothy doesn't just drop into a fairyland. She goes to a land everybody knows, the subconscious or dream world. When, in the midst of a cyclone, a flying window hits her on the head, she is automatically transferred to an existence she had been day-dreaming about.

"In the picture the transition from the real world is done by use of color. The picture opens on a Kansas farm, photographed in black and white. When Dorothy reaches Oz, the picture goes into Technicolor.

"In Oz the characters she meets are adaptations of the characters she knows in Kansas; hired men on the farm — Haley, who putters with mechanical things and harps about having a heart; Bolger, a dull chap as a farmer who imagines himself brainy; Lahr, who is afraid of baby pigs but who talks of courage; Morgan, a medicine show faker; Margaret Hamilton, the mean schoolteacher whom Judy calls an old witch.

"Haley becomes the Tin Woodman, Bolger the Scarecrow, Lahr the Cowardly Lion, Morgan the Wizard and Miss Hamilton the Wicked Witch.

"To give the picture some substance for thought, we accented the underlying philosophy. The trouble with fantasy is that it often doesn't get anywhere. This picture has a theme: The characters start out wanting something; at the end they find that they had what they wanted all along, only didn't realize

it. When Dorothy gets home from she says: 'This is the place I was lo ing for all the time, and I never kn it.' The Scarecrow discovers that really has brains, the Woodman th he really has a big heart, the Lion th he really is courageous."

JACK DAWN w given the job of creating makeups wh would be fantastic and still leave players recognizable. At first it w considered necessary for Judy Garla to wear a blond wig. But with a blo wig she was no longer Judy Garla and the idea was dropped. Judy wea the only realistic costume in the p ture, and it is the only costume she h The Metro wardrobe department ma 10 copies of the dress, and Judy wo out all 10 in making the picture.

Bolger's Scarecrow costume ca from the familiar illustrations in book and from Fred Stone's stage co tume. It is filled with straw. Bolge face was covered with a thin burl makeup so applied that his featur show through it. Putting it on w a two-hour job every morning.

Haley wears a metal suit which w so cumbersome that he could not down and if he fell down he could get up. Yet he had to sing and dan in it. His face was covered with metallic makeup which could be bu nished like a freshly polished shoe, wi a cloth. Lahr's costume and make consisted mostly of lion skins — 50 poun of them. The Witch wears a black co tume and green makeup and Bil Burke appears in typical fairy que costume.

For the Munchkins, characters sembling those Little Men who are puted to come out of liquor bottles perch on the foot of the bed in t morning, LeRoy wanted 120 midge He got them. Leo Singer, whose midg shows have long been famous, suppli the troupe, and for weeks it was ve difficult to walk around the Metro l without feeling a strong urge to ca for aspirin. The studio built a midg commissary, with suitable tables a chairs, and hired six men to lift th midgets onto and off high places

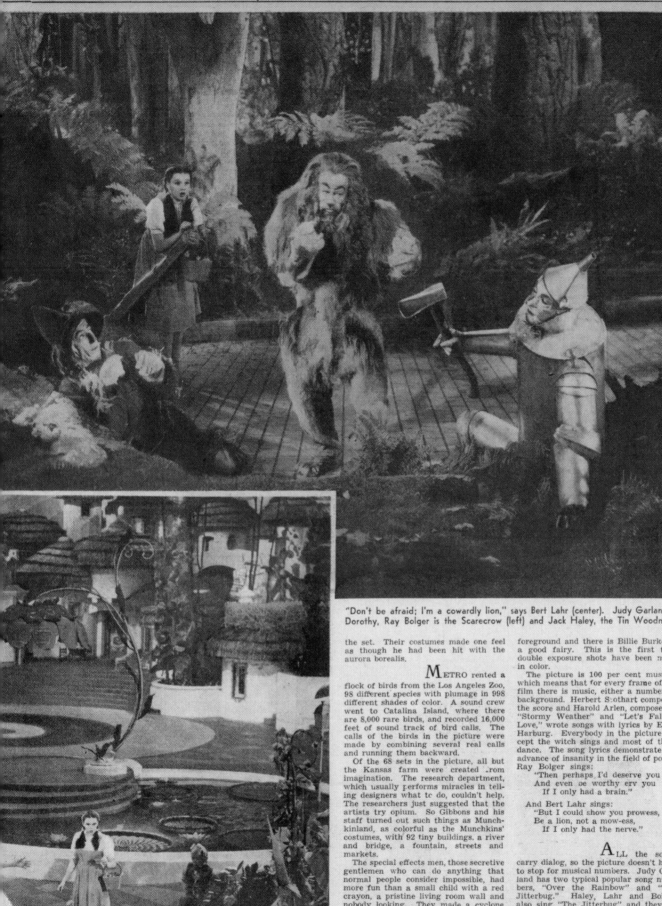

"Don't be afraid; I'm a cowardly lion," says Bert Lahr (center). Judy Garland is Dorothy, Ray Bolger is the Scarecrow (left) and Jack Haley, the Tin Woodman.

Glinda the Good (Billie Burke) and Dorothy are greeted by the tiny Munchkins.

the set. Their costumes made one feel as though he had been hit with the aurora borealis.

Metro rented a flock of birds from the Los Angeles Zoo, 98 different species with plumage in 998 different shades of color. A sound crew went to Catalina Island, where there are 8,000 rare birds, and recorded 16,000 feet of sound track of bird calls. The calls of the birds in the picture were made by combining several real calls and running them backward.

Of the 68 sets in the picture, all but the Kansas farm were created from imagination. The research department, which usually performs miracles in telling designers what to do, couldn't help. The researchers just suggested that the artists try opium. So Gibbons and his staff turned out such things as Munchkinland, as colorful as the Munchkins' costumes, with 92 tiny buildings, a river and bridge, a fountain, streets and markets.

The special effects men, those secretive gentlemen who can do anything that normal people consider impossible, had more fun than a small child with a red crayon, a pristine living room wall and nobody looking. They made a cyclone and did a scene in which a house blows away and Judy Garland sits in one room and looks out from the inside of the vortex. The schoolteacher rides by on a bicycle and suddenly turns to a witch on a broomstick. Later she melts in front of the camera after the girl throws water on her.

In Munchkinland a huge bubble bounces down a hill, growing larger and changing color until it bursts in the foreground and there is Billie Burke as a good fairy. This is the first time double exposure shots have been made in color.

The picture is 100 per cent musical, which means that for every frame of the film there is music, either a number or background. Herbert Stothart composed the score and Harold Arlen, composer of "Stormy Weather" and "Let's Fall in Love," wrote songs with lyrics by E. Y. Harburg. Everybody in the picture except the witch sings and most of them dance. The song lyrics demonstrate the advance of insanity in the field of poesy. Ray Bolger sings:

"Then perhaps I'd deserve you
And even be worthy erv you
 If I only had a brain."

And Bert Lahr sings:
"But I could show you prowess,
Be a lion, not a mow-ess,
 If I only had the nerve."

All the songs carry dialog, so the picture doesn't have to stop for musical numbers. Judy Garland has two typical popular song numbers, "Over the Rainbow" and "The Jitterbug." Haley, Lahr and Bolger also sing "The Jitterbug" and they all dance.

Preparations on "The Wizard of Oz" started in July, 1938. Tests for players started in September. The cameras were grinding from December through March. The sound, musical and special effects folks have been working ever since. The picture is due to be ready for public showing in September, which will be about the time that Mervyn LeRoy will once more be able to walk past a psychopathic hospital without feeling that he ought to hide.

Because he just found another Munchkin under his desk.

SETTING THE DATE

THE JULY 8, 1939, edition of *Daily Variety* announced that *The Wizard of Oz* would have its official premiere at the Carthay Circle Theatre in Hollywood on August 16, 1939. The Carthay had the reputation of being the launching site of important pictures intended for limited-engagement theatrical road shows;

The Tin Man (JACK HALEY) holds the mooring rope as the Wizard (FRANK MORGAN) and Heroine Dorothy (JUDY GARLAND) take off for a "balloon ascension" during the production of "THE WIZARD OF OZ," screening at Carthay Circle.

The Wizard of Oz was at first scheduled to have its premiere at the Carthay Circle Theatre on August 9 but the date was pushed back a day and then canceled; the date and venue were both rescheduled.

that is, select screenings with reserved seats at premium prices. At 75 cents per ticket (three times the national average), the projected several-month run of *The Wizard of Oz* at the Carthay would uphold an aura of prestige for the succeeding road show premiere of the highly anticipated *Gone with the Wind*. By early August, a scheduling adjustment changed the expected August 16 premiere date to August 10. Meanwhile, M-G-M determined how to best showcase *The Wizard of Oz*: Would the road show angle be lucrative? Should it be single-billed or double-billed with another picture? In an attempt to make the film more accessible to a wider audience, in terms of both show times and prices, the premiere venue switched from the Carthay to

> "GAIETY! GLORY! GLAMOUR!"
> —M-G-M'S PUBLICITY CATCHPHRASE TO HYPE THE FILM

Grauman's Chinese Theatre, necessitating an early termination of *Stanley and Livingstone*. *The Wizard of Oz* would have its Hollywood premiere Tuesday evening, August 15.

Such premiere musical-chairs was not unheard of; *The Women*, which followed *The Wizard of Oz* on Metro's release schedule, endured similar logistical snafus. The scheduling roulette accounted for the film's debut in scattered regional play dates (largely shore resorts) ahead of the Grauman's screening but post–August 10—the originally intended premiere date. These included Cape Cod, Massachusetts, and Kenosha and Appleton, Wisconsin, on August 11; Oconomowoc, Wisconsin, on August 12; and Portsmouth, New Hampshire, and Racine and Sheboygan, Wisconsin, on August 13.

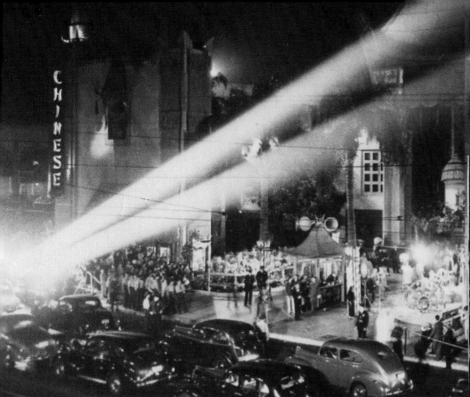

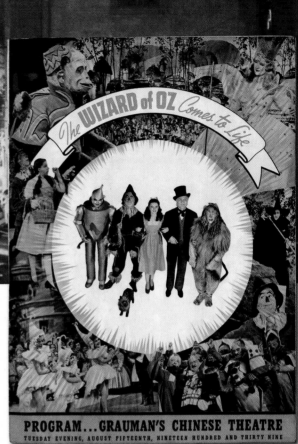

THE WEST COAST PREMIERE:
GRAUMAN'S CHINESE THEATRE

THE WIZARD OF OZ premiere at Grauman's was *the* event to cap the summer in Hollywood, and no expense was spared in mounting it. The Grauman's court-yard was adorned with decor direct from the film's sets: a section of the Yellow Brick Road; a fenced cornfield and a scarecrow dressed in Ray Bolger's duds; green glass Emerald City spires; the large overhanging flower canopy from the Munchkinland pavilion; a Tin Man robot (better suited to the New York World's Fair); and flat cutouts of the Munchkin huts. Several Munchkin players, made up and costumed for their parts, were on hand to lend atmosphere and to mingle with the guests. Bleach-ers were erected—a Grauman's first—for 3,500 star seek-ers and autograph hounds. Inside, Grauman's seated about 2,000 (anticipating a hit, Mervyn LeRoy reserved seats for a party of sixty), and, with the $2.20 tickets in hot demand, the *Evening News* ran a promotional "Cin-derella Girl" contest to give away an evening of luxury for some lucky winner that climaxed in the VIP treatment at the premiere.

TOP: The forecourt of Grauman's Chinese Theatre for the *Wizard of Oz* premiere. • TOP, RIGHT: Cover of the souvenir program. • ABOVE, LEFT: Guests of honor are, from left to right, actress Paula Stone; Maud Baum, widow of L. Frank Baum; Ray Bolger; and Fred Stone, scarecrow in the 1902 musical-comedy. • ABOVE, RIGHT: Actor Harold Lloyd and his son greet a Munchkin.

HOLLYWOOD PREMIERE of *"Wizard of Oz"*

Screen celebrities galore flocked to the opening at the Chinese Theatre

IT WAS a festive evening as Hollywood got its first glimpse of Mervyn Le Roy's "Wizard of Oz." The "Merry Munchkins" gathered in the lobby to greet arriving guests, and assist with the broadcast of the proceedings. In clockwise fashion are Wallace Beery and his daughter, Carol Ann, at the lobby microphone; weird-looking Orson Welles and his wife; Bert Lahr, who plays the "Cowardly Lion" in the picture, with Margaret Schroeder to whom he's reported engaged; Edgar Bergen doing a Charlie McCarthy on the lap of the Robot in the lobby, with Mervyn Le Roy supplying the voice of the Robot; Doug Fairbanks, Jr., and his wife were among those who attended; Eleanor Powell tries to get the Robot to dance with her; and in the center, the "Mayor of Munchkinland" reads a proclamation of welcome to Virginia Weidler as she enters the lobby. Among others seen at the premiere were Eddie Cantor and his daughter, Janet; Virginia Bruce and her hubby, Director J. Walter Ruben; Allan Jones and his wife, Irene Hervey; Harold Lloyd and his family; and Ann Rutherford.

Photos by Gene Lester

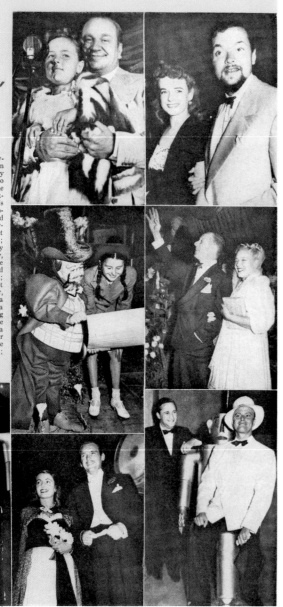

The Wizard of Oz premiere was covered in fan magazines, which pictured attending Hollywood stars such as Orson Welles, Wallace Beery, Bert Lahr, Eleanor Powell, and Mervyn LeRoy, with ventriloquist Edgar Bergen. After the opening, members of the cast and crew (including Fleming and LeRoy) reconvened at the Trocadero nightclub to belatedly celebrate Bert Lahr's August 13 birthday.

Such was the growing fan frenzy that the press reported that Joan Crawford would *not* be in attendance, as was originally announced, and Lana Turner had taken ill. Plenty of Hollywood's finest did turn out, though, and Maud Baum, widow of author L. Frank Baum, was a guest of honor. According to her granddaughter, Ozma Baum Mantele, Maud appeared "engulfed" in the excitement, taking questions from Frank Whitbeck, the master of ceremonies, for a live radio broadcast at the premiere dais located outside the theatre. In a nostalgic nod to old-timers, Fred Stone, the actor who portrayed the Scarecrow in the original 1902 stage show, made an appearance that night, as did Goodee Montgomery, niece of the show's deceased Tin Woodman, David Montgomery. Among the M-G-M cast present were Frank Morgan, Charley Grapewin, Bert Lahr, Margaret Hamilton, Billie Burke, and Ray Bolger. Because she was in New York at the time, Judy Garland missed the festivities and only saw *The Wizard of Oz* for the first time in its entirety in an M-G-M projection room a year later.

Immediately following the revelry, Maud Baum expressed her enthusiasm in a letter to D. L. Chambers, president of Bobbs-Merrill and publisher of *The Wizard of Oz*: "The *Wizard* premiere was the most elaborate and largest Hollywood has ever seen. They had to call out the mounted police to handle the crowds. The court of the Chinese Theatre was fixed to look like the Oz country. I spoke over the [dais] mic—had my picture taken dozens of times, etc. The picture is beautiful—and I have never seen such reviews."

The premiere was indeed a smashing success, with glowing reviews the following day granting praise as equally for the picture as for the star-studded event. The Los Angeles critics were unanimous in their admiration for *The Wizard of Oz*. Philip K. Scheurer said, "I can think of no other film with human actors with which to compare the 'reality' of its make-believe." Edwin Schallert called it "a new experience and a new thrill." And Harrison Carroll attested to the film's timelessness: "You can see it again and again and never tire of its marvels." Riding the current of its West Coast accolades, the film was set to break—just two days later—in New York City.

THE EAST COAST PREMIERE:
NEW YORK'S CAPITOL THEATRE

IN JULY 1939, it was anticipated that *The Wizard of Oz* would open at New York's Astor Theatre "shortly after Labor Day," with a national release "two or three weeks later." But a month on, both the New York premiere date and venue had been adjusted, to August 17 at the Capitol Theatre. It was a momentous occasion for Syracuse, New York's, celebrated native sons, L. Frank Baum and Harold Arlen, as *The Wizard of Oz* debuted at the local Loew's theatre on the same date.

The East Coast premiere of *The Wizard of Oz* at New York's Capitol Theatre was eventful enough to be fictionally dramatized two years later in the novelty book *Mickey Rooney and Judy Garland: The Story of Their Rise to Fame and Fortune in the Movies*, which also included an inaccurate account of how Garland got her role as Dorothy. The book's fabricated retelling has the precocious teens storming the offices of M-G-M vice president Louis B. Mayer to spontaneously suggest that the studio send them on a personal appearance tour culminating with a send-off in New York—all motivated by their collective itch to return to their vaudeville roots on the stage. After some deliberation, Mayer picks up the phone and says, "Judy Garland and Mickey Rooney are opening at the Capitol Theatre in New York with *The Wizard of Oz*. Yes . . . yes . . . I want the stage reopened. Make the arrangements with Loew's."

In actuality, Garland and Rooney's engagement at the Capitol was a carefully orchestrated cross-country junket with publicity stops along the way, by which the young stars' appearances not only heightened the excitement

The Gotham premiere of *The Wizard of Oz* was covered in the regional publications *Info About New York* and *Cue*.

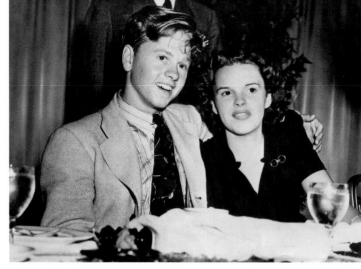

ABOVE: Mickey Rooney and Judy Garland arrive in New York's Grand Central Station, August 14, 1939. There, the two were mobbed by more than ten thousand fans. The duo's appearance gave rise to nationwide Mickey-Judy fan clubs. • RIGHT: A press luncheon at the Waldorf Astoria, where the pair was lodged. • OPPOSITE, ABOVE: After August 31, 1939, Mickey left New York, but Garland was reunited at the Capitol with her costars Ray Bolger and Bert Lahr. The actors joined Garland onstage for a song-and-comedy act, which featured the film's deleted "Jitterbug" number. Garland traded ribs with Lahr: when he turned out the lights and grabbed her microphone during a serious song, she retaliated during his routine by showering him with a bushel of wood chips, crowning him with the basket, and squirting him with seltzer. • OPPOSITE, BELOW: *New York Herald Tribune* cartoonist William O'Brian caricatured *The Wizard of Oz* cast for the picture's Capitol opening.

for *The Wizard of Oz*'s opening but also created buzz for their upcoming feature, *Babes in Arms*. The duo was slated to present a live show consisting of musical numbers and comedy sketches that preceded each screening of *The Wizard of Oz*.

Just prior to the New York premiere, Ben Serkowich, press agent of the Capitol's publicity department, issued an announcement:

"Fun history for New York will probably date from Thursday, August 17, when Metro-Goldwyn-Mayer brings *The Wizard of Oz* to the Capitol Theatre. Although this event in itself is expected to be enough to make it a red-letter day on anyone's calendar, the Capitol will also present Mickey Rooney and Judy Garland, in person, on the stage, between performances of the film. Judy is the little Kansas girl blown by a cyclone to the Land of Oz. Mickey is not in *The Wizard of Oz* but he does come along on the screen a few months hence with Judy in *Babes in Arms*." Garland and Rooney's New York sojourn exceeded all expectations, and on opening day it was estimated that anywhere from ten thousand to fifteen thousand moviegoers stood in line to see *The Wizard of Oz*—and to take in the live entertainment by the young Hollywood stars.

Loew's saw to it that its East Coast licensing merchants got premiere invites as well. At the Capitol, first-week grosses were $70,000, or 167 percent over the normal take, while in twenty-five of the subsequent first key-city openings, *The Wizard of Oz* brought in an average of 58 percent more ticket sales.

After the August 30 evening show, Rooney returned to the West Coast, and the following day, performances continued with Garland and cast mates Ray Bolger and Bert Lahr. Lahr arrived in New York agitated: the Super Chief streamliner, otherwise known as the "Train of the Stars," had misplaced the comedian's luggage.

The film's great triumph may have served to console one regret: its prolonged shooting schedule, coupled with plans for the personal appearance tour, caused Judy Garland to cancel the European vacation

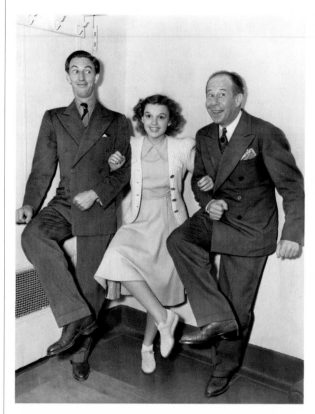

Some Favorite Impersonations in "The Wizard of Oz"

Ray Bolger swings a right where it hurts while Judy Garland and Jack Haley (the Tin Woodman) look on in the film which opened last week at the Capitol

she and her mother had been planning since the previous February; by summer 1939, the imminent declaration of war made the overseas excursion ill-advised. In early September Garland returned to Hollywood with a limp, having performed the last two shows at the Capitol with a sprained ankle.

PUBLICITY AND THE REVIEWS

AS THE PUBLICITY machine geared up to promote *The Wizard of Oz*, M-G-M proclaimed: "Greatest magic film ever to be made! Screen's most spectacular musical! Thousands of living actors in a sensation unmatched since the wonders of famed *Snow White*!" Plans for publicizing *The Wizard of Oz* began in early April 1939 with a target date of July 1 to begin breaking coverage nationally, though some photos slipped out as early as the previous February. News-

paper and fan magazine coverage ranged from colorful advertisements to Kodachrome layouts to Sunday paper rotogravures, all of which served to fuel intrigue for the highly anticipated motion picture.

Some theatres added the line "Not a Cartoon" to their newspaper ads for *The Wizard of Oz*, to make it clear that the film was, in fact, live action. Reviewers followed suit, with one journalist writing, "Don't go to see *The Wizard of Oz* thinking you are going to be treated to a Walt Disney color cartoon." Despite these clarifications, the overall look and style of the film had an otherworldly aura, so much so that Sterling Sorensen, the stage-and-screen editor for the Madison,

Wisconsin, *Capital Times*, wrote, "The strangest thing about *The Wizard of Oz* . . . is that it resembles a color cartoon by Walt Disney. It seems at times to have been drawn, rather than enacted on solid stages with living people . . . Judy Garland as the little girl is sweet and as pretty as Snow White."

As *The Wizard of Oz* began playing in theatres across the country from late August into September 1939, the reviews poured in. Most were sensational accolades for the sets, trick photography, songs, and cast. On Sep-

> "I SAW [*THE WIZARD OF OZ*] YESTERDAY, AND, PUTTING ASIDE MY INTEREST AS AN EMPLOYEE, HAVE NO HESITANCY IN SAYING THAT I THINK IT IS THE FINEST MOTION PICTURE ENTERTAINMENT I HAVE EVER SEEN IN MY TWENTY-FIVE YEARS OF ASSOCIATION WITH THE INDUSTRY . . . IT IS REALLY THE KIND OF THING PEOPLE WILL WANT TO SEE AGAIN AND AGAIN."
>
> —CAPITOL THEATRE PRESS AGENT BEN SERKOWICH, IN AN AUGUST 4, 1939, LETTER TO NEW YORK FILM CRITICS

His role of Tin Woodman in *Wizard of Oz* finished, Jack Haley vacationed in N.Y. at World's Fair, & showed Jackie, Jr., the World of Tomorrow at General Motors Exhib.

tember 1, movie editor David B. Kaufman declared *The Wizard of Oz* "one of the ten best pictures of 1939, if not the best thus far produced this year." When Kaufman asked Garland if the film was any good in her opinion, she chimed in, "I'll say it's good, the best picture I've ever been in." Highest critic marks singled out both Garland's and Bert Lahr's performances. Of the former, Louella O. Parsons wrote, "Judy Garland is a surprisingly well-liked young lady. Her *Wizard of Oz* turned the trick and puts her in line for the Academy Award®"; while the journalist Dorothy Kingsley advocated, "Bert Lahr as the Cowardly Lion in *The Wizard of Oz* should

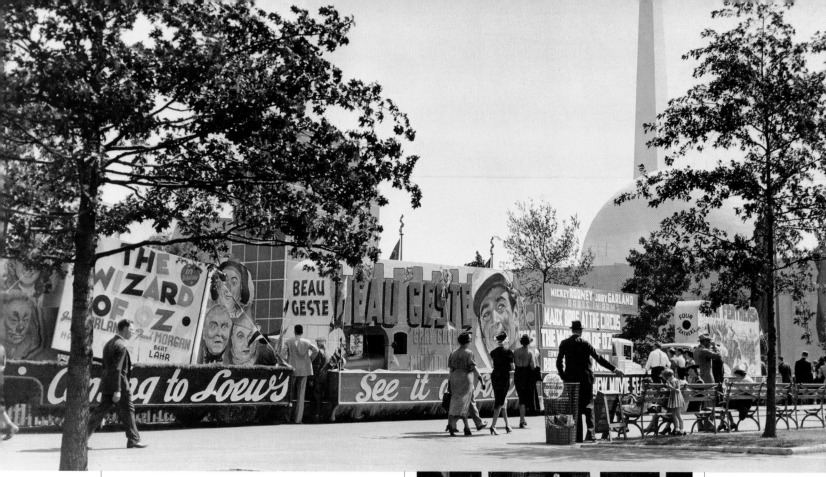

get some kind of a special Academy Award.®" The Associated Press listed Lahr's farcical turn among the "Ten Best 'Scene-Stealers' in 1939 Movies" alongside Hattie McDaniel's *Gone with the Wind* Mammy and "The Bells" of *The Hunchback of Notre Dame*.

A good number of seasoned critics recalled the turn-of-the-century stage musical in their reviews. Famed Broadway columnist Walter Winchell summed up *The Wizard of Oz* as "[the] old Montgomery and Stone forget-me-not, brightened up with color and nifties and looking very audience-catching." Some of the more charming reviews came verbatim from children. One little Zanesville, Ohio, boy became exasperated with Judy Garland after seeing the film a second time: "[T]hat girl said she'd never run away from home again, but darned if she didn't do it!" Even *Pathfinder* magazine declared: "Children

TOP: *The Wizard of Oz* is among the parade of the season's new pictures advertised on a walkway en route to the 1939 World's Fair (the famed Trylon and Perisphere are visible in the distance). *The Wizard of Oz* alumni who attended the Fair were Jack Haley, seen with son Jack, Jr. (opposite), and Frank Morgan. ABOVE: On a rare break from performing at the Capitol Theatre, Mickey and Judy share a photo op with Mayor Fiorello LaGuardia at the Fair.

especially will love this film, and grown-ups will find it an eye-filling escape from politics and war scares."

Among movie house owners, operators, and managers, *The Wizard of Oz* ranked tops in record-breaking box office. One enthusiastic rave affirmed, "A perfect picture in every way and one of the world's masterpieces in picture making and one of the leading pictures of the year . . . good for a return date any old time." Further business feedback in the theatre industry reported that publicity tie-ups for the film included gimmicks, stunts, and contests, all of which were boosted by a touring van sent by M-G-M to pivotal cities across the country, featuring the miniature black Shetland ponies—conveniently named

Award winner by the National Screen Council for September 1939. *Photoplay* magazine included the film on its list of "Outstanding Pictures of 1939" Gold Medal Award nominees. *The Wizard of Oz* was also appointed another distinction by the university humor publication *Harvard Lampoon*, in its spoof recap of movie "worsts" for 1939: "most colossal flop of the year"—a claim refuted by Hollywood columnist Jimmie Fidler, who countered by accurately citing the film's above-average box office. The truth was somewhere in between: *The Wizard of Oz* was a box-office success, but, on paper, it failed to break even due to its exorbitant production fees.

Today, *The Wizard of Oz* has been universally embraced

SINCE ITS 1939 DEBUT, IT IS ESTIMATED THAT THE FILM HAS BEEN ENJOYED BY MORE THAN A BILLION PEOPLE WORLDWIDE.

"Wizard" and "Oz"—that steered the picture's Munchkin-land coach. Accompanied by animal trainer Captain Volney Phifer, owner of M-G-M's Leo the Lion, the ponies could reportedly walk a wire, sleep in bed, and count by pawing with their hooves. The tour began in New York on August 25, 1939, with the Capitol Theatre opening, and continued through early October. Child-size versions of the movie costumes were outfitted for those lucky children chosen to don them for the local press. Well acquainted in the ways of showmanship, L. Frank Baum would have beamed.

By year's close, *Parents' Magazine* named Mervyn LeRoy winner of their annual award for best picture produced for family audiences. *The Wizard of Oz* made 1939's top ten lists for *Film Daily* and *Showmen's Trade Review*—for which it placed among the top twenty-five money-makers of 1939—and was voted a *Boxoffice* magazine Blue Ribbon

as one of the greatest and most enduring films of all time. Since its 1939 debut, it is estimated that the film has been enjoyed by more than a billion people worldwide. In 1978, *The Wizard of Oz* was named one of the ten best American films ever made by the thirty-five thousand members of the American Film Institute. On the occasion of its fiftieth anniversary in 1989, *The Wizard of Oz* was recognized as one of the twenty-five most important American films by the Library of Congress. In 1998, it ranked sixth out of the one hundred best American films in an American Film Institute poll. Most recently, in a 2011 ABC-News and *People* magazine survey that tabulated five hundred thousand Internet votes, *The Wizard of Oz* was rated No. 2 for the category Best Film of All Time. It was also ranked No. 3 in another category, for Best Movie Musical of All Time.

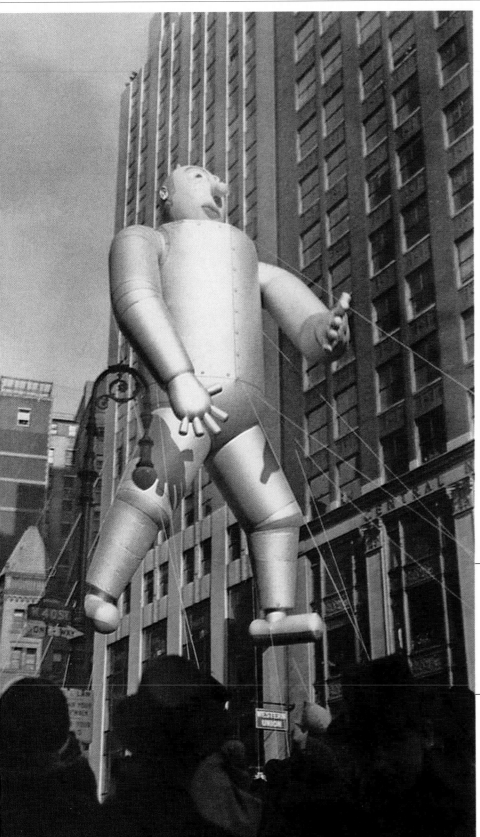

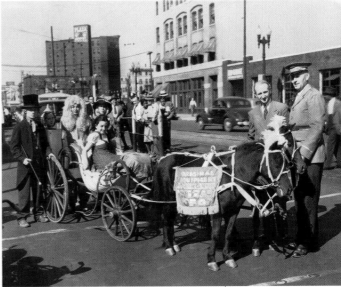

OPPOSITE: The elaborate marquee for Columbia, South Carolina's, Palmetto Theatre in 1939. · **LEFT:** New for the 1939 Macy's Thanksgiving Day Parade was a balloon of the Tin Man from *The Wizard of Oz*, who towered seventy feet in the air. · **ABOVE:** *The Wizard of Oz* motor van toured select cities, accompanied by animal trainer Volney Phifer (wearing the cap).

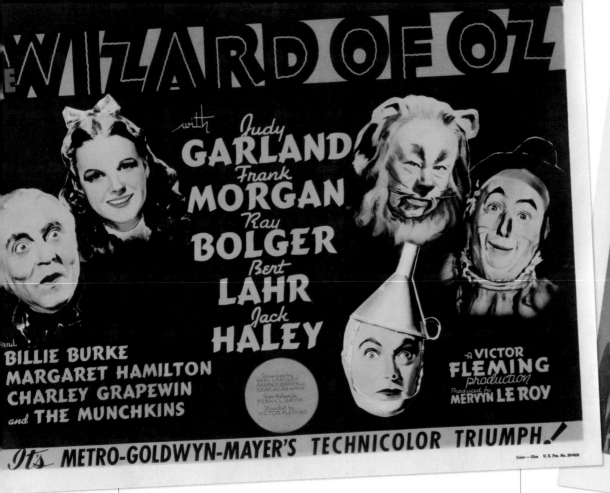

"THE WIZARD OF OZ" with Judy Garland, Frank Morgan

So-called "Color Glos" photographs were standard black-and-white production stills hand tinted (with varying degrees of accuracy) and distributed as poor-man's lobby cards by the newly established National Screen Service. Note the inaccuracy of the Scarecrow's red ensemble (below, right and opposite, top), the nondescript hue of Dorothy's Ruby Slippers (below, right), and the Tin Man's golden sheen (above, right and opposite, below). The scene of the parade through the Emerald City after the Wicked Witch of the West has been defeated (which was trimmed from the final film) shows Judy Garland appropriately attired for the celebration, in lime green (above, right).

"THE WIZARD OF OZ" with Judy Garland

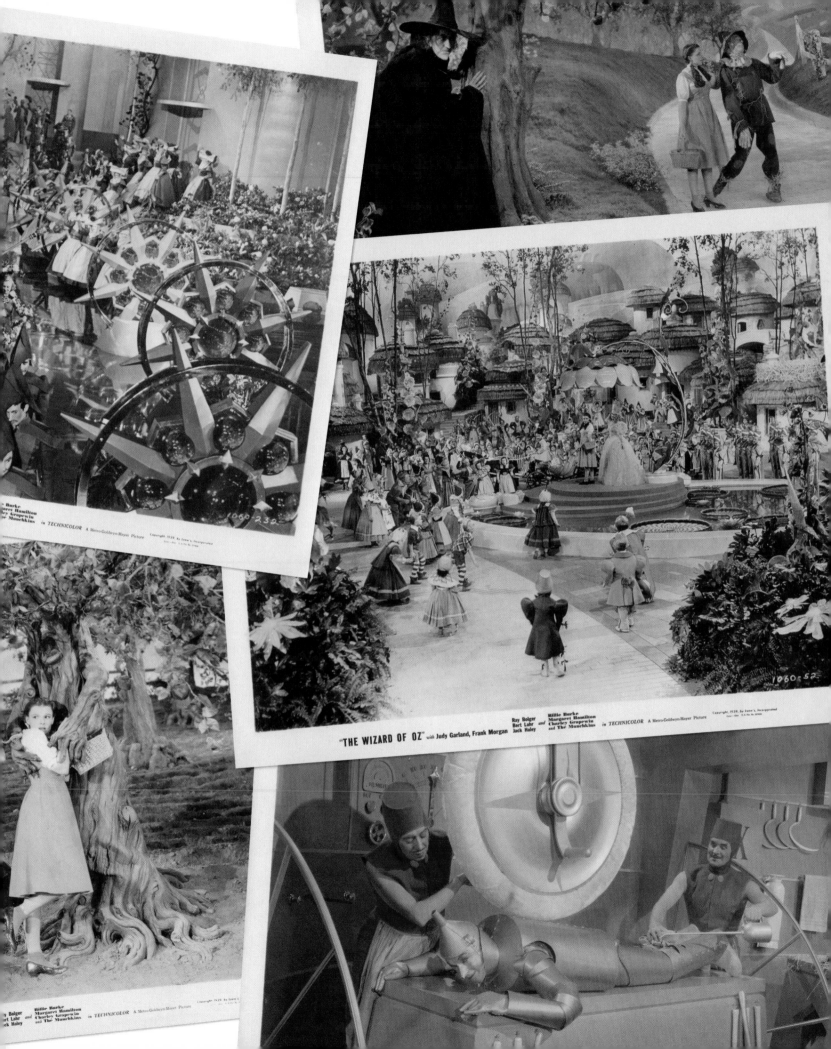

"THE WIZARD OF OZ" with Judy Garland, Frank Morgan

Ray Bolger Billie Burke
Bert Lahr *and* Margaret Hamilton
Jack Haley Charley Grapewin
and The Munchkins

in TECHNICOLOR A Metro-Goldwyn-Mayer Picture

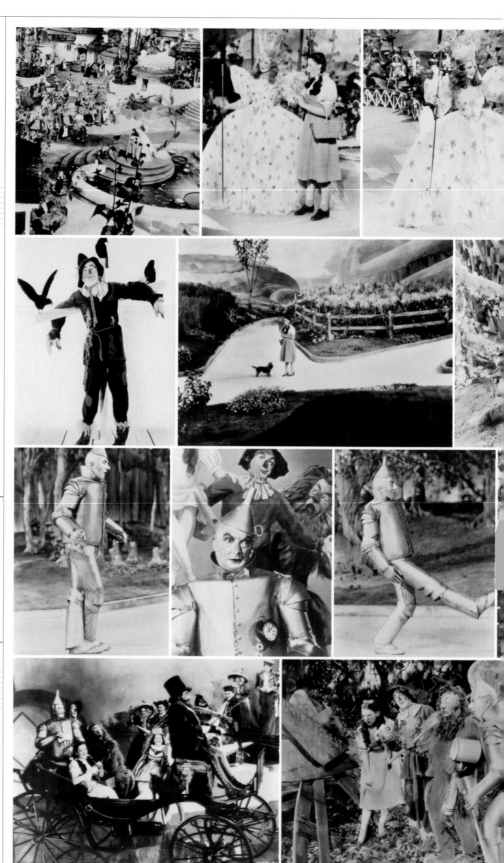

With *The Wizard of Oz* debuting at the start of a new school year, the juvenile set was targeted through various primary- and secondary-education journals. M-G-M's publicity department could have put it no more succinctly than *My Weekly Reader,* which instructed, "See the movie!" For motion picture appreciation classes, there was *Photoplay Studies* and a series of twenty-seven hand-tinted glass slides (shown here) for projecting key scenes and players, produced by the Visual Division of the Buffalo, New York, Board of Education.

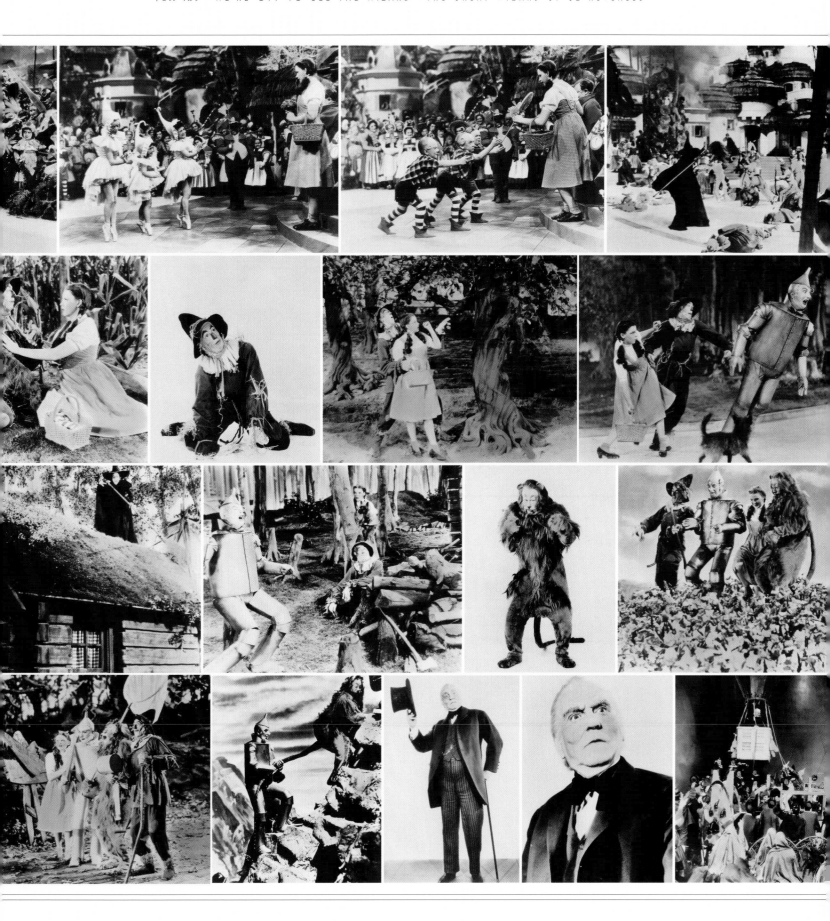

THE TWELFTH ACADEMY AWARDS

ON FEBRUARY 29, 1940, *The Wizard of Oz* was one of ten films competing for Best Picture of 1939 by the Academy of Motion Picture Arts and Sciences, among them David O. Selznick's *Gone with the Wind*, which garnered nearly every major award at that evening's ceremony. It is often said that *The Wizard of Oz* lost the Best Picture Oscar® to *Gone with the Wind*. While this is technically true (eight other nominees also conceded to the Civil War saga), for its era *The Wizard of Oz* was not a serious contender for Best Picture. If *Gone with the Wind* had not won, the honor would

M-G-M's resources, opulence, and capability—the studio's way of asserting its position in the film industry. It was assumed that the film was to be a "prestige" picture.

Perhaps one oversight was the failure to award *The Wizard of Oz* for its technical achievements, an aspect already singled out by critics and review editors. Journalist Wood Soanes wrote that "the technical side of it alone" would ensure recognition by the Academy. Nineteen thirty-nine was the first year the Academy instituted a special-effects category, and *The Wizard of Oz* was edged out by the realistically simulated earthquake and flood of *The Rains Came*. A Best Makeup

> *"I OWE YOU EVERYTHING, MR. LEROY."*
>
> —MESSAGE PASSED FROM JUDY GARLAND TO MERVYN LEROY UPON RECEIVING
> THE 1939 ACADEMY AWARD® FOR OUTSTANDING JUVENILE PERFORMANCE

most likely have gone to either *Goodbye, Mr. Chips* or *Mr. Smith Goes to Washington*, ranked No. 1 and No. 2 in *Film Daily*'s annual poll of 542 film critics (*Gone with the Wind* was released after the poll's October 31, 1939, cut-off). Instead, *The Wizard of Oz* was a showcase for

OPPOSITE: Wearing a lavender gown and matching orchid, Judy Garland was presented with a gold-plated miniature Oscar® for best juvenile performer at the 1939 Academy Awards® ceremony (Mickey Rooney did the honors). Louella Parsons paid Judy a backhanded compliment when she said, "[I]n a long sweeping skirt, [Judy] looked like she borrowed her mama's dress." In his "Behind the Scenes in Hollywood" feature, Harrison Carroll reported, "After Judy Garland received the special award for her performance in *The Wizard of Oz*, she scribbled a note on a napkin and sent it to Mervyn [LeRoy]. 'I owe you everything, Mr. LeRoy,' she wrote."

award was only created in 1981, but in 1940 Louella O. Parsons was one of the first to plead for just such a prize. On the eve of the 1939 awards ceremony, she included Jack Dawn's work on *The Wizard of Oz* when she attested, "Why not give our Hollywood makeup men an Academy Award®? Every other branch in the industry is honored at the annual dinner save these men, who do so much to make it possible for actors to look their part."

"Over the Rainbow" was honored as Best Song from a motion picture at the 1939 Academy Awards® ceremony, following its stint as a chart-topping hit parade single. Judy Garland herself was partial to it, as quoted in January 1940: "My favorite popular song, the prettiest and most beautiful in the world, is 'Over the Rainbow.' I think it's a relief from some of the other numbers you hear." By 1941,

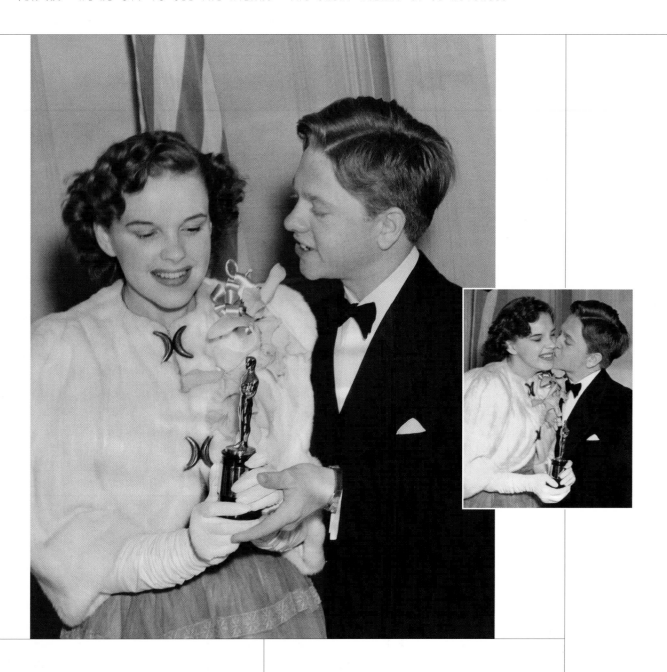

orchestra leader David Rose (newly wed to Judy the same year) included "Over the Rainbow" in his film-favorites compilation of Best Song winners for Victor Records.

Also at the Awards program, Garland was bestowed with an honorary Oscar® in recognition of her outstanding work as a screen juvenile. Neither a film nor a film role was specified (Garland also had a hit in *Babes in Arms* that year), but it was generally conceded that the achievement was for *The Wizard of Oz*. For the film's 1949 rerelease, Garland's Oscar® was promoted as exclusive to *The Wizard of Oz* in the theatrical trailer, which noted, "Starring Judy Garland . . . in her special Academy Award® role."

While *The Wizard of Oz* may not have won for Best Picture, it has since made virtually every "Top Ten" or "Best Film" list in recent times—proof positive of its ever-lasting appeal.

NOT IN KANSAS ANYMORE

THE WIZARD GOES GLOBAL

A set of eight full-color lobby cards (one of which is shown here) introduced Judy Garland and Frank Morgan in *El Mago de Oz* in Mexico, autumn 1939.

In autumn 1939, Montreal's Loew's Theatre enticed moviegoers to take in the "picture to make the world forget its troubles," alluding to the onset of World War II. *The Wizard of Oz* also played to Canadians at the Capitol in Winnipeg, where it was held over a second week.

MEXICO AND CANADA

SHORTLY AFTER ITS August 1939 release in the United States, *The Wizard of Oz* began playing in Mexico and Canada. On September 16, a special screening was held in Manitoba at the Winnipeg Capitol Theatre to benefit orphans. The event was a cooperative between the *Winnipeg Free Press* and the Winnipeg Electric Company, endorsed by a telegram direct from Judy Garland: "Would deeply appreciate it if the *Free Press* and the Winnipeg Electric Company would act as hosts on my behalf to the children of Winnipeg orphanages at the special advance showing of *The Wizard of Oz* . . . Please extend my sincere best wishes to all." A pictorial feature two days later showed the packed house filled with spellbound youngsters.

As *The Wizard of Oz* continued its Canadian bookings into winter, a $10,000 skating revue, "Cracked Ice Follies of 1940," was mounted at Alberta's Lethbridge Arena on February 28, drawing 2,500 spectators. The spectacle's pièce de résistance was a reenactment of *The Wizard of Oz* with elements from the film version, including the cyclone, during which the Wicked Witch appeared on a bike and a brood of Winged Monkeys scurried across the sky in half light. The forty-member troupe performed on pastel-colored ice against a raised platform of the Wizard of Oz's Emerald Castle.

SOUTH AMERICA

THE WIZARD OF OZ debuted in South America at the regal movie palace Gran Cine Ideal in Buenos Aires, Argentina, on November 15, 1939. Two days later, it premiered at the Cine Metro in Montevideo, Uruguay. Movie critic W.J. compared the film to the 1935 film version of Shakespeare's *A Midsummer Night's Dream*, except that "*The Wizard of Oz* is more of a childhood dream with satire in between." W.J.'s sole criticism missed the purpose of the picture's dramatic conflict; the reviewer was mildly dismayed that all the merriment was marred by the Witch's death, which introduced dissonance to the harmonious whole.

In São Paulo, Brazil, a radio serialization of the screenplay for *O Magico de Oz* was broadcast in December 1939, complemented by a hardcover novelization illustrated with stills—the earliest such publication based on the movie story and not the Baum novel. The book's interpreter presumed to suggest that it should be retitled in the opening chapter: "I'll tell you the story of *The Wizard of Oz*, which, more reasonably, should be called *The Story of Dorothy and Her Little Dog Toto*, because they are the principal characters of this book."

AUSTRALIA

AUSTRALIA ADVERTISED *THE Wizard of Oz* in November 1939 as a seasonal treat for the upcoming holidays. A suite of song sheets for the film's tunes was published, and a series of cloth dolls depicting Dorothy and Toto, the Scarecrow, and the Cowardly Lion was introduced for Christmas. The picture was still making the rounds in 1941, by which time "We're Off to See the Wizard" was advertised as the morale-boosting World War II battle march of the Australian Imperial Force. The battlefield tale, which made US national news courtesy of DeWitt MacKenzie, an Associated Press foreign affairs writer, was that the Aussie troops chanted *The Wizard of Oz* marching song during the Battle of Bardia, Libya, that January—the first such WWII military pursuit for which the Imperial Force participated as an ally. One columnist, lauding the Australians, cracked that they sang the tune without consulting ASCAP, the performance-rights organization.

Winston Churchill was so taken by the Australians' spirit of resolve that he mentioned the troops' singing of "We're Off to See the Wizard" in his 1949 WWII history *Their Finest Hour*, noting, "This tune always reminds me of these buoyant days." In all likelihood, the incident inspired a scene in the British WWII film saga *The Life and Death of Colonel Blimp* (1943), in which a soldier warbles a quick chorus of the song.

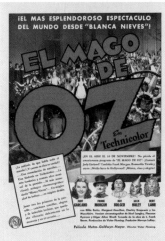

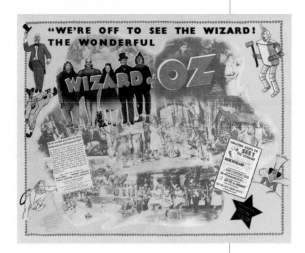

TOP: A theatre leaflet for *O Magico de Oz* from Rio de Janeiro. · MIDDLE: A magazine ad from Argentina captures the spectacle of *El Mago de Oz*. · RIGHT: A multicolor program heralds "M-G-M's Technicolor Show of Shows" and was distributed from 1939 through 1941 to pique the interest of Australian audiences.

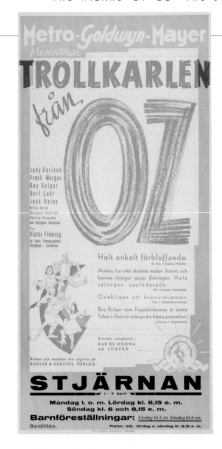

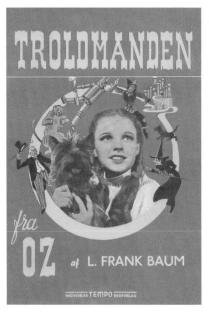

SWEDEN

THE WIZARD OF OZ had its European premiere at the Rigoletto Cinema in Stockholm, Sweden, in time for Christmas 1939, and broke in outlying towns, including Malmö, Ängelholm, Kristianstad, Karlstad, Söderhamn, and Nybro shortly thereafter. "Vad ar Oz?" was the ambiguous tagline translated from the US campaign ("What Is Oz?"), intended to pique moviegoers' curiosity for *Trollkarlen från Oz*. The Rigoletto theatre artists created elaborate lobby attractions, and local merchants and shopkeepers aided the campaign with storefront displays and promotions—all of which was carefully documented in *Metro Nytt* ("Metro News"), the Swedish in-house journal for M-G-M's pictures.

Swedes had been primed for the unusual new film since July 1939, and it received continuing coverage in Swedish periodicals, replete with pictorial layouts. To coincide with the premiere, Swedish publisher Reuter & Reuter issued an edition of *The Wizard of Oz* illustrated with Denslow's original line drawings but with a photograph of Judy Garland surrounded by drawings of the M-G-M cast on the book cover. By arrangement with US publisher Leo Feist, Reuter & Reuter also printed the film's songs in Swedish ("The Merry Old Land of Oz" became "Det Lyckliga Landet Oz").

DENMARK

THE WIZARD OF OZ wasn't as well received in neighboring Denmark, despite the fact that the cast of characters was renamed in an effort to make them more personable to the Danish market: Miss Gulch became sour old Miss Bile; the Scarecrow became Peter Scarecrow; the Tin Man became Herr Bliktud or Mr. Tin-Spout; and the Cowardly Lion was transformed into "Lion Afraid Trousers," or the Scaredy-Pants Lion. In fact, when *Troldmanden fra Oz* had its first run in Copenhagen at the Palladium theatre—known for its lengthy engagements—on March 26, 1940, the reviews were rather unkind, and it was reported that some cinemagoers left the theatre before the picture was over.

TOP: In April 1940, *The Wizard of Oz* was advertised in Sweden with an elongated poster (called a *stolpe*). · ABOVE: The Danish photoplay softcover edition of the L. Frank Baum book.

GREAT BRITAIN

THE WIZARD OF OZ had its London premiere in January 1940 at the Empire Theatre in Leicester Square. Its release had been heralded throughout the previous December but was deferred until George Cukor's *The Women* finished its run at the Empire. On March 14, 1940, BBC Radio broadcast a one-hour radio version of the film story, sanctioned by M-G-M and derived from the screenplay, augmented by the BBC Revue Orchestra. An encore of *The Wizard of Oz* songs, performed by the same cast of players, aired the following evening. The film's lyricist, E. Y. Harburg, had come to Great Britain specifically to stage this event for BBC Radio before traveling to Sweden to do the same there.

For the new Metro-Goldwyn-Mayer Pictures, Ltd. motion picture—as per the official British credit—a number of books and paper novelties were marketed in 1939 and 1940, based directly on Metro's movie. As a book, *The Wonderful Wizard of Oz* was little known in Great Britain. Prior to the English release of the picture there had been two printings of the L. Frank Baum story, the last in 1925, in keeping with interest generated by the Larry Semon silent picture released that year. Unlike the American merchandise, all the English *Wizard of Oz* products made extensive use of the film imagery.

British publisher Hutchinson & Company issued two differently packaged full-length editions of *The Wonderful Wizard of Oz*, as well as several abridged editions and a "colouring" book—all prominently featuring Judy Garland et al. A cutout book of paper dolls styled after the movie's cast was another Hutchinson offering. In addition, premium cards of movie characters and scenes from the film were inserted into packages of Barrett & Company's candy cigarettes; Castell Bros., Ltd. produced a card game that told the story of the film in full color; and Williams, Ellis & Company, Ltd. issued four boxed jigsaw puzzles. English printings of all the sheet music to *The Wizard of Oz*'s songs were sold by Francis Day & Hunter, Ltd.

Most UK reviews praised the film but said the Wicked Witch was too terrifying for children. A succession of British rereleases in 1945, 1955, and 1964 (on a double bill with *Tom Thumb*) revived interest in the picture, and it gained in popularity and familiarity in Great Britain.

ABOVE: British publisher Hutchinson & Co. issued a line of *Wizard of Oz* photoplay books in late 1939, which were advertised with a 28x30-inch hardboard merchant sign.

RIGHT: The front cover of the British exhibitor's campaign book for the 1940 engagement of *The Wizard of Oz* in England.

ABOVE, LEFT: Concurrent with the 1940 debut of *The Wizard of Oz* in Portugal, a lavish photoplay edition of the Frank Baum book was published in Lisbon. The book was reprinted in 1946 when the movie was reissued. · ABOVE, RIGHT: Hungary saw the debut of *Oz a Csodák Csodája* in spring 1940, as featured on the cover of magazines like *Radioelet*, a radio guide. · BELOW: French sheet music cover for "Over the Rainbow," 1939.

ELSEWHERE AROUND THE WORLD

THE WIZARD OF OZ continued playing in those countries not yet directly impacted by World War II. In Holland, *De Grote Toovenaar van Oz* opened in Amsterdam in March 1940. In April, Hungary welcomed *Oz a Csodák Csodája*, while in Portugal it was *O Feiticeiro de Oz*.

No matter where it was screened, it seemed, *The Wizard of Oz* proved to be appealing entertainment and a lighthearted diversion from war worries. On March 28, 1940, the movie review editor for the Kingston, Jamaica, *Daily Gleaner* attested to the film's "rare beauty," citing it as one of the screen's greatest triumphs for all ages, noting, "Personally, I saw the picture sitting alongside a party of four sailors off the warship—who enjoyed the fun of the film in typical naval fashion."

In many key markets, the onset of World War II in September 1939 curtailed much of the foreign potential for *The Wizard of Oz* to recoup its expenses and generate merchandise revenue. *The Wizard of Oz* was one of seven American motion pictures scheduled to debut at the first Cannes Film Festival starting September 1, 1939, but the event was canceled due to war threats. The film was also advertised as forthcoming in France and Belgium, but was delayed until June 1946. The war further postponed the opening of *The Wizard of Oz* in Finland (1943), Austria and Spain (1945), Italy (1948), and Germany (1951).

The most prolonged of all theatrical delays for *The Wizard of Oz* occurred in Japan—the picture did not surface there until late 1954. At the time, it was warmly recalled by Private First Class Robert D. Sweeney, writing for *Pacific Stars & Stripes*, the military newspaper of the US Department of Defense. In his "On the Town" column for December 30, 1954, Sweeney was nostalgic for the picture's revival at Tokyo's Piccadilly Theatre: "[T]he film is as gay and as good now as it was when we first saw it fifteen years ago."

In the years succeeding its initial release, *The Wizard of Oz* was prevented by prevailing global circumstances from reaching the cinemas of the world. But its magical stronghold would resurface with international influence in the decades to follow such that "Oz" would become an instantly recognizable word, synonymous with Dorothy and her friends, no matter the native language of the land.

RARE OUTTAKES FROM OZ

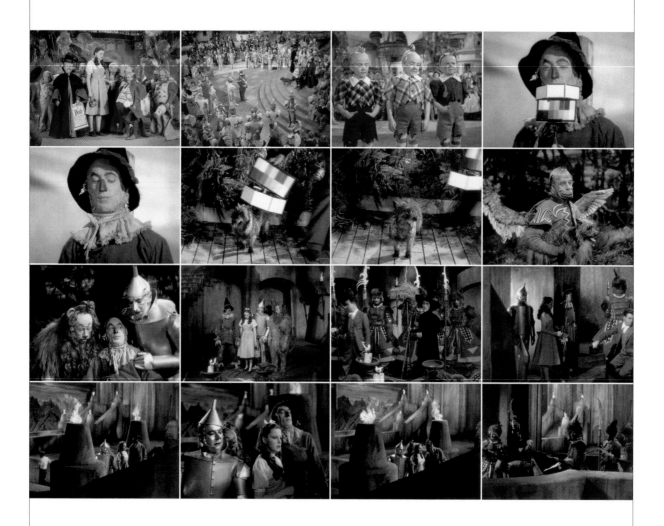

ECAUSE TECHNICOLOR photography had not yet been perfected in 1938, every camera setup on *The Wizard of Oz* required testing to check the appropriateness of the lighting and to ensure that the set, wardrobe, and makeup hues translated to film properly. After each scene, several feet of extra footage was shot during which a technician holding a color-correct chart (called a *Lilly*) would step in momentarily. If on the developed film the white portion of the Lilly remained white, the color footage was acceptable. After use, these lengths of film were cut into strips of three frames each and distributed to the crew as souvenirs. These off-guard moments often show various studio personnel while cast members pause for the break.

MERVYN LeROY
THE MAN BEHIND THE CURTAIN

IN GUIDING *THE Wizard of Oz* from conception through completion, Mervyn LeRoy was more than ably assisted by myriad creative talent and a superlative cast and crew—all of whom he thanked publicly in full-page trade ads in *Hollywood Reporter* and *Daily Variety*: "My sincere thanks and deep appreciation to all the wizards who made *The Wizard of Oz* a reality." But to the motion picture industry at large, the film was LeRoy's baby.

of Oz." Even director Victor Fleming knew that the film was LeRoy's pet project. When the film was being edited, he posted a letter on May 31, 1939, to the Screen Directors' Guild waiving his right to the last title card of the picture's opening credits, transferring such right to LeRoy (although the adjustment went unimplemented).

But perhaps the review that paid the most fitting tribute to LeRoy's labor of love came from Walt Disney. On August 23, 1939, Disney wrote to LeRoy:

> "MERVYN ALWAYS HAD THE VISION."
> —MEREDYTHE GLASS, COUSIN TO LeROY

If his gamble on *The Wizard of Oz* was ever questioned, LeRoy was exonerated once the picture premiered. The *New York Sunday Mirror* announced, "Young and old will relish *The Wizard of Oz* and applaud producer Mervyn LeRoy's courage for having made it so spectacularly." *Screenland* magazine declared LeRoy "Public Benefactor No. 1" and *Daily Variety* dubbed him "The Wizard of Hollywood." *Oakland Tribune* film critic Wood Soanes opined, "Mervyn LeRoy can now take his place with Walt Disney for excellence in the production of fantasy . . ." And in his West Coast show biz column, "Town Called Hollywood," Philip K. Scheurer wrote, "Nobody was more surprised than Hollywood—collective, Hydra-headed Hollywood—when 'LeRoy's Folly' turned out to be fantasy of the year. By 'LeRoy' Hollywood meant Mervyn LeRoy, the smart little producer who went over to Metro-Goldwyn-Mayer from Warner Bros., and by 'folly,' the $3,000,000, more or less, that he persuaded his backers to sink into an old fairy tale by L. Frank Baum called *The Wizard*

Mrs. Disney and I saw The Wizard of Oz *the other night and we both liked it very much. The sets were swell, the color was perfect for the story, and the make-ups far exceeded anything I thought possible. Knowing the difficulty that we have with cartoons, a medium that is limited only to the imagination, I can fully realize how tough a production of this type would be in the live-action medium. All in all, I think you turned out a fine picture and you have my congratulations.*

LeRoy responded to Disney immediately and with venerable idolatry: "It is needless for me to tell you how proud I am to know that you liked *The Wizard*. . . ." And while LeRoy reveled in Disney's admiration—that November he would recommend Walt for president of the Academy of Motion Picture Arts and Sciences—he was concurrently, and most assuredly, hoping to duplicate Disney's success in the merchandise marketplace to follow.

MAGICAL MERCHANDISE

"MOST OF THE CAST OF THE LAND OF OZ [SIC] ARE ON SALE—DOROTHY, THE TIN MAN, THE SCARECROW, THE COWARDLY LION, GLINDA THE GOOD, AND NIKKO, THE GENERAL OF THE WICKED WITCH'S WINGED MONKEYS."

—*EL PASO* (TEXAS) *HERALD POST*, 1939

The American Colortype Company produced a series of twelve die-cut greeting cards, just in time for Valentine's Day 1940, with illustrations inspired by production stills from the film.

METRO-GOLDWYN-MAYER WAS TOPS in publicizing its four-star and "B" pictures but was inexperienced when it came to merchandising them. Despite the talents of cast and crew, Mervyn LeRoy was under pressure from the front office of Loew's Incorporated, M-G-M's parent company: not only did Loew's Incorporated want *The Wizard of Oz* to be a cinematic success, it also wanted the film to generate revenue via character merchandising. The characters from *The Wizard of Oz* were so beloved that it made sense that M-G-M would want to explore their merchandising possibilities. More and more films were being created with merchandising packages and licensing possibilities built in. Paramount, for example, announced that it would release a full-length animated feature every year, replete with licensing arrangements, just as it was preparing for its cartoon version of *Gulliver's Travels*. And Disney's *Pinocchio* was set for a Christmas 1939 premiere, simultaneously with a complete merchandising package.

Once principal photography on *The Wizard of Oz* wrapped in February 1939, save for postproduction and retakes, LeRoy turned his attention to marketing his movie characters, and went straight to the best for outside expertise: Walt Disney. Like any self-made mogul, Disney was fiercely protective of his brand, yet he didn't see *The Wizard of Oz* as a threat to his domain, in equal parts perhaps because the film was live-action and because he and LeRoy had a genuine rapport. In an affable gesture, Disney put LeRoy in touch with Herman "Kay" Kamen, but, shrewdly, not without his legal oversight. Kamen had achieved remarkable success leading Disney's character merchandise division throughout the 1930s. (Kamen wasn't a Disney employee but an independent contractor free to pursue outside business ventures, provided there was no conflict of interest with his primary work for Disney.) Concurrently, LeRoy

sought to finesse licensing arrangements with Maud Baum, who served as an unofficial consultant to the picture.

By August 1939, the press projected, "This Xmas the kiddies will be asking for characters from *The Wizard of Oz* instead of *Snow White and the Seven Dwarfs*." By late November, the Newspaper Enterprise Association syndicated a gift-giving feature that pictured the Land of Oz soap figures; and newspapers noted the film's characters among the holiday season's dolls. For Christmas 1939, W. L. Stensgaard & Associates, a firm specializing in store display materials, had designed an extensive *Wizard of Oz* retail promotion and display plan for department, toy, and hardware stores. In truth, the initial merchandising push behind *The Wizard of Oz* was minor, compared to the product lines being set up by Paramount and Disney. For Christmas 1939, both *Pinocchio* and *Gulliver's Travels* had about one hundred licensed accounts each; all told, *The Wizard of Oz* had roughly two dozen—which accounts for the present-day rarity (and desirability by collectors) of the film's original novelties.

TOP: Philadelphia's Dartboard Equipment Company (also known as DECO) issued its dart game in time for Christmas 1939 in a limited issue of one thousand sets. The instructions recommended several games that could be enjoyed by players using the playing board as a Land of Oz map. The set originally sold for $1.00. • **ABOVE:** Swift & Company signed on as a Loew's licensee in 1940 and, that September, debuted its Oz-The Wonderful Peanut Spread, packaged in two different-sized glass jars and tin containers (a sample tin is pictured here).

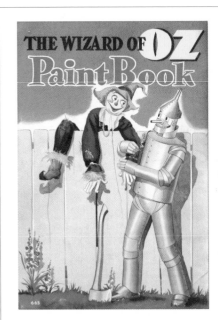

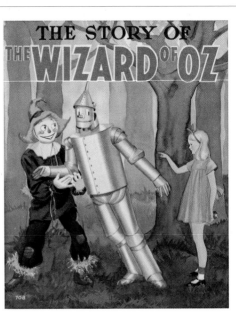

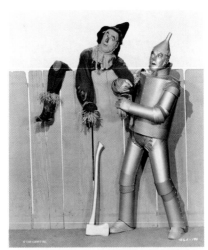

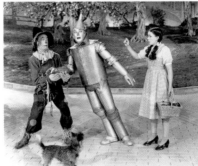

TOP ROW: Einson-Freeman Co., publishers of puzzles, prints, and games, issued a set of paper masks accompanied by a flyer for suggested uses. • **ABOVE:** Prolific illustrator Henry E. Vallely produced full-page line drawings for Whitman's *The Wizard of Oz Paint Book*, which were then edited for *The Story of "The Wizard of Oz."* The covers were patterned after M-G-M poses (shown at right).

BELOW: Maud Baum, widow of the original book's author, was an uncredited consultant to *The Wizard of Oz*. Here, she poses with the new edition of *The Wizard of Oz* in a 1939 clipping. · Bobbs-Merrill published a special photoplay edition of the L. Frank Baum book in a new dust jacket and reduced price. The book became a bestseller. In 1940 it cost twenty cents more and was still advertised as "used in movie."

ABOVE, LEFT: Little girls could emulate Judy Garland with John C. Wellwood's hairbows. · ABOVE, RIGHT: Four-inch unlicensed miniatures of *The Wizard of Oz* cast included the Tin Man. The figurines were issued by the Artisans Studio, Nashua, New Hampshire, circa 1939.

THE HAROLD ARLEN and E. Y. Harburg score for *The Wizard of Oz* met with immediate success. "Over the Rainbow" became a top-selling song sheet, and separate versions recorded by Judy Garland or Glenn Miller and his Orchestra (backed with "Ding-Dong! The Witch Is Dead") were selling in record stores—at 35 cents each—by late August 1939. Other artists soon followed with their renditions of the movie songs, released on various labels. "Be the first to play the hit records from the motion picture *The Wizard of Oz* . . . In a few weeks everybody will be singing them . . . but you'll be the first to 'spring' them on the crowd," read the ads. Come September, Decca Records had collected the melodies sung by Garland and the Ken Darby Singers, accompanied by the Victor Young Orchestra, in a four-disc set packaged to sell for $1.90.

On September 26, 1939, Garland became a regular on radio's *The Pepsodent Show Starring Bob Hope*, at which time she sang "Over the Rainbow" just as the song was hitting its stride in popularity. Garland understood the charge of putting over the new tune. *Music Makers* magazine reported: "Although she [Garland] is naturally gay and fun-loving during broadcast rehearsals, she is extremely serious, devoting all her attention to her songs . . . She realizes her responsibility in introducing a new number to the public, for the way in which she interprets it may mean the difference between success and failure for the song."

"OVER THE RAINBOW"

"AS FOR MY FEELINGS TOWARD 'OVER THE RAINBOW,' IT'S BECOME PART OF MY LIFE. IT IS SO SYMBOLIC OF ALL DREAMS AND WISHES THAT I'M SURE THAT'S WHY PEOPLE SOMETIMES GET TEARS IN THEIR EYES WHEN THEY HEAR IT."

—JUDY GARLAND IN A LETTER TO HAROLD ARLEN

The public clearly took a liking to Garland's interpretation, and by December 1939 the sheet music for "Over the Rainbow" had sold almost half a million copies. Harry Link, of Leo Feist, Inc., publishers of M-G-M sheet music, advised Metro's music department head, Nat Finston, "We are contemplating getting out a folio comprised of all the songs in *The Wizard of Oz* . . . the front cover of which will be more or less on the same order as the Decca Records album with the pictures on the front cover." The official songbook, issued as a "souvenir album" for 50 cents, was profusely illustrated with production stills throughout, and, in one format or another, has remained in print to this day.

In one amusing anecdote, the popularity of "Over the Rainbow" wasn't enough to grant its composer Harold Arlen, full star immunity. In early 1940, Arlen was stopped for running a traffic light. When the officer asked his profession, Arlen replied that he was a song composer. "Oh, yeah," said the incredulous cop, "I suppose you wrote 'Over the Rainbow,' too!" Arlen snapped that, in fact, he *had*—but he still got a ticket.

Even though "Over the Rainbow" was recorded by other vocalists, it became an undeniable signature theme for Judy Garland, particularly during the war years, when the song's yearning became synonymous with that of countless families with loved ones overseas. During her first tour entertaining army camps in 1942, Garland noticed that the servicemen wanted to hear "Rainbow" over any others. In 1942, "Over the Rainbow," sung by Garland in *The Wizard of Oz*, was ranked the all-time best motion picture number by Barry Wood, host of radio's *Your Hit Parade*, the nation's favorite song barometer.

Judy Garland's "Over the Rainbow" served to comfort the troops during the war, but the soothing properties of her singing the song can be traced back to December 1939. Columnist Harrison Carroll related that Garland made a mercy mission to St. Joseph's Hospital at Anaheim to comfort Natalie Norris, a child who, when lucid, spoke about being Dorothy in *The Wizard of Oz*—the last picture she had seen before being stricken by illness. Natalie was alleged to have instantly recognized Garland, exclaiming, "My goodness, where is Toto?" After making gifts of dolls

OPPOSITE: July 20, 1943: Judy Garland performs "Over the Rainbow" for troops stationed at Fort Indiantown Gap Military Reservation outside Lebanon, Pennsylvania. In 1990, Martha M. Reilly, who worked at the base's Post Exchange store, told the *Lebanon Daily News* that Judy was "very, very nervous, but when she sang, you forgot all about her anxiety . . . Bad nerves or not, she was superb . . . So I can brag that I once heard Judy Garland—live and in person—sing 'Over the Rainbow.'"

and books, Garland sang "Over the Rainbow" before departing; afterward it was reported that "the youngster has shown definite improvement since the visit."

In his 1939 article about the song's genesis, "The Story Behind a Hit: Tune Makes Top Quickly," journalist Walker Corbett wrote, "It's pretty difficult not to hear it. Every band plays it. Every vocalist sings it. It's as solid a hit as the season has produced . . . and the singer [who introduced it] is cute, lovely, serious little Judy Garland, who sings it better than anyone else ever will!" (Corbett's proclamation would prove prophetic, at least in the eyes of the legions of Garland worshippers.)

There were critics, though, who hadn't yet assimilated "Over the Rainbow" well enough to appreciate it fully. As Mervyn LeRoy noted in his 1974 autobiography, "[I]t always takes a private ear several hearings before it appreciates a ballad . . . I had had the benefit of hearing ['Rainbow'] often." Following the film's premiere at Grauman's Chinese Theatre, journalist Harrison Carroll found Dorothy's song number in the

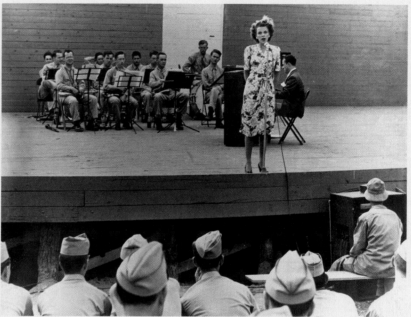

prologue objectionable for causing "a needless delay in the story." Another critic suggested, "Dorothy's first song should have been eliminated." Robbin Coons, of the Associated Press, agreed, writing, "The picture could have been speeded more at its beginnings, especially by the elimination of Judy's first song." But by September 1940, Coons changed his opinion: "My own record for picking hit tunes is about zero-zero-zero. I do better on horses." At the time of this quote, Coons was interviewing director-composer Mark Sandrich about song selection for motion pictures. Sandrich openly speculated on the crapshoot politics of pleasing the public, saying, "Remember 'Over the Rainbow'—how they almost left it out of *The Wizard of Oz*? But who can guess what the public will like?"

That "Over the Rainbow" almost didn't make the final cut of *The Wizard of Oz* is one of the greatest near-misses in cinema history. In 1966, LeRoy recounted:

> We previewed the picture in San Bernardino, and after the preview we all came out, stood out front, you know how you do after the preview. Two or three studio heads said we gotta take out "Over the Rainbow" because who would sing in a farmyard, and I said [likely paraphrasing an expletive-laden rant], "Who would be a munchin' Munchkin in Munchkinland?" So, I had to fight and fight, and I almost had to get on my knees to L. B. Mayer, to let me leave in "Over the Rainbow," which turned out to be one of the greatest hits of all time, a great classic.

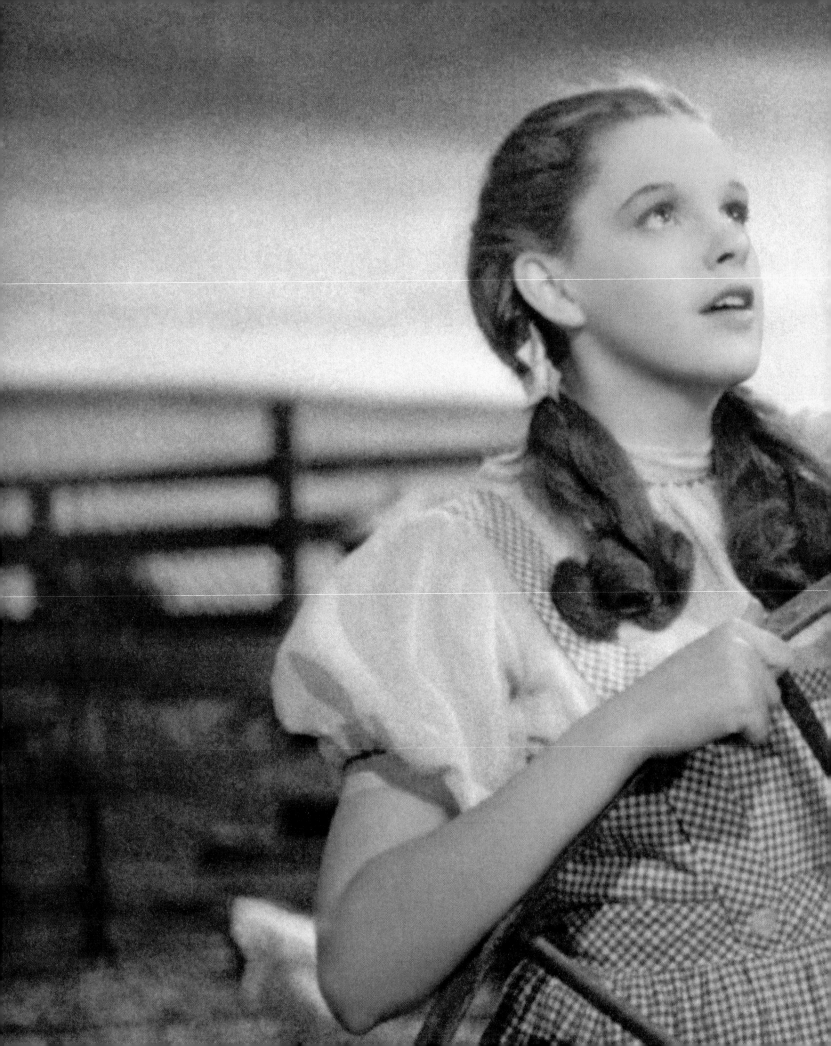

③ IF EVER

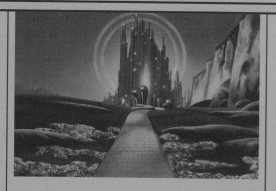

THERE'S EMERALD CITY!

OH, WE'RE ALMOST THERE AT LAST!
IT'S BEAUTIFUL, ISN'T IT?
JUST LIKE I KNEW IT WOULD BE.

DOROTHY AND FRIENDS:
We want to see the Wizard.

EMERALD CITY GATEKEEPER:
The Wizard? But nobody can see the Great Oz!
Nobody's ever seen the Great Oz!
Even I've never seen him!

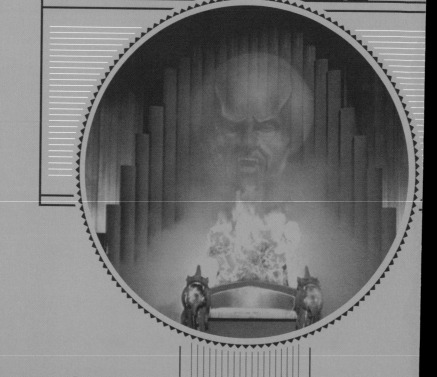

THE WIZARD OF OZ TO DOROTHY AND FRIENDS:

BRING ME THE BROOMSTICK OF THE WITCH OF THE WEST

AND I'LL GRANT YOUR REQUESTS.

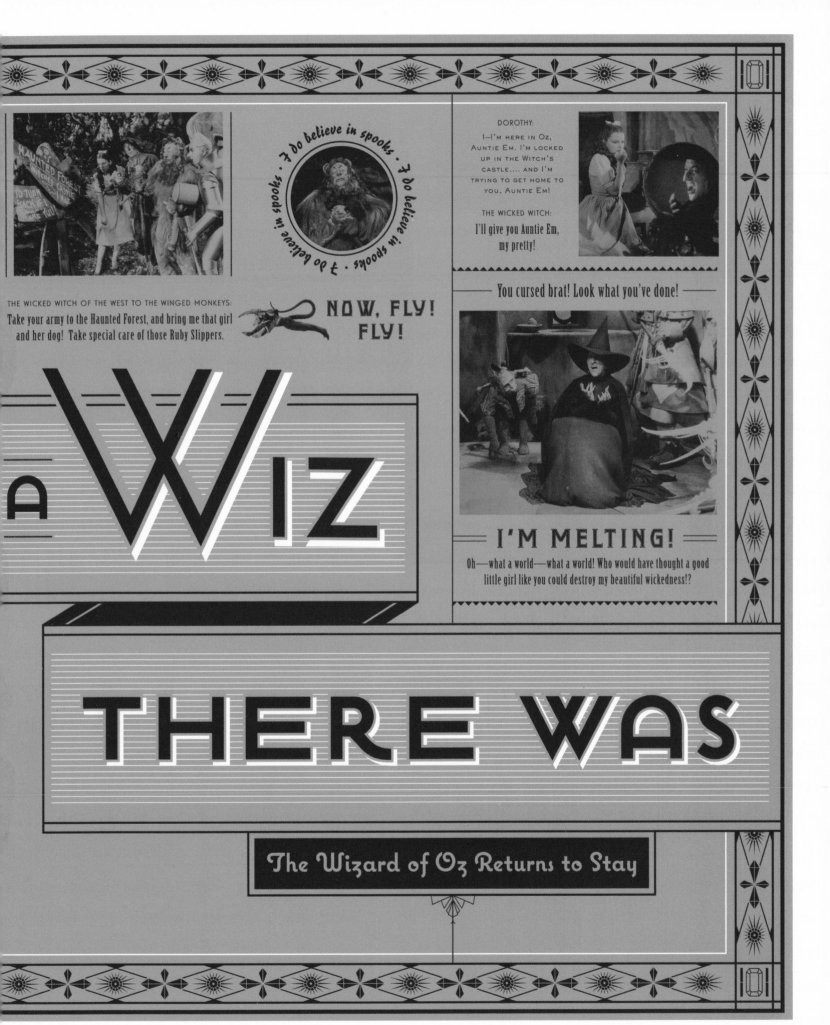

· I do believe in spooks · I do believe in spooks · I do believe in spooks ·

DOROTHY:
I—I'M HERE IN OZ, AUNTIE EM. I'M LOCKED UP IN THE WITCH'S CASTLE.... AND I'M TRYING TO GET HOME TO YOU, AUNTIE EM!

THE WICKED WITCH:
I'll give you Auntie Em, my pretty!

THE WICKED WITCH OF THE WEST TO THE WINGED MONKEYS:
Take your army to the Haunted Forest, and bring me that girl and her dog! Take special care of those Ruby Slippers.

NOW, FLY! FLY!

— You cursed brat! Look what you've done! —

I'M MELTING!

Oh—what a world—what a world! Who would have thought a good little girl like you could destroy my beautiful wickedness!?

A WIZ

THERE WAS

The Wizard of Oz Returns to Stay

THE 1949 RERELEASE

BEGINNING IN THE spring of 1943 and continuing into the summer of 1945, veteran Hollywood correspondent Jimmie Fidler began a public campaign to revive *The Wizard of Oz*, advocating on behalf of "dozens of kids" who'd requested a reissue of the film, and who, in Fidler's words, "comprise at least 50 percent of the habitual movie patrons." On July 13, 1944, he listed the film among his choices to be rescreened in honor of M-G-M's twentieth anniversary, and in one of his later columns he cited *The Wizard of Oz* as "undoubtedly the best kids' picture ever filmed." Fidler wasn't alone in his efforts.

Rival Tinseltown reporter Hedda Hopper took up the crusade on her own in October 1946, writing, "My cam-

Hopper reiterated the appeal for a rerelease in November 1948, writing, "Letters are pouring into my desk from parents urging me to beg Metro to reissue *The Wizard of Oz* again over the holidays." Hopper's impetus was, in part, personal, as she was a staunch supporter of Judy Garland. And in addition to having made a cameo in 1939's *The Women*, Hopper also had a bit part as an extra among the Ozites in the Emerald City, according to makeup artist Charles Schram. The collective fan campaign worked: it was announced that *The Wizard of Oz* would be reissued for postwar audiences and a new generation of youth. The ads proclaimed: "The Wonder Show for the Whole Family!"

Metro promoted *The Wizard of Oz* as the "most requested" of its hits from years past. In her March 26,

> "I TOOK MY LITTLE GIRL TO *THE WIZARD OF OZ* AND SHE HAD NIGHTMARES FOR WEEKS."
>
> —ACTOR GENE KELLY, 1949

paign to have *The Wizard of Oz* rereleased has borne fruit. As soon as Metro can get enough Technicolor prints, it'll be put back on the screen." A month prior, Hopper questioned why *The Wizard of Oz* was not among other upcoming M-G-M reissues. Hopper followed up twice more in 1947 and again on February 26, 1948, when she reported, "*Philadelphia Story* is being reissued, but not *The Wizard of Oz*, which the fans are clamoring for. Metro can't get enough Technicolor prints for the latter." *The Wizard of Oz*'s official release schedule ran from 1939 to 1942—too close for a mid-1940s comeback. Stall tactics notwithstanding, the circumstances regarding the number of print copies are unclear. However, any discrepancy over the number of *The Wizard of Oz* prints in the US may be attributed to most copies circulating in foreign countries, where the film was only just debuting after World War II.

1949, column, Hopper reported, "For years I've been urging Metro to reissue *The Wizard of Oz*. Now they'll do it—at Easter time. The studio will take advantage of three of their stars—Ray Bolger, Bert Lahr, and Jack Haley—each of whom is starring in his own play on Broadway. In *The Wizard of Oz* you'll see Judy Garland at her tip-top, singing that haunting melody 'Over the Rainbow.'" Fidler's efforts were also appeased. He wrote, "Better make it a point to tell parents who have been bewailing the dearth of pictures 'ideal for kid audiences' that M-G-M is giving them a real break by reissuing [one] of the greatest juvenile favorites of screen history—*The Wizard of Oz* . . . "

A test booking of *The Wizard of Oz* launched on April 16, 1949, at New York's Mayfair Theatre, and was incredibly successful. Advance screenings of the film, called trade shows, were held for theatre owners in

thirty-one major cities on May 19, 1949. Once the picture released nationally the following July 1, box-office returns for "M-G-M re-presents *The Wizard of Oz*" were such that the film earned back its original costs not recouped in 1939. (By example, in mid-September 1939, Loew's resident manager, Sam Shurman, had encouraged theatre owners to establish "a minimum children's price of 25 cents for all performances on this picture" in order to protect the film's expected revenue over the usual 10-cent juvenile tickets, and those patrons who sat through more than one show.) But in 1949, *The Wizard of Oz* received publicity and promotion on par with a new debut, and it nabbed rave reviews all over again, including mentions in *Time* and *Rotarian*. Journalist Wood Soanes suggested that *The Wizard of Oz* could very well be an entry for an Academy Award® in the 1949 lists.

The picture's assorted terrors also withstood the test of time and even gained potency. Reporter Marjorie Turner wrote of how "frighteningly real" it was: "Indeed, at one point the rear of the theatre was crowded with tots who refused to sit cooped up in a theatre seat while the Wicked Witch got her comeuppance, or the trees talked and clutched, or the Wizard [of Oz] bellowed through sheets of fire and smoke."

By the end of 1950, CBS's Lux Radio Theatre announced a dramatization of *The Wizard of Oz* as a seasonal treat for Christmas that year with a special twist. "Judy Garland re-creates one of her most memorable screen roles," read the December 18 press release. "She plays Dorothy, who is whisked by a tornado into the faraway Land of Oz . . . Musical highlights of the movie, including 'Over the Rainbow,' will be featured in the holiday presentation." The Associated Press's Bob Thomas announced that Garland had adopted a "show must go on" attitude, despite her separation from her husband Vincente Minnelli, which was made official earlier that month. The show, broadcast live from the CBS Studio on North Vine Street in Hollywood, was an abridged version of the M-G-M screenplay. It aired, minus any other original cast members, on Monday, December 25, 1950, from 6 to 7 P.M., with doors closed at 5:50 and no children under twelve admitted.

ABOVE: Coinciding with the 1949 rerelease, M-G-M Records issued a newly packaged set of *The Wizard of Oz* movie songs. A merchants' display poster advertised the recordings. · BELOW: An unusual one-sheet poster for the 1949 rerelease does double duty in promoting the recent stage successes of Judy Garland's costars.

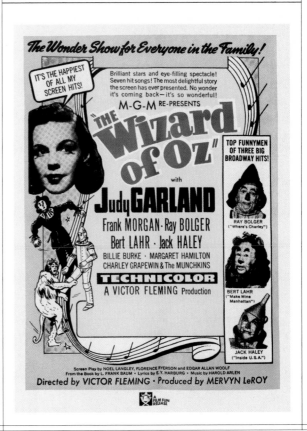

JUDY GARLAND COMES OF AGE

"That entire production is precious to me. It aroused my imagination and it all seemed like a fairy dream come true."

—JUDY GARLAND, REFLECTING ON *THE WIZARD OF OZ* IN 1952

IN THE YEARS following *The Wizard of Oz*, Judy Garland attained "glamour girl" status in wartime pictures like *For Me and My Gal* (1942) and *Presenting Lily Mars* (1943). But, as she told journalist Robbin Coons, her new allure came at a cost that made her wistful for earlier times: "It used to be I could run into the wardrobe department, try on a gingham frock, and that was that. Now it's hours of fittings. And two hours earlier in makeup . . . I guess I never really appreciated those pigtail parts." Even as she grew into more mature roles, however, Garland remained loyal to the film that established her as a household name and realized a girlhood wish. "*The Wizard of Oz* was always my favorite story," Garland recollected in October 1940, "but I never dreamed that I would ever be lucky enough to go through all of the experiences that Dorothy had, to see the Emerald City, the Land of the Munchkins, the Winged Monkeys, and all the rest. It is certainly a funny world, isn't it?"

Within a decade after *The Wizard of Oz*, Garland had come into her own as an incomparable screen talent and leading lady, winning top box-office status and worldwide acclaim. At the time of the 1949 revival of *The Wizard of Oz*, her greatest hit of all had been *Meet Me in St. Louis* in 1944, and the revamped campaign prominently featured portraits of the adult Garland in her *St. Louis* role. During production of *Meet Me in St. Louis*, the media was all too eager to draw parallels between Garland's parts in both films: "Judy Garland Plays a Little Girl Again," read one headline. As relayed from the *St. Louis* set: "When the star reported for makeup tests, everyone who saw her agreed that winsome Dorothy of *The Wizard of Oz* was back. As Esther Smith . . . Judy wears almost an exact duplicate of the hairdress she wore in her Academy Award® portrayal of Dorothy. Drawn back from the temples and anchored on top with a barrette."

The 41x81-inch three-sheet poster for the 1949 reissue of *The Wizard of Oz* pictures Garland in her role as Esther Smith from M-G-M's hit *Meet Me in St. Louis.*

THE 1955 RERELEASE

"Judy and Joy! Nothing to equal the joyousness, the eye-filling scenes, the music and the happiness of M-G-M's Glory Entertainment in Technicolor!"
—HANDBILL FOR THE 1955 RERELEASE OF *THE WIZARD OF OZ*

ALT DISNEY'S animated features were popularly released every seven to ten years, and M-G-M might have done well to follow a similar schedule with *The Wizard of Oz*. Instead, Metro brought *The Wizard of Oz* back again in 1955, though the 1949 reissue had only wrapped its show dates in 1951. Broadway columnist Dorothy Kilgallen inferred that M-G-M was seizing the opportunity to profit after the rerelease of another oldie-but-goodie, Greta Garbo's *Camille* (1936), broke attendance records at New York's Normandie Theatre.

Sixteen years after its initial release, *The Wizard of Oz*—and Garland's performance, in particular—still entranced audiences (especially children), as exemplified in an anecdote shared by the Hollywood branch of the Newspaper Enterprise Association:

A "reader" writes: "Thought maybe you'd like an outside Hollywood picture of what happens when Judy Garland sings. My four-year-old blond is slightly cold-blooded.

The only sentiment she has ever shown has been for Davy Crockett, a Davy Crockett rifle, and a galloping horse at the pony track, which almost parts her head from her shoulders.

"I took her to see The Wizard of Oz. *Judy's 'Over the Rainbow' song was less than a minute old when she started sobbing—tears running down her cheeks. I still don't believe it—but I saw it. Is it genius or hypnotism?"*

It's genius, ma'am.

The 1955 theatrical outing of "An M-G-M Masterpiece Reprint" for *The Wizard of Oz* proved less lucrative than the 1949 rerelease. The following year, however, *The Wizard of Oz* began its second career via a venue that was in its infancy at the time the film was conceived: television.

The 1955 window card poster for *The Wizard of Oz*. At the time of the 1955 *The Wizard of Oz* rerelease, Judy Garland was enjoying a film career comeback for her role in *A Star Is Born* the previous year. Ads prominently featured the adult Garland and promoted the picture as her greatest ever.

March 21- 27, 1970

TV VIEWER

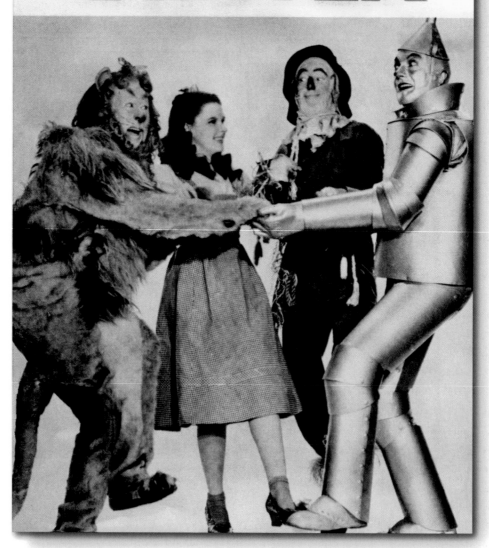

OZ RIGHT AT HOME

THE BURGEONING MEDIUM of television (*color* TV, in fact) brought *The Wizard of Oz* to national prominence once more, when M-G-M leased its film property to CBS Television for the Ford Star Jubilee program. CBS purchased the TV rights to the film for $200,000, and advised new color TV owners to expect the initial scenes of the picture to be in black and white "so they won't think something is wrong with their set."

The showing of *The Wizard of Oz*, which aired on November 3, 1956, started at 9 P.M., and—because it was

was inducted into the Grammy Hall of Fame, spurred, no doubt, by fond baby-boomer recollections of reliving the film's most magical moments via its recording.

Commencing with its second telecast in 1959, *The Wizard of Oz* became a traditional television special that endeared itself to millions of viewers with each airing. That *The Wizard of Oz* not only survived but thrived as it was discovered by a new generation did not go unnoticed. Journalist William E. Sarmento articulated the essence of the picture's staying power:

> "IN FACT, THEY COULDN'T HAVE PICKED A GRANDER SHOW THAN [*THE WIZARD OF*] OZ, WHICH DEFIES BOTH TIME AND THE DIMINUTION TO HOME SCREEN SIZE."
> —*DAILY VARIETY*'S NOVEMBER 7, 1956, REVIEW OF THE FIRST TELEVISION BROADCAST OF *THE WIZARD OF OZ*

padded to fill a two-hour time slot—ended well past the average youngster's bedtime. Newspaper ads gave parents fair notice: "Let the kids stay up with the entire family to watch the first television broadcast of the brilliant musical fairy tale set in the enchanted Land of Oz." Despite the movie's concluding at 11 P.M. (fortunately it wasn't a school night), forty-five million viewers tuned in.

Concurrent with the 1956 broadcast, M-G-M Records released a pared-down edit of *The Wizard of Oz* sound track (any mention of the Ruby Slippers is absent, as is the "Merry Old Land of Oz" number) as a 33-1/3 LP and as a boxed set of 45s. The album proved to be a hit, and for Christmas 1961 it sold more than one hundred thousand copies as a Duncan Hines premium through Procter & Gamble. The record was later issued as a Pepsi-Cola tie-in, and an edition was sold in Great Britain as well. The original cast album got a makeover in 1962 with new cover art, a gatefold jacket, and revised liner notes to attract the new generation of fans who discovered the film on TV. In 2006, the sound track album

Everything is right with the world once more. Well, at least it seems that way after viewing for the umpteenth time Judy Garland, Ray Bolger, Jack Haley, and Bert Lahr following the Yellow Brick Road to see the Wizard of Oz. Maybe Congress could pass some sort of law that would compel the CBS network to show this classic film every holiday season forever . . . Just when one is about to give up hope on television, something comes along like The Wizard of Oz *that makes you feel that all is not lost. I'm sure that many parents remember toddling into one of the downtown theatres some twenty-odd years ago to see little Dorothy fly over the rainbow. It must be a real kick for these same grown ups to sit with their children in front of the television set and make that magical journey all over again . . . I'm sure you join with me in a sincere plea to the powers that be to keep Dorothy, the Tin Man, the Scarecrow, and the Cowardly Lion together, singing and dancing into the hearts of all of us through all the years to come.*

LOOKING FOR OUR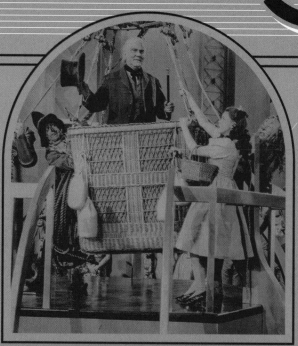

PART 4

DOROTHY TO THE WIZARD OF OZ:

PLEASE, SIR.
WE'VE DONE WHAT
YOU TOLD US.

WE'VE BROUGHT
YOU THE
BROOMSTICK OF
THE WICKED WITCH
OF THE WEST.

— **WE**
MELTED HER.

THE WIZARD OF OZ TO THE SCARECROW:

I hereby confer upon you

THE HONORARY DEGREE OF Th.D.
(DR. OF THINKOLOGY).

THE WIZARD OF OZ TO THE COWARDLY LION:

You are now a member of

THE LEGION OF COURAGE!

THE WIZARD OF OZ TO THE TIN MAN:

In consideration of your kindness, I present you with a small
token of our esteem and affection:

A TESTIMONIAL.

THE WIZARD OF OZ TO DOROTHY:

The only way to get Dorothy back to Kansas is for me to

TAKE HER THERE MYSELF!

THE WIZARD OF OZ,
AS TOTO REVEALS HIM:

PAY NO ATTENTION
TO THAT MAN BEHIND
THE CURTAIN.

DOROTHY TO
THE WIZARD OF OZ
AS THE BALLOON
TAKES OFF
WITHOUT HER:

OH!
COME BACK!
DON'T GO
WITHOUT ME!

PLEASE
COME BACK!

OH,
NOW
I'LL
NEVER
GET
HOME!

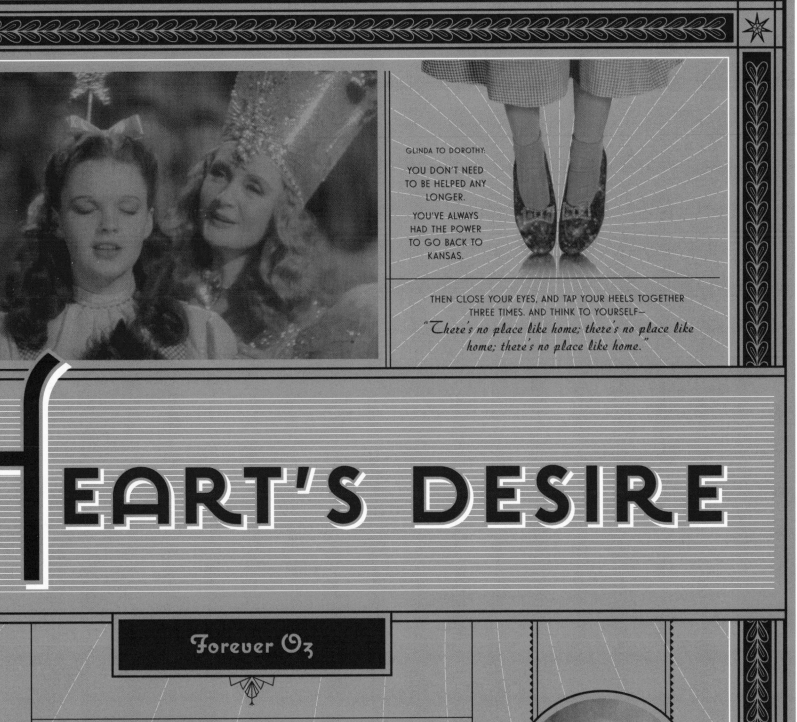

GLINDA TO DOROTHY:

YOU DON'T NEED TO BE HELPED ANY LONGER.

YOU'VE ALWAYS HAD THE POWER TO GO BACK TO KANSAS.

THEN CLOSE YOUR EYES, AND TAP YOUR HEELS TOGETHER THREE TIMES. AND THINK TO YOURSELF—

"There's no place like home; there's no place like home; there's no place like home."

HEART'S DESIRE

Forever Oz

DOROTHY, AFTER WAKING FROM HER DREAM:

TOTO, WE'RE HOME! AND THIS IS MY ROOM—AND YOU'RE ALL HERE! AND I'M NOT GOING TO LEAVE HERE EVER, EVER AGAIN, BECAUSE I LOVE YOU ALL! AND—OH, AUNTIE EM—

THERE'S NO PLACE LIKE HOME!

The End

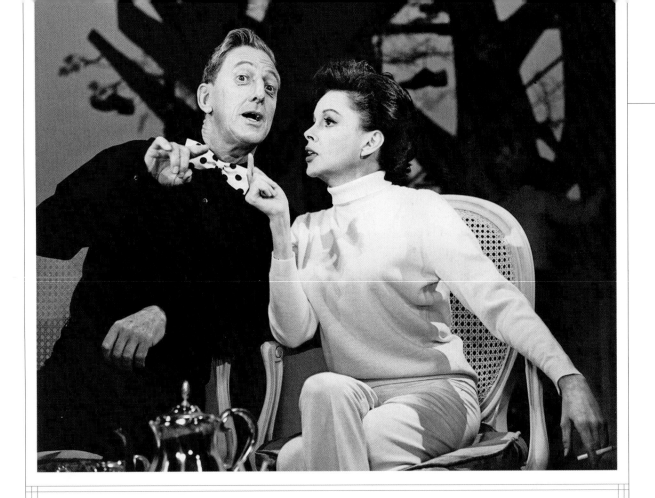

"THERE'S A PHILOSOPHY IN *THE WIZARD OF OZ* THAT
SPEAKS TO ALL OF US. EVERYONE HAS A HEART, A BRAIN, AND COURAGE.
IF USED PROPERLY, THEY LEAD TO THE POT OF GOLD AT THE END OF THE RAINBOW.
THE GOLD, WHEN FOUND, IS THOSE PEOPLE WHO LOVE YOU."

—RAY BOLGER

JUDY GARLAND'S UNTIMELY passing at age forty-seven, in June 1969, caused a shift in status for *The Wizard of Oz*. Judy's life had frequently been portrayed as tragic, and her death gave greater pathos to Dorothy and "Over the Rainbow." (Like her paternal muse, L. Frank Baum, Garland died within her birthday month.) For the next airing of *The Wizard of Oz* in March 1970, corporate sponsor the Singer Company—of sewing machine fame—pulled out all the stops in honoring Garland's legacy. Mervyn LeRoy was tapped to direct actor Gregory Peck,

then-president of the Academy of Motion Picture Arts and Sciences, for a one-minute tribute to Garland that would introduce the film; a regrettable concession was that LeRoy was compelled to excise sixty seconds from *The Wizard of Oz* to make up the time difference and not sacrifice valuable commercial advertising. Margaret Hamilton, Jack Haley, and Ray Bolger reunited to reflect on their roles, the film's impact, and their relationships with Garland in interviews and a photo shoot specifically for this "special encore telecast."

Long before their passing, the surviving cast members resigned themselves

to their inescapable association in public consciousness with their movie counterparts, regardless of where they went or what they did. Even Bert Lahr's grumblings about playing the Cowardly Lion had softened by the 1960s, when he told reporter Charlie Rice, "I don't regret [the role] at all—when you play a part like that, it brings you awfully close to the public. People feel they know you personally." Such personal accessibility was also experienced by Lahr's cohorts, as Ray Bolger explained anecdotally: "I was doing some shopping recently and I noticed a woman staring at me. She finally leaned down and whispered something to her small son. The boy looked at me for a few seconds and then walked over. 'Are you *really* the Scarecrow?' he asked. I said I was—and he put his hand inside my shirt. I'm used to kids doing that. They're checking to see if I'm stuffed with straw!"

Margaret Hamilton experienced similar reactions. She reported, "Many times I see mothers and little children, and the mothers always recognize me as the Witch. Often they say to the kids, 'Don't you know who she is? She's the Witch in *The Wizard of Oz*!' Then the kids look so disappointed and say, 'But I thought she melted.' It's as though they think maybe I'm going to go back and

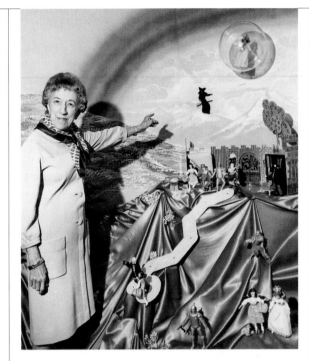

cause trouble for Judy Garland again." Hamilton's legacy is one of Hollywood's greatest oxymorons, as she held a lifelong fondness for children and, prior to acting, was a kindergarten instructor. She, Bolger, and Jack Haley all lived to see the film achieve cult status beyond mere fame; each actor accepted and appreciated immortality as an ancillary benefit, in lieu of telecast residuals.

OPPOSITE, ABOVE: Long after their famous journey down the Yellow Brick Road together, Garland and Bolger remained friends and reunited to reminisce on Garland's weekly TV show in 1963. · OPPOSITE, BELOW: Mervyn LeRoy and Gregory Peck peruse a copy of *The Wizard of Oz*, 1970. · ABOVE: Margaret Hamilton poses with Mego Corporation's line of *The Wizard of Oz* dolls at the New York Toy Fair, February 10, 1975. · BELOW, LEFT TO RIGHT: Bert Lahr in later years; Bolger and Hamilton in 1969; Jack Haley with his wax likeness, 1976.

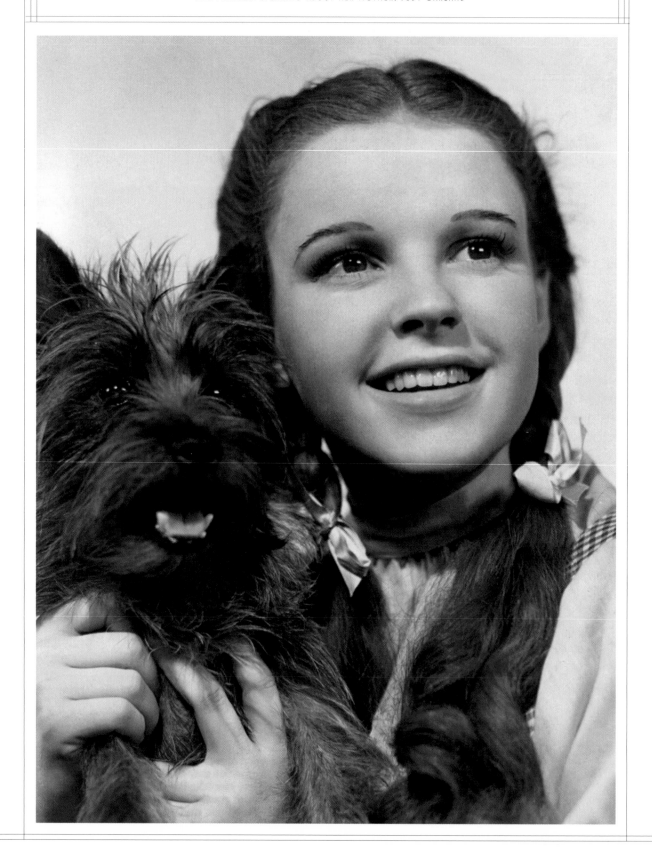

THE LEGACY

AS AN ADULT and mother, Judy Garland's appreciation for her legacy as Dorothy was surely gratified most by how *The Wizard of Oz* was perceived by her own children. In an August 15, 1989, interview with *CBS This Morning*, Judy's daughter Lorna Luft explained, "You know, it's funny, but I never thought of *The Wizard of Oz* as a children's film because it's frightening . . . I remember when I first saw it, and I guess I was around seven, my mom had come to New York. And we had someone [watching us] who kept saying, 'Your mother's going to be on television.' So I started to watch this movie, and the monkeys and all of that started to happen, and I started to cry. And she called from New York, and I was on the phone, hysterical, saying, 'Monkeys . . . take . . . you . . . to . . . New York!' And from then on, we never watched the film alone; she always watched it with us." During a March 6, 1967, TV interview, Barbara Walters asked both Lorna and Judy's young son Joe about *The Wizard of Oz*. Joe magnanimously enthused, "I could just watch it for a million times. I never get tired of it," which prompted Judy to tenderly caress him.

According to all present-day surveys and contentions, *The Wizard of Oz* is undeniably an inextricable part of our cultural heritage—one that has expanded to attain legendary significance, transcending perceptions as a fondly remembered movie favorite or TV special. Evidence of this manifested with the 2011 auction of actress Debbie Reynolds's Hollywood memorabilia; among the top-selling lots was one of the dresses worn by Judy Garland during the initial production phase on *The Wizard of Oz*. Though the costume went unused in the finished film, it brought a staggering $1.1 million at the sale—proof positive of the film's capacity to enrapture admirers of all ages.

But perhaps it is the child in each one of us to which *The Wizard of Oz* speaks most compellingly. In a 1939 editorial, journalist Gilbert Garretson took note of the spell cast on his own youngsters by the local theatre's signage for *The Wizard of Oz*. Even before seeing the film, Garretson reported, there'd be a howl unless the family drove by the theatre every night, stopped, and interpreted the meaning of the display pictures. Not only were Garretson's children counting down the hours until they saw the picture, the editor recommended to all parents, "To miss [*The Wizard of Oz*] would be one of the tragedies of childhood, and of course we are not going to let that tragedy happen."

As Garretson sagely implied, tales of the fabled and fantastic—then as now—are necessary components for encouraging youthful imaginations. Today, *The Wizard of Oz* is no longer an annually telecast special event, but its regular broadcasts and home-viewing accessibility ensure that generations to come will have unfettered viewing of this fixture of Americana. As with any folk tradition, *The Wizard of Oz*'s legacy must be transferred with regard and approbation from our culture's elders to upcoming generations. In this manner, the fairy tales of Hans Christian Andersen, the stories of the Brothers Grimm, and Lewis Carroll's *Alice* books have not only withstood the test of time, but they also continue to provide substantial source material for re-envisioning and reinterpretation as popular entertainment. When compared against the longevity of those works, *The Wizard of Oz* is still a newborn. But unlike European fables and folklore, *The Wizard of Oz* is a native heirloom that is uniquely American, uniquely our own.

Suffice it to say that *The Wizard of Oz* will continue to be revered and written about as long as there are people with childish hearts and a curiosity to learn more about this Hollywood cornerstone. And all future reenactments and reworkings of Dorothy's journey over the rainbow will owe inspiration to Turner Entertainment Co.'s *The Wizard of Oz* as the definitive standard—one that, proudly, will prevail and persist in one format or another for all time.

CREDITS

Except as noted, the material presented in this book—vintage photographs, ephemera, original artwork, posters, merchandise, and other memorabilia—is the physical property of the authors from their private collection.

Page 1: M-G-M, promotional artwork, 1939. Artist unknown.

Page 5: M-G-M, publicity still, February 25, 1939. Photographer unknown.

Page 7: M-G-M, promotional artwork, 1939. Art by Al Hirschfeld.

Page 8: Photograph courtesy Caren Marsh-Doll.

Page 9: top: M-G-M, photograph, clipping from *Pic* magazine, January 24, 1939. Photographer unknown; bottom: Caren Marsh-Doll signature, 2013.

Page 10: Loew's Incorporated, 1939. Photographer unknown.

Page 15: *The Wonderful Wizard of Oz* by L. Frank Baum, George M. Hill Co., Chicago, 1900. Illustrations by W. W. Denslow.

Page 17: left: M-G-M, publicity photograph, 1939; original photograph from 1908. Photographer unknown; right: © C.F. Payne, 2003.

Page 18: clockwise from top left: Scarecrow illustration, *New York American & Journal Supplement,* 1903; advertisement published in *Los Angeles Express,* April 14, 1913; publicity photograph for Meglin production, 1933. Photographer unknown; candid snapshot, 1916. Subjects/photographer unknown; publicity photograph, Chadwick Pictures press book, 1925. Photographer unknown; promotional art for radio play sponsored by Jell-O, 1933. Artist unknown; advertisement published in *Chicago Sunday Tribune,* December 1, 1929.

Page 19: clockwise from top left: Publicity photograph for Meglin production, 1933. Photographer unknown; back cover art for *Songs Sung in…The Wizard of Oz,* M. Witmark & Sons, 1902. Photographer unknown; press photograph for NBC-Radio, 1934; photograph from Betty Benwell's dancing class, 1933. Photographer unknown; cover from Lawrence Wright Music Co., 1925. Artist unknown; handbill, Oz Film Manufacturing Co., 1914; publicity photography for Meglin production, 1933. Photographer unknown; sheet music cover, Brooks & Denton Publishers, New York, 1904; promotional art for radio play, 1933. Artist unknown; photograph of Margaret "Tot" Qualters as Fred Stone in *Miss 1917.* Photographer unknown; Chadwick Pictures, 1925. Photographer unknown.

Pages 18-19: Background image from "The Wonderful Stories of Oz," George Matthew Adams Service, New York, 1918.

Page 21: clockwise from top: M-G-M Studios, 1938. Art by Henry Major; press photograph, 1933. Photographer unknown; United Artists Studios/Warner Bros., 1933. Art by Willy Pogany.

Page 23: left: *Time* magazine cover, December 27, 1937; right: M-G-M, publicity photograph, 1939. Photographer unknown.

Page 24: *Film Daily* clipping, March 31, 1938.

Page 25: M-G-M Studios, press photograph for *Little Nellie Kelly,* 1940. Photographer unknown.

Page 26: top: M-G-M, publicity photograph, 1939. Photographer unknown; bottom: M-G-M Studios press photograph, 1938. Photographer unknown.

Page 27: M-G-M Studios, advertisement in *Daily Variety,* August 15, 1939.

Page 28: top: M-G-M Studios, candid press photograph, 1939. Photographer unknown; bottom: M-G-M, publicity photograph, 1939. Photographer unknown.

Page 29: King Vidor's amended contract, M-G-M Studios/Loew's Incorporated, 1939.

Page 30: Loew's Incorporated, 1939.

Page 33: Loew's Incorporated, 1939.

Page 34: left: *Lost Princess of Oz,* L. Frank Baum, Reilly & Britton, Chicago, 1917; right: M-G-M Studios, publicity photograph of Judy Garland, 1937. Photographer unknown.

Page 35: top: illustration, Reilly & Britton, Chicago, 1915; bottom: M-G-M Studios, Judy Garland photograph, 1938. Photographer unknown.

Page 36: M-G-M Studios, test photographs, 1938.

Page 37: M-G-M Studios, press photograph, 1938. Photographer unknown.

Page 38: M-G-M, publicity Kodachrome, 1938. Photographer unknown.

Page 39: clockwise from left: M-G-M Studios, test photograph, 1938; M-G-M photograph as printed in *Screen Guide* magazine, 1939; M-G-M Studios, advertisement in *Showmen's Trade Review,* 1938.

Page 40: M-G-M Studios, test photograph, 1938. George Hommel, studio photographer.

Page 41: M-G-M Studios, photograph of Judy Garland, 1939. Photographer unknown.

Pages 42-43: M-G-M Studios, test photographs, 1938. Virgil Apger, studio photographer.

Page 46: Loew's Incorporated, 1939. Photographer unknown.

Page 48: clockwise from top left: M-G-M Studios, test photograph, 1938; A.M.P.A.S., Margaret Herrick Library, Jack Dawn, M-G-M makeup artist, 1938; *The Wonderful Wizard of Oz* by L. Frank Baum, George M. Hill Co., Chicago, 1900. Illustrations by W. W. Denslow; A.M.P.A.S., Margaret Herrick Library, Jack Dawn, M-G-M makeup artist, 1938; M-G-M Studios, test photograph, 1938; photograph of Ray Bolger by Maurice Seymour, Chicago, 1936.

Page 49: M-G-M Studios, test photograph, 1938; right: M-G-M Studios, test photograph, 1938. Photographer unknown.

Page 50: M-G-M Studios, test photographs, 1938. Photographer unknown

Page 52: Loew's Incorporated, 1939.

Page 54: Clockwise from top left: M-G-M Studios, test photograph, 1938. Photographer unknown; A.M.P.A.S., Margaret Herrick Library, Jack Dawn, M-G-M makeup artist, 1938; *The Wonderful Wizard of Oz* by L. Frank Baum, George M. Hill Co., Chicago, 1900. Illustrations by W. W. Denslow; Loew's Incorporated, 1939. Photographer unknown.

Page 55: M-G-M Studios, test photographs, 1938. Photographer unknown.

Pages 56-57: M-G-M Studios, test photograph, 1938. Virgil Apger, studio photographer.

Page 60: clockwise from top left: A.M.P.A.S., Margaret Herrick Library, Jack Dawn, M-G-M makeup artist, 1938; M-G-M Studios, test photograph, 1938. Photographer unknown; *The Wonderful Wizard of Oz* by L. Frank Baum, George M. Hill Co., Chicago, 1900. Illustrations by W. W. Denslow.

Page 61: clockwise from top left: M-G-M Studios, test photograph, 1938. Photographer unknown; *Screen Guide* magazine, 1939. Photographer unknown; advertisement published in *Film Daily Yearbook,* 1939.

Pages 62-63: Loew's Incorporated, 1939. Photographer unknown.

Page 66: M-G-M Studios, test photograph, 1938. Virgil Apger, studio photographer.

Page 67, top: M-G-M Studios, test photographs, 1938. Virgil Apger, studio photographer; bottom: A.M.P.A.S., Margaret Herrick Library, Jack Dawn, M-G-M makeup artist, 1938.

Page 68: clockwise from top left: Loew's Incorporated, 1939. Photographer unknown; M-G-M Studios, 1939. Photographer unknown; press photograph, May 20, 1938, credited to ACME.

Page 69: Loew's Inc., 1939. Photographer unknown.

Page 71: top: Warner Bros.; bottom: Loew's Incorporated, 1939.

Page 72: M-G-M Studios, test photograph, 1938. Photographer unknown.

Page 73: *O Feiticeiro de Oz,* Portuguese photoplay edition, 1939.

Page 74: clockwise from left: M-G-M Studios, test photograph, 1938. George Hommel, studio photographer; Loew's Incorporated, 1939; M-G-M Studios, test photograph, 1938. Photographer unknown.

Page 75: clockwise from left: Warner Bros.; M-G-M Studios, test photograph, 1938. Photographer unknown; M-G-M Studios, test photograph, 1938. Photographer unknown; Warner Bros.

Page 77: Loew's Incorporated, 1939. Photographer unknown.

Page 78: clockwise from top left: M-G-M Studios, test photograph, 1938. Photographer unknown; M-G-M Studios, test photograph, 1938. Virgil Apger, studio photographer; M-G-M Studios, test photograph, 1938. Virgil Apger, studio photographer; M-G-M Studios, 1939. Photographer unknown.

Page 79: M-G-M Studios, test photograph, 1939. George Hommel, studio photographer.

Page 81: left: Loew's Incorporated, 1939. Photographer unknown; right: detail of *Son of the Navy* lobby card, 1940.

Page 84: top: M-G-M publicity photograph, 1939. Photographer unknown; bottom: MGM publicity photograph, 1939. Photographer unknown.

Page 88: middle row, M-G-M film frames-outtake footage, 1938. Top and bottom rows: M-G-M Studios, test photographs, 1938. Photographer unknown.

Page 89: top: Loew's Incorporated, 1939. Photographer unknown; bottom: M-G-M Studios, test photographs, 1938. Photographer unknown.

Page 90: clockwise from top left: Loew's Incorporated, 1939; M-G-M Studios, portrait, 1938. Photographer unknown; M-G-M Studios, publicity photograph, 1938. Photographer unknown; M-G-M Studios, publicity photograph, 1938. Photographer unknown.

Page 91: Loew's Incorporated, photograph, 1938. George Hommel, studio photographer.

Page 92: M-G-M Studios, publicity photograph, 1944. Photographer unknown.

Page 93: top: M-G-M Studios, test photograph, 1938. Photographer unknown; bottom: illustrations, A.M.P.A.S., Margaret Herrick Library, Jack Dawn, M-G-M makeup artist, 1938; A.M.P.A.S., Margaret Herrick Library (Leonard Stanley Collection); A.M.P.A.S., Margaret Herrick Library (Leonard Stanley Collection); A.M.P.A.S., Margaret Herrick Library (Leonard Stanley Collection).

Page 94: Loew's Incorporated, 1939.

Page 96: M-G-M Studios, test photograph, 1939. Photographer unknown.

Page 97: clockwise from top: M-G-M Studios, test photograph, 1939. Photographer unknown; M-G-M "Hollywood News & Features" publicity publication, August 8, 1938; M-G-M Studios, publicity photograph published in the *Minneapolis Journal*, 1939.

Page 98: Loew's Incorporated, 1939. Photographer unknown.

Page 99: left: M-G-M Studios, test photograph, 1938. Virgil Apger, studio photographer; right: Loew's Incorporated, 1939. Photographer unknown.

Page 100: left: M-G-M Studios, test photograph, 1938. Photographer unknown.

Page 101: Loew's Incorporated, 1939. Photographer unknown.

Page 103: M-G-M Studios, test photograph, 1938. Photographer unknown.

Page 104: clockwise from top: Warner Bros.; A.M.P.A.S., Margaret Herrick Library, Jack Dawn, M-G-M makeup artist, 1938; M-G-M Studios, test photograph, 1939. Photographer unknown.

Page 105: Loew's Incorporated, 1939.

Page 106: M-G-M Studios, 1938. Jack Martin Smith, assistant art director.

Page 107: top: Loew's Incorporated, 1939. Photographer unknown; bottom: M-G-M Studios, test photograph, 1939. George Hommel, studio photographer.

Page 108: top: Loew's Incorporated, 1939. Photographer unknown; bottom: M-G-M Studios, test photograph, 1938. Virgil Apger, studio photographer.

Page 109: top: M-G-M Studios, test photograph, 1939. George Hommel, studio photographer; bottom: M-G-M Studios, test photograph, 1939. George Hommel, photographer.

Page 110: left: Loew's Incorporated, 1939; right: M-G-M Studios, test photograph, 1938. Virgil Apger, studio photographer.

Page 111: left: M-G-M Studios, test photograph, 1938. Virgil Apger, studio photographer; right: Loew's Incorporated, 1939. Photographer unknown.

Page 114: M-G-M Studios, test photograph, 1938. Photographer unknown.

Page 115: clockwise from top left: M-G-M Studios, test photograph, 1938. Virgil Apger, studio photographer; M-G-M, film frame—outtake footage, 1938; M-G-M, film frame—outtake footage, 1938; M-G-M Studios, test photograph, 1938. George Hommel, studio photographer.

Page 118: left: Loew's Incorporated, art by Wiley Padan, studio artist, *The Mifflinburg Telegraph*, Pennsylvania, 1939; right: M-G-M, publicity photographs as published in *Film Daily Yearbook*, 1939. Photographer unknown.

Page 121: top, Warner Bros.; bottom row: M-G-M Studios, test outtake frames, 1938. Photographer unknown.

Page 122: top: M-G-M Studios, test photograph, 1939.George Hommel, studio photographer; bottom: front cover of sheet music, Leo Feist Inc., 1939.

Page 123: top: Loew's Incorporated, 1939. Photographer unknown; bottom: Technicolor outtakes, M-G-M, 1939.

Page 124-125: Loew's Incorporated, 1939. Photographers unknown.

Page 126-127: Loew's Incorporated, photographs as published in *The Pioneer Magazine,* St. Paul, Minnesota, 1939.

Page 128: Loew's Incorporated, press still published in unidentified newspaper clipping, 1939. Photographer unknown.

Page 129: clockwise from top: M-G-M Studios, press photograph, 1939. Photographer unknown; Loew's Incorporated, 1939. Photographer unknown; M-G-M Studios, press photograph, 1939. Photographer unknown; International News Photo, Los Angeles Bureau (S) 24 328 ABC, 1939. Photographer unknown.

Page 130: *Silver Screen* magazine, 1939. Photographer unknown.

Page 131: top: *Info About NY* magazine, 1939; bottom: *Cue* magazine, 1939. Photographer unknown.

Page 132: clockwise from top: press photograph, 1939. ACME, photographer; press photograph, 1939. ACME, photographer; M-G-M, publicity photograph, 1939. Photographer unknown.

Page 133: top: *New York Post* press photograph. Photographer Anthony Calvacca; bottom: *New York Herald Tribune*, 1939. Art by William O'Brian.

Page 134: M-G-M Studios, press photograph published in *Movies* magazine, 1939. Photographer unknown.

Page 135: top: M-G-M Studios, publicity photograph, 1939. Photographer unknown; bottom: press photograph, 1939. ACME, photographer.

Page 136: Press photograph by Charles Old, 1939.

Page 137: left: candid snapshot, 1939. Photographer unknown; right: M-G-M Studios, publicity photographs, 1939. Photographers unknown.

Pages 138-139: Loew's Incorporated, 1939. Photographers unknown.

Page 140-141 Loew's Incorporated, Buffalo, New York, Board of Education, 1939. Photographer unknown.

Page 142: Stamp from Screen Stars Stamp Album, Harlich Manufacturing Co., Chicago, 1947.

Page 143: Press photographs, 1940. Photographer unknown.

Page 144: top: Loew's Incorporated, 1939. Photographer unknown; bottom: Newspaper ad from *The Montreal Daily Star*, September 30, 1939.

Page 145: top: *Metro* leaflet, Loew's Incorporated, 1939; middle: Loew's Incorporated, *Cine-Mundial* magazine, 1939; bottom: Loew's Incorporated, 1939.

Page 146: top: Loew's Incorporated, 1939; bottom: *Troldmanden fra Oz* book cover, Tempo Books, Copenhagen, 1940.

Page 147: top: M-G-M, Hutchinson & Co., London publisher, 1939; bottom: M-G-M, 1939.

Page 148: clockwise from top: *O Feiticeiro de Oz* book cover, Editorial Progresso, Lisbon, 1940; Loew's Incorporated, photograph published on the cover of *Radiolet*, 1940; Leo Feist Inc., New York Editions France, 1939.

Page 149: clockwise from top: Loew's Incorporated, 1943; Loew's Incorporated, 1948; Loew's Incorporated, 1948; Loew's Incorporated, 1955; Loew's Incorporated, 1946; Loew's Incorporated, 1945.

Page 150: All images: M-G-M, film frames—outtake footage, 1938–1939.

Page 151: *Film Daily Yearbook* advertisement by M-G-M Studios, 1939.

Page 152: Loew's Incorporated, 1940. American Colortype Co., manufacturer.

Page 153: clockwise from top left: Loew's Incorporated, 1939. Dart Board Equipment Company, 306-308 Cherry St., Philadelphia, Pennsylvania, manufacturer; Loew's Incorporated, 1939. Dart Board Equipment Company, 306-308 Cherry St., Philadelphia, manufacturer; Loew's Incorporated, 1939. Swift & Company, Chicago, Illinois, manufacturer.

Page 154: clockwise from top left: Loew's Incorporated, 1939. Einson-Freeman Co., In., Long Island City, New York, manufacturer; Loew's Incorporated, 1939. Einson-Freeman Co., In., Long Island City, New York; Loew's Incorporated, 1939. Photographer unknown; Loew's Incorporated, 1939. Photographer unknown;

Loew's Incorporated, Whitman Publishing, 1939; Loew's Incorporated, Whitman Publishing, 1939.

Page 155: clockwise from top left: Loew's Incorporated, 1939. Einson-Freeman Co., In., Long Island City, New York, manufacturer; Loew's Incorporated, 1939. Einson-Freeman Co., In., Long Island City, New York, manufacturer; *Publishers Weekly* advertisement for Loew's Incorporated, licensed movie edition book, 1939; *The Fargo Forum*, 1939. Photographer unknown; Artisans Studio, Nashua, New Hampshire, circa 1939; Loew's Incorporated, 1939. John C. Wellwood Corporation.

Page 157: left: Leo Feist/M-G-M cover of song sheet, 1940s; right: PFC Anthony E. Brunetti, photographer, 1943. Photo Section, 1325th Service Unit, U.S. Army, IGMR, PA.

Page 163: top: Loew's Incorporated, M-G-M Records, 1949; bottom: Loew's Incorporated, 1949.

Page 164: Loew's Incorporated, 1949.

Page 165: Loew's Incorporated, 1955.

Page 166: *TV Viewer* cover, March 26, 1970.

Page 170: top: CBS, press photograph, 1963. Photographer unknown; bottom: United Press International, 1970.

Page 171: clockwise from top: United Press International, 1975; Unidentified press photo, July 1976. Photographer unknown; Associated Press, Newsfeatures photograph, 1969. Photographer unknown; International Portrait Gallery press photo, Gale Research Co, Detroit, 1977.

Page 174: Loew's Incorporated, 1939. Photographer Virgil Apger.

Pages 2, 6, 12–13, 20, 31, 44-45, 47, 51, 58, 64, 70, 80, 82, 85, 86, 102, 112-113, 116–117, 120, 158–159, 160–161, 168–169: Warner Bros.

REMOVABLES:

Advertising herald, 1939, M-G-M/ Loew's Inc. (Authors' Collection)

Lobby card booklet, 1939, M-G-M/Loew's Inc. (Authors' Collection)

Bookmark: Art from British edition campaign book, 1939, M-G-M/Loew's Inc. (Authors' Collection)

Color-glos still, 1939, M-G-M/ Loew's Inc. (Authors' Collection)

Half-sheet poster, 1939, M-G-M/ Loew's Inc.

Newspaper: Art from Warner Bros.

All character portraits (except Good Witch and Wicked Witch, which are WB) are Loew's Incorporated, 1939 (Authors' Collection).

ACKNOWLEDGMENTS

THE AUTHORS ARE grateful to the following individuals, including those in spirit, for their assistance, support, and enthusiasm: Beverly Allen, Paula Allen, Dorothy Barrett, Ozma Baum Mantele, Janet Cantor Gari, John Davidson, Esq., Preston Evans, Brian Gari, Meredythe Glass, J. B. Kaufman, Kristine Krueger (The Academy of Motion Picture Arts and Sciences/The Margaret Herrick Library), Rob Roy MacVeigh, Dona Massin, Fred M. Meyer, Charles Oellig (Fort Indiantown Gap), C. F. Payne, Ann Rutherford, Dede Schaeffer, Charles Schram, Dave Smith, Martin Spellman, Donna Stewart-Hardway, and David Suggs. Photography of select items was skillfully handled by Tim McGowan Studio. Darrell Hickman facilitated our acquisition of Allen Davey's Technicolor collection. Film historian Brian Sibley's sage advice proved invaluable to us. Special recognition is due James Comisar, wish-broker extraordinaire, who truly made dreams come true by negotiating our transaction for the photo archive of M-G-M film editor Michael J. Sheridan. We thank Caren Marsh-Doll for years of friendship and camaraderie, and for providing us with the perfect foreword to this volume. Our friend and agent, Grace Ressler, made all things possible and shared our vision from the start, and for that we are forever indebted to her.

Special thanks to Ashley Woodall, Melanie Swartz, Elaine Piechowski, Victoria Selover, Kathleen Wallis, Steve Fogelson, Stephanie Mente, Avis Frazier-Thomas, and Josh Anderson, as well as Marta Schooler, Signe Bergstrom, Lynne Yeamans, Dori Carlson, Julie Hersh, and Paige Doscher. A very special thanks to Paul Kepple and Ralph Geroni.